C. Turner

01 DEC 09

2 0 DEC 2013

01. APR 10.

AAC

SPINE BROKEN ON
ARRIVAL 11/3/20 C.J.

Andy Warhol by Andy Warhol

ASTRUP FEARNLEY MUSEUM
OF MODERN ART

ANDY WARHOL BY ANDY WARHOL

Edited by
Gunnar B. Kvaran
Hanne Beate Ueland
Grete Årbu

SKIRA

Cover
Big Electric Chair, 1967

Back Cover
Self-Portrait (Fright Wig), 1984

Art Director
Marcello Francone

Editorial Coordination
Eva Vanzella

Editing
Emily Ligniti

Layout
Sara Salvi

Translations
Simon Pleasance (Benhamou)

Photo Credits
Poul Buchard, Copenhagen;
Halvard Haugerud, Oslo; Paul
Hester, Houston; Jochen
Littkemann, Berlin;
Lindeman/Fremont; Metropolitan
Museum, Gerard Malanga;
Phillips/Schwab; Peter Schälkli,
Zurich; Courtesy Sonnabend
Gallery; Andy Warhol Foundation
for the Visual Arts, Inc., The Andy
Warhol Museum, Pittsburgh

First published in Italy in 2008 by
Skira editore S.p.A.
Palazzo Casati Stampa
via Torino 61
20123 Milano
Italy
www.skira.net

© 2008 Astrup Fearnley Museum
of Modern Art, Oslo
© 2008 The Au[thors]
© 2008 Gerard [Malanga]
© 2008 Skira e[ditore]
© Andy Warhol
Visual Arts, by S[IAE ...]
© 2008 The An[dy Warhol]
Museum, Pittsb[urgh ...]
museum of Carn[egie ...]
rights reserved
© Andy Warhol [Foundation ...]
Visual Arts / BC[...]

All rights reserve[d ...]
international copyright
conventions.
No part of this book may be
reproduced or utilized in any form
or by any means, electronic or
mechanical, including
photocopying, recording, or any
information storage and retrieval
system, without permission in
writing from the publisher.

Printed and bound in Italy.
First edition

ISBN: 978-88-6130-800-8

Distributed in North America by
Rizzoli International Publications
Inc., 300 Park Avenue South,
New York, NY, 10010.
Distributed elsewhere in the world
by Thames and Hudson Ltd.,
181a High Holborn, London
WC1V 7QX, United Kingdom.

This catalogue was published
on the occasion of the exhibition
Andy Warhol by Andy Warhol held
at the Astrup Fearnley Museum
of Modern Art, Oslo,
September 13 – December 14, 2008

**ASTRUP FEARNLEY MUSEUM
OF MODERN ART**

Dronningens gate 4,
PB 1158 Sentrum,
N.0107 Oslo
Ph: (+47) 22 93 60 60
Fax: (+47) 22 93 60 65
info@fearnleys.no
www.afmuseet.no

Contents

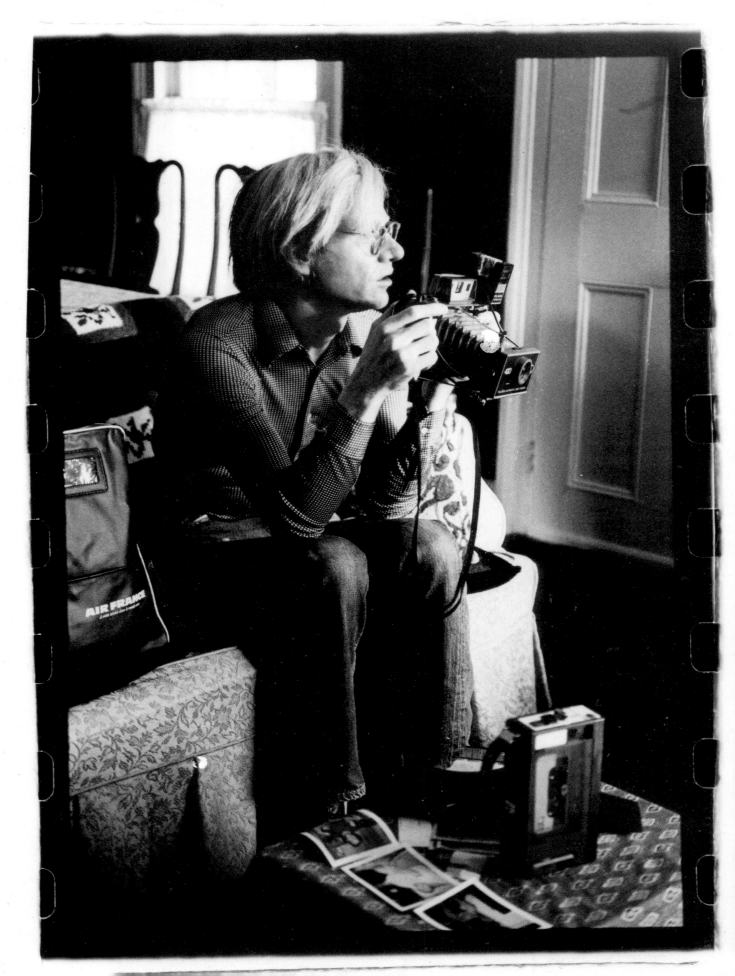

Gunnar B. Kvaran

Andy Warhol by Andy Warhol
An Introduction

Andy Warhol with his media toys
© Gerard Malanga, 1971

Andy Warhol is the first American artist.

Of course there still are people related to the art world who see abstract expressionists like Jackson Pollock and Mark Rothko as the pioneers of American art. But if we look at this critically in terms of detachment with European artistic tradition, it seems clear that the roots of American abstract expressionism lie firmly within the European avant-gardes, such as surrealism and abstraction, which the mid-century American artists dynamically extended in new directions.

Compared to these heroic New York School painters, Andy Warhol represents more of a rupture with art history. This break was manifest on a technical level through Warhol's use of the silkscreen, a reproduction device which became the artist's signature language. It was also achieved through Warhol's choices of subject matter and symbols, which were indicative of the then emergent American consumer society, a society which created new behavior patterns and, in fact, a new kind of personal identity.

The American society of consumerism and spectacle created a novel living condition for everyday people. It standardized methods of work and modes of consumption and it created, or should we say, increased, the social phenomena of the middle class which quickly became the dominant social force in American, and eventually European, culture.

Awareness of these conditions led to a multifarious profusion of artistic reactions within the avant-garde communities in the 1950s and 1960s, including the onset of happenings, Fluxus, and pop art and significant innovation in the fields of performance, experimental film (initially the Nouvelle Vague), and literature (the Nouveau Roman). Indeed, many artists proposed a new kind of "realism" within their oeuvre, and prominent sociologists like Guy Debord and Jean Baudrillard began writing their seminal cultural critiques. Debord, for example, stressed the fact that our "visual" world was no longer "real," unlike its representation, where all direct experience was replaced by mediated representation. He argued that it is a constellation of images and references—the *spectacle*—that holds together and governs a society. The French sociologist Jean Baudrillard wrote that social reality was just a "simulacrum" as "reality" evaporates from one media representation to another. During that same period, French writer and critic Roland Barthes introduced the idea of the "death of the author," emphasizing how authenticity and personal experience were on the wane within the new media society.

From within this, Warhol was among the first, and certainly the most influential, to identify the significance of this new "social situation" and to transfer it onto the canvas. In so doing, he created a whole new artistic vision. "It strikes me," wrote philosopher Arthur Danto, "that Andy Warhol was exceptional in seeking to make reality of his era conscious of itself through his art."[1]

In an art-historical context, Andy Warhol moved the locus of artistic expression from the first to the third person; he removed all semblance of personal expression loaded with psychological references and his art became a neutral, arguably objective, means of communication. Warhol often referred to himself as a machine that endlessly reproduced ephemera from the media world of magazines and newspapers. He even emphasized the fact that the images he used did not have any kind of personal meaning: "If you want to know all about Andy Warhol, just look at the surface: of my paintings and films and me, and there I am. There's nothing behind it."[2]

But even though Warhol yearned to present himself as an "objective" artist, and despite the fact that he created a distance with the spectator and did everything to mislead the beholder, it remains legitimate to question whether Warhol's art entirely beholds his personal subjectivity in terms of the aesthetics he deployed and his choice of imagery. Warhol on many occasions stressed the fact that he was not "personally" involved in choosing his subject matter and even in the making of his own paintings. Both of these claims, however, have turned out to be less and less true. For even though Warhol's paintings were mainly about the mechanic transferring of images to the canvas through the use of silkscreen reproduction techniques, they were nevertheless highly composed and structured. In this sense, the mode of production that Warhol applied to his paintings—and also his sculptures, films, and installations—required numerous decisions to be made along the way. First, he had to decide exactly what type of techniques to apply and then he had to select, or at least accept, images borrowed from the media world—"second-hand" images. Next, Warhol had to determine the actual composition of the paintings, frequently involving a subtle reframing of the borrowed imagery. Such choices included where and how the images were to be placed on the canvas and what colors were to be utilized. Together, all of these elements responded to a certain kind of subjectivity despite the fact that the works themselves were not loaded with what is traditionally defined as the artist's physiological expression: the notion of "subjectivity" cannot be escaped.

This tension between the objective and subjective also arose in a conversation I had some years ago with the pioneering French author Alain Robbe-Grillet who compared pop art and Nouveau Roman. (In fact, our conversation about the role of subjectivity in relation to pop art and Nouveau Roman was an early inspiration for the present exhibition.) In a related reflection on his own work, Robbe-Grillet questions an important misunderstanding concerning an objective reading of his work: "In common parlance, *objective* signifies 'neutral' or 'impartial.' Transposed to literature, the meaning is as though the author were no longer present. Well, illiterate critics have failed to read the article by Barthes with care and have given the term its everyday sense. Barthes demonstrated instead that *Les Gommes* was essentially concerned with Husserlian intentionality and therefore subjective literature but directed toward the object, the very opposite of traditional literature, which is directed toward consciousness."[3] In a different reflection on the notion of the conscious where he compares the ideas of Kant and Husserl, Robbe-Grillet also makes the following remark: "In actual fact, it is impossible to have a Husserlian consciousness because one always has something in oneself."[4]

[1] Arthur C. Danto, *Unnatural Wonders: Essays from the Gab between Art and Life*. New York: Columbia University Press, 2005, p. 180.
[2] Gretchen Berg, *Andy: My True Story*. Los Angeles: Los Angeles Free Press, 1967, p. 3.
[3] Alain Robbe-Grillet, *Préface à une vie d'écrivain*. Paris: Éditions du Seuil, 2005, p. 80.
[4] Ibid., p. 34.

Accepting the fact that one, or in this case the artist, always has "something in oneself," we would like, in this exhibition entitled *Andy Warhol by Andy Warhol*, to examine Warhol's personal relationship to the subject matter of his art and to see if the choice of techniques (the silkscreen, most notably), of images, and of themes included a personal commitment. To address these vast, and of course complicated, questions we have decided to focus on some major themes which share many similar points of departure and which cumulatively reveal Warhol's relationship with his surroundings and with his own feelings about the society and times in which he lived. Specifically, we want to evaluate Warhol's views on consumerism, icons, religion, and politics and to see in what ways his "self" was manifest in his artistic expression. This method of reflection enables us to evaluate the notion of subjectivity in Warhol's art. In what way did his subjectivity and sensibility interfere with the themes and images he selected? How did his personality color his work? Did his upbringing condition his choices? Did his sexuality influence his *vision du monde*? Did the images Warhol choose for his paintings have an intentional *a priori* meaning? Did Warhol have "inner necessity"? We are therefore looking for the autobiographical thread, the first person under the pictorial surface, the subjectivity behind the machine.

Andy Warhol was a strategically self-made public figure. His way of dressing and talking, what he said about himself, and how he expressed himself were all part of a larger *mise en scène*. Warhol, more than anybody else, was aware of the show he was putting on: "Everyone always reminds me about the way I'd go around moaning, 'Oh, when will I be famous, when will it all happen?' etc., etc., so I must have done it a lot. But you know, just because you carry on about something doesn't mean you literally want what you say. I worked hard and I hustled, but my philosophy was always that if something was going to happen, it would, and if it wasn't and didn't, then something else would."[5]

Andy's rhetoric, which mostly appeared in interviews, was entirely in keeping with his straightforward paintings. Neither his words nor his art were preoccupied with grand narratives; rather, they were concerned with conveying provocative single images and anecdotes—short sentences that could never have been taken for any kind of explanation balanced perfectly with the images on the canvas. His well-known remarks about being a "machine" or "picture surface" were an intelligent way to position himself within the context of the socially alienated middle class his paintings were supposed to come from and to represent. Warhol kept quite well to his act.

But even though his art concerned itself with common things and the commonplace, and that he himself evoked the impersonal artist, we also know that he was totally taken by the idea of fame, that he tirelessly aspired to rise above the average. There were also numerous times and situations when Warhol would slip out of his distant "artistic" role, when his subjectivity or sensibility hardly corresponded with the nature of his work. In this sense, his pursuit of fame and his fascination with consumption, which have been documented on many occasions, were absolutely genuine. Despite being extremely shy, Andy wanted to be famous: "I've always wanted people to notice me."[6] He loved famous people and he was very conscious of their power. Gerard Malanga, in this catalogue, states: "When we silkscreened the *Silver Liz* portrait—and I believe we made at least three that first day—there was very little conversation that I can recall about why he chose this subject, except at some point—maybe later—he expressed to me his interest in movie stars. He said something to the effect that they were or could be as powerful as politicians."[7]

Andy wanted to be among them. And he managed to. He reminisced: "To meet a person like Judy [Garland] whose real was so unreal was a thrilling thing. She could turn every-

[5] Andy Warhol and Pat Hackett, *POPism: The Warhol Sixties.* New York: First Harvest Edition, 1990, p. 82.
[6] Ibid., p. 47.
[7] *Long Day's Journey into the Past: Gunnar B. Kvaran Speaks with Gerard Malanga*, Astrup Fearnley Museum of Modern Art, 2008.

thing on and off in a second; she was the greatest actress you could imagine every minute of her life."[8] "I met so many stars at Arthur—Sophia Loren, Bette Davis—everybody but Liz Taylor Burton—but the most thrilling thing was meeting an astronaut, Scott Carpenter."[9]

But most of the time there was a reason why Andy admired these celebrities. It was not only because they were well-known or how they were represented in the media, but absolutely about what they stood for and what they achieved: "I liked Dylan, the way he'd created a brilliant new style."[10] "Picasso was the artist I admired most in all of history, because he was so prolific."[11]

Andy took advantage of being among the social elite and made a lot of money by painting the rich and famous. In fact, Andy seems to have been well off throughout his career, first by establishing himself as a successful commercial artist and eventually through selling his paintings. He was never the stereotypically poor, bohemian artist. He had his own townhouse already in the early 1960s and with time, and especially with the production of portraits and serigraphs, his wealth became considerable, enabling him to live lavishly. He was an immensely generous host and, as we could see when his house was opened to the public posthumously, a huge collector of all kinds of things. Not merely a shrewd commentator of American consumer society, he was an American consumer *par excellence.*

Time passes, new exhibitions are organized, and the discourse on Andy Warhol and his art balloons. We learn ever more about his "secrets" and, with clearer perspective, we gain new understanding of and a greater appreciation for his legacy. On the occasion of Warhol's memorial ceremony at St. Patrick's Cathedral, New York, on April 1, 1987, John Richardson disclosed what for many was a surprising revelation about Warhol's religious commitment. In his eulogy, he reminded us that Andy came from a religious family, that he was brought up in the Catholic "Ruska Dolina," the Ruthenian section of Pittsburgh, and that throughout his years in New York he attended mass regularly and even took part in the Church's charity work for homeless people. One can find photos, for example, showing Andy serving food and drinks one afternoon in his local church.

This knowledge opens up the possibility of vibrant new readings of Warhol's work. Most significant for our purposes, it makes it all the more convincing to say that Warhol had a *personal* commitment to his religious paintings. And it casts another kind of light on his iconic treatment of figures like Marilyn Monroe and his series of the electric chairs, skulls, and shadows. Read in this light, they indeed seem deeply spiritual.

But although Andy was a sincere believer in God, he was also keenly aware of how religion could be subjugated to mechanisms of power and politics and how artificially orchestrated the Pope's public appearances could be. Andy was especially impressed by the "thunder and speedy" Pope Paul VI's visit to America in 1965: "Definitely the most pop public appearance tour of the sixties was that visit of the Pope to New York City. He did it all in one day—October 15, 1965. It was the most well planned, media-covered personal appearance in religious (and probably show business) history."[12]

Most of the people who knew Warhol say that he gave the impression that he did not have any kind of political consciousness. Some even laughed about the idea. But when one closely reads interviews with the artist and the major texts that he wrote, notably *POPism: The Warhol Sixties* (1980), with Pat Hackett, and *The Philosophy of Andy Warhol* (1975), a solo effort, one can rightly question this attitude about Andy's political commitments. Indeed, there are numerous remarks that suggest that Warhol was very aware of American politics, in particular how power structures functioned and the important correlation between media and politics.

[8] Andy Warhol and Pat Hackett, *POPism: The Warhol Sixties, Op. cit.,* p. 101.
[9] Ibid., p. 115.
[10] Ibid., p. 108.
[11] Ibid., p. 114.
[12] Ibid., p. 143.

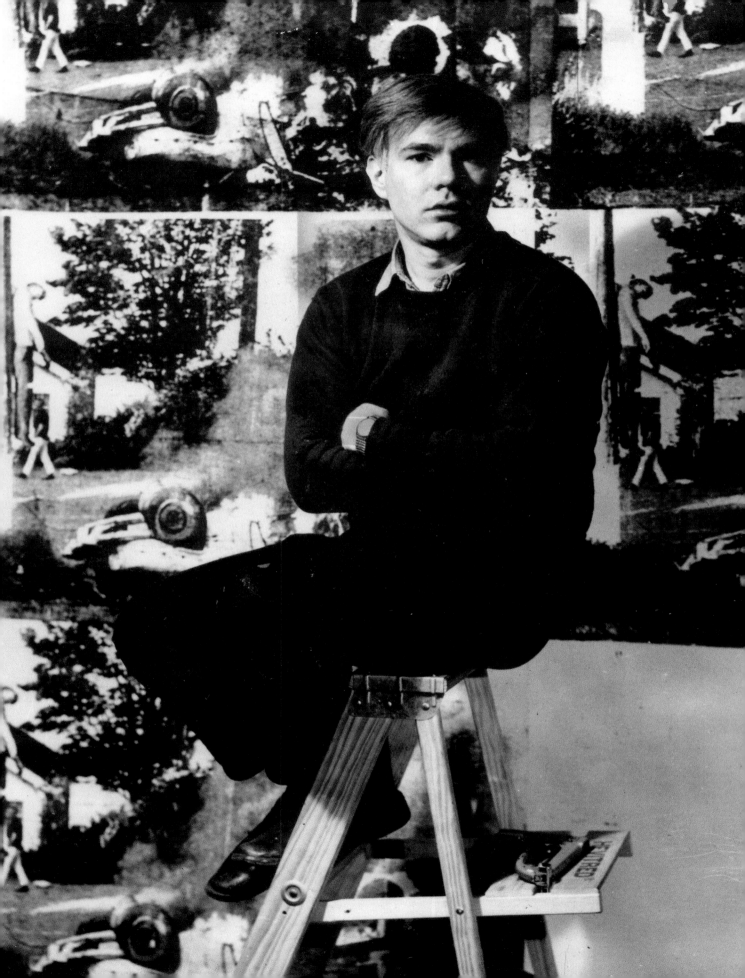

In this context, we should remember that in 1972 Warhol was approached by representatives of the Democratic Party who wanted him to make a poster for George McGovern's presidential campaign against Richard Nixon. Warhol consented and created one of the most terrific political posters in American history—a silkscreen painting showing Nixon with a terrible gray-green head (giving Nixon a "bad face") with the words, "Vote McGovern" directly below. Rumor has it that this poster caused him considerable anxiety when Nixon eventually emerged victorious. It is also one of few paintings where we can identify a clear personal and political message—*Vote Democratic*—and for this reason it sheds important light on Warhol's political awareness, in general.

Warhol was aware of censorship and the limits of what American society was morally willing to accept. He wanted to test these limits and provoke new situations: "The only thing 'underground' about American underground movies—I mean, in the strict political sense of having to hide from some authority—was that in the early sixties there was the big censorship problem with nudity."[13] As is well known, Warhol was one of the main filmmakers in the 1960s to challenge this conservatism. However, it is crucial to underscore that this wasn't simply a matter of trying to liberalize puritanical attitudes about the depiction of nudity and sexuality. Rather, he was driven by a deep-seated personal commitment to exposing how the media conditioned everyday life, dictating what people were supposed to think and feel: "I'd been thrilled having Kennedy as President; he was handsome, young, smart—but it didn't bother me that much that he was dead. What bothered me was the way the television and radio was programming everybody to feel so sad."[14] Television really fascinated him: "Up until then I'd been in *Time* and *Life* and all the newspapers a lot and nothing had ever made me be recognized this much, but now just a few minutes on TV had really done it."[15]

Warhol followed what was happening in American society and in the world, in general. His notes and comments in *POPism* make this especially clear. In the important essay that Warhol wrote together with Pat Hackett about himself and his entourage, he regularly refers to the broader historical and social context in an effort to show that he and his entourage were not totally isolated within the Factory: "When the news came over the radio in February that Malcolm X was just shot up in Harlem . . .[16] Cuba was a running political topic at the time. That past December Che Guevara had been down the street from the Factory at the United Nations giving a speech."[17] (Warhol did a film inspired by Waldo. His sister had been married to Castro.) "Our first weekend at the Gymnasium was also the weekend of the big spring mobilization march against the Vietnam war. Martin Luther King, Jr., Stokeley Carmichael, and some other people gave speeches in the Sheep Meadow and then marched down Fifth Avenue."[18] The tragedy of the Vietnam war was also closer to Warhol's heart than we often tend to think: "He (Eric) didn't hear me walk in, and I stood at the back of the chapel watching him. On the walls were hundreds of pictures of Indian boys—soldiers from around Tucson who'd died in Vietnam—and beside each picture was a little name card and a candle and each soldier's personal jewellery. Eric was standing in front of one of the cards. I went to him and asked how long he'd been standing there, and he said, 'There're so many.' He'd been standing there for hours."[19]

Women's rights were also on Warhol's mind. This certainly reflected his understanding about and personal experience with his own sexuality, and his spite for discrimination in general. One should not forget that 1960s America remained very racially fragmented and that the Equal Rights movement was only just beginning to take shape. "Women's issues weren't even being discussed then; there was no large organized women's movement yet—I mean right up through '69 it was almost impossible for women to get a legal abor-

[13] Ibid., p. 78.
[14] Ibid., p. 60.
[15] Ibid., p. 139.
[16] Ibid., p. 100.
[17] Ibid, p. 113.
[18] Ibid., p. 209.
[19] Ibid., p. 262.

tion in this country. Viva was unusual for those times—a girl who'd look into a camera and complain about cramps from her period, or tell men that they were bad in bed, that maybe they might think they were doing great but it wasn't doing a thing for her. Viva was the first girl we'd ever heard talk that way."[20] Above all, Warhol was concerned about the violent era that was brewing at the end of the decade. For example, he was moved by the impact Joseph McCarthy, "the most visible public face of a period of intense anti-communist suspicion inspired by the tensions of the Cold War," and McCarthyism had on Viva: "She talked about her family a lot—her parents and her eight brothers and sisters—and her stories all usually cast her father as a Roman Catholic fanatic and her mother as a Joseph McCarthy fanatic who made the kids watch the hearings on television in their entirety."[21] Indeed, Warhol felt that social and political strife was pervasive: "The new style was violence—hippie love was already old-fashioned. In '68 Martin Luther King, Jr., and Robert Kennedy both got assassinated, the students at Columbia took over the whole campus and fought with the police, kids jammed Chicago for the Democratic National Convention, and I got shot. Altogether, it was a pretty violent year."[22]

When Andy entered the New York art scene, he would constantly evaluate his work in relation to that of his contemporaries, expending considerable amounts of energy trying to make his place in art history. One of the most telling anecdotes concerns how he reacted upon first seeing Roy Lichtenstein's comic paintings. Warhol had made some cartoon appropriation paintings in 1960, but when he saw Lichtenstein's work at the Leo Castelli Gallery in 1961, he concluded that he had to drop these pictorial ideas and look for something else—to invent his own language. "Ivan had just shown me Lichtenstein's *Ben Day* dots and I thought, 'Oh, why couldn't I have thought of that?' Right then I decided that since Roy was doing comics so well, that I would just stop comics altogether and go in other directions where I could come out first."[23] Warhol wanted to be radically creative—"I would go absolutely anywhere I heard there was something creative happening"[24]—and he not only looked at art, but also attended literature readings, integrated into the New York avant-garde film scene, and was passionate about music: "It was exciting to hear pop music sounding so mechanical; you could tell every song by sound now, not melody: I mean, you knew it was 'Satisfaction' before the first fraction of the first note finished."[25] He was extremely curious about the world in general, small and big things alike, especially about what people were thinking and saying: "It's called gossip, of course, and it's an obsession of mine."[26]

Warhol had an uncanny prowess at drawing upon elements from his everyday life and inserting them into his art. His adoption of silver is a great example of this, for in Warhol's mind this was no ordinary color, but a symbol of precise social, period-specific references: "It was great, it was the perfect time to think silver. Silver was the future, it was spacy—the astronauts wore silver suits—Shepard, Grissom, and Glenn had already been up in them, and their equipment was silver, too. And silver was also the past—the Silver Screen—Hollywood actresses photographed in silver sets. And maybe more than anything, silver was narcissism—mirrors were backed with silver."[27]

Coming from the world of publicity and media, Warhol was extremely conscious of the role he was playing as a pop artist, a new phenomenon in the art world in which artists and their work had become more or less one: "I wondered what it was that had made all those people scream. I'd seen kids scream over Elvis and the Beatles and the Stones—rock idols and movie stars—but it was incredible to think of it happening at an *art* opening. Even a pop art opening. But then, we weren't just *at* the art exhibit—we *were* the art exhibit, we

[20] Ibid., p. 266.
[21] Ibid., p. 267.
[22] Ibid., p. 255.
[23] Ibid., p. 18.
[24] Ibid., p. 51.
[25] Ibid., p. 116.
[26] Ibid., p. 73.
[27] Ibid., pp. 64–65.

were the art incarnate and the sixties were really about people, not about what they did; 'the singer / not the song,' etc. Nobody had even cared that the paintings were all off the walls."[28]

As a genius of communication, Warhol also knew the importance of right timing. In 1965, he made the brazen announcement that he would retire from painting: "Art just wasn't fun for me anymore. . . ."[29] Ivan [Karp] understood what I meant—that I didn't want to keep repainting successful themes.' . . ."[30] I was completely satisfied with being retired: the basic pop statements had already been made."[31] For Warhol, the revolution had already been made and had exhausted the potential of new techniques and themes. His conclusion was that there was nothing more to get out of these materials, except perhaps commercial success, which came from recycling this radical aesthetic to the marketplace.

Film was one avenue that Warhol identified as possessing dynamism, and he had a very clear idea and intention about filmmaking: "I never liked the idea of picking out certain scenes and pieces of time and putting them together, because then it ends up being different from what really happened—it's just not like life, it seems so corny. What I liked was chunks of time all together, every real moment."[32] For Warhol, filmmaking was a serious matter: "I told her [Edie], 'But don't you *understand?* These movies are art!'"[33]

The people closest to Warhol who passed their days at the Factory (Warhol's studio) formed a close-knit society of colorful attitudes and personalities. Warhol was the conceptual brains of the operation—the leader—and a great many complicated personal relationships developed revolving around his intentions and the expectations of others. Warhol was there, some say, as a voyeur—he was known to be quite distant—and a creative manipulator.

It is probably Warhol's relationship with Edie Sedgwick that has generated more speculation about his personality and morals than anything else, especially about him being a negative influence. "Whatever anyone may have thought, the truth is I never gave Edie a drug, ever. Not even one diet pill. Nothing. She certainly was taking a lot of amphetamine and downs, but she certainly wasn't getting any of them from me. She was getting them from that doctor who was shooting up every Society lady in town.

Now and then someone would accuse me of being evil—of letting people destroy themselves while I watched, just so I could film them and tape record them. But I don't think of myself as evil—just realistic. I learned when I was little that whenever I got aggressive and tried to tell someone what to do, nothing happened—I just couldn't carry it off. I learned that you actually have more power when you shut up, because at least that way people will start to maybe doubt themselves."[34]

The 1960s were a momentous time for Warhol and the Factory. If the abstract expressionists revolutionized painting the decade before, Warhol revolutionized art, as Arthur Danto has put it.[35] This not only involved overhauling notions of the visual arts but filmmaking, too, and it was deeply satisfying for him: "People say that you always want the things you can't have, that 'the grass is greener' and all that, but in the mid-sixties I never, never, never felt that way for a single minute. I was so happy doing what I was doing, with the people I was doing it all with. Certainly, at other times in my life I'd wanted lots of things I didn't have and been envious of other people for having them. But right then I felt like I was finally the right type in the right place at the right time. It was all luck and it was all fabulous. Whatever I didn't have that I wanted, I felt that it was just a matter of any day now. I had no anxieties about anything—everything just seemed to be coming to us."[36]

In this exhibition, we invite audiences to experience some of Andy Warhol's great masterpieces, works that revolutionized the notion of art. These paintings completely trans-

[28] Ibid., p. 133.
[29] Ibid., p. 113.
[30] Ibid., p. 115.
[31] Ibid., p. 115.
[32] Ibid., p. 110.
[33] Ibid., p. 123.
[34] Ibid., p. 108.
[35] Arthur C. Danto, *Unnatural Wonders, Op. cit.*, p. 137.
[36] Andy Warhol and Pat Hackett, *POPism: The Warhol Sixties, Op. cit.*, p. 101.

formed how we understand the practice of art marking and created an unprecedented objective distance between the artist and the spectator. Andy Warhol, often referred to as an "artist in third person," encapsulated the consumer society of his time by integrating the leading images, hopes, and aspirations of post-war America into his art. He did so with such authority and conviction that his art, his persona, became a brand in its own right, much like the objects and ideas he depicted. Because of this, he has a legitimate claim to being the "first" genuine American artist—an unparalleled mirror onto the great social transformations of post-War Americana.

As the title, *Andy Warhol by Andy Warhol*, suggests, we would like to encourage audiences to reflect upon Warhol's personal involvement with his art and his subject matter, to place the artist in the center not only as an icon and an "artist in third person," but as a person with extreme commitment to the times in which he lived. It is thus our hope that this exhibition exceeds well rehearsed clichés about Warhol and emphasizes instead the ambition, subjectivity, and consciousness of Andy as a person.

To guide us in this adventure, we not only have Warhol's art, essays, and interviews, but a whole universe of critical writing about him. In this catalogue we are privileged to add to this body of discourse with important new essays by prominent scholars and writers including Graham Bader, Rachel Baum, Judith Benhamou-Huet, Glenn O'Brien, David Carrier, Jane Daggett Dillenberger, Aram Saroyan, Svein Inge Sæther, Steven Watson, and an interview with Gerard Malanga.

An exhibition entitled *Andy Warhol by Andy Warhol* can only succeed by presenting works of great quality. We are immensely proud to be able to show a selection of major works, art-historical icons, thanks to the generosity of the Daros Collection, Switzerland, the Metropolitan Museum of Art, New York, the Sonnabend Collection, New York, the Froehlich Collection, Stuttgart, the Shelton Group, London, Bruno Bischofberger, Zurich, the Louisiana Museum for Moderne Kunst, Humlebæk, Tate, London, the Stephanie and Peter Brant Foundation, Greenwich, Connecticut, the Astrup Fearnley Collection, Oslo, and various private lenders.

This exhibition, the most ambitious show ever organized by the Astrup Fearnley Museum of Modern Art, has been made possible by the generous support of I.M. Skaugen SE, the Foundation Thomas Fearnley, Heddy and Nils Astrup, and Astrup Fearnley A/S.

Essays

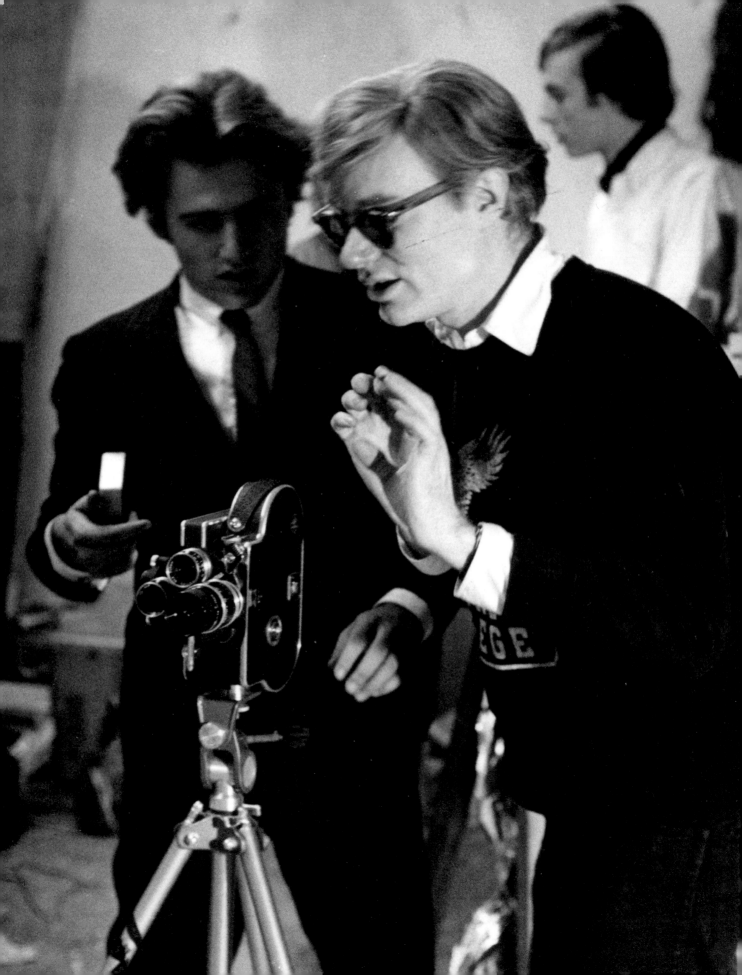

Andy Warhol and Gerard Malanga
setting up a shot for a
"screen test" (detail)
Archives Malanga, 1964

To think about Warhol and politics, let's start with a specific time and place: Los Angeles, the Ferus Gallery, Warhol's first solo painting exhibition in July and August 1962. The content and design of this exhibition are well known. Working in conjunction with gallery director Irving Blum, Warhol arranged thirty-two Campbell's soup can paintings, identical but for the flavor of soup featured in each, on a series of shallow level shelves cutting across the space's walls. Seemingly devoid of individual touch or compositional volition, leaning against rather than attached to the gallery's walls, and aggressive in their rote repetition, Warhol's works appeared—like the items they represented—as a set of take-it-with-you supermarket commodities.

Warhol's comments on the series, however, complicate its references. Responding to Gene Swenson's question (in the critic's well-known series of 1963 interviews around the question of "What is pop art?") as to why he started to paint soup cans, Warhol responded: "Because I used to drink it. I used to have the same lunch every day, for twenty years, I guess, the same thing over and over again."[1] The soup cans, in other words, formed a kind of self-portrait—a presentation, quite literally, of the very substance of Warhol himself. The artist began his discussion with Swenson, furthermore, by aligning this notion of self-as-repeated-commodity with both Soviet conformism and the political motivations of Brechtian aesthetics:

> Someone said that Brecht wanted everyone to think alike. I want everybody to think alike. But Brecht wanted to do it through Communism, in a way. Russia is doing it under government. It's happening here all by itself without being under a strict government; so if it's working without trying, why can't it work without being Communist? Everybody looks alike and acts alike, and we're getting more and more that way.[2]

[1] Andy Warhol as cited in Gene Swenson, "What is Pop Art? Part I," *Art News*, 62, 7, November 1963, pp. 24–27 ff. Reprinted in Steven Henry Madoff (ed.), *Pop Art: A Critical History*. Berkeley: University of California Press, 1997, pp. 103–111. Warhol's remarks are on page 104 of Madoff's volume.
[2] Ibid., in Steven Henry Madoff, p. 103.

This is an oft repeated but nevertheless still startling passage. For Warhol here not only positions his practice as explicitly *political*, but does so in the most global of terms. Indeed, his declaration of the parallel development of Soviet and American culture recalls, perhaps more than anything else, the opening passage of Theodor Adorno and Max Horkheimer's chapter on the culture industry in their seminal 1947 polemic *Dialectic of Enlightenment*. Writing during their wartime exile in sunny Los Angeles (the site, we can remember, of Warhol's Ferus debut), the two German theorists proclaim:

Culture today is infecting everything with sameness. Film, radio, and magazines form

a system. Each branch of culture is unanimous within itself and all are unanimous together. Even the aesthetic manifestations of political opposites proclaim the same inflexible rhythm. The decorative administrative and exhibition buildings of industry differ little between authoritarian and other countries.[3]

If Warhol's soup cans appear a far cry from the polemical broadside of Adorno and Horkheimer's text, his paintings' political dialectics are arguably more complex. For while the authors of the *Dialectic of Enlightenment* situate themselves in a position of ambiguous immunity to the total instrumentalization of the daily life they describe, Warhol makes his placement within—indeed, determination by—this totalizing system the very engine of his series. Even more, he infects the series' portrait of radical sameness with a subtle but insistent *difference*: none of the soup cans' flavors repeat, even as the echoes of each other ("Vegetable," "Vegetarian Vegetable," "Vegetable Bean," etc.) suggest their dance with Adorno and Horkheimer's prognosis of unrelenting homogeneity.

This interweaving of dialectics, I want to propose, comprises the substance of Warhol's politics. His work and life present a portrait of culture in the reign of total spectacle within which structures of difference, however tentative or muted they may be, constantly emerge and proliferate, bound to but never fully consumed by the totalizing system that produces them. His is not a politics of positions or protest, but of insistent, self-reflexive, and all-consuming critique. Just as his 1962 Ferus exhibition created a self-portrait by seemingly negating the self, so Warhol's broader practice constructs a political stance out of the apparent rejection of politics altogether. This is, we can imagine, not a simple operation. The present essay is an attempt to grapple with some of its forms, its problems, its paradoxes, and its possibilities—to move toward an understanding of the radically non-political political consciousness of Andy Warhol.

As should be clear, the identification of any specific Warholian political positions or passions is a thankless task. Though one of the very few prominent artists of the 1960s to emerge from a truly working-class background, Warhol identified in his youth more with Shirley Temple than any proletarian heroes and spent much of the 1970s celebrating the ultra-rich (and frequently ultra-reactionary) as a celebrity portraitist-for-hire and publisher of *Interview* magazine.[4] While Warhol was one of the most prominently "out" gay men in postwar American culture—and arguably brought gay desire to the public eye more forcefully than any other contemporary figure—he had little to say about the AIDS crisis that ravaged much of gay America in the 1980s, skipping funerals of friends who died from the epidemic and even snubbing the photographer Robert Mapplethorpe because he knew him to be sick from complications related to HIV.[5] And if Warhol's iconography, stretching from electric chairs to race riots to Mao and the hammer and sickle, was the most directly political of any figure associated with pop, his images are so formally leveled—Mao appears just as fashion designer Halston, the electric chair just as a can of soup—that any political significance appears purged. It is fitting that Warhol's most explicitly "committed" work, a 1972 silkscreen declaring "Vote McGovern"—commissioned by Democratic party activists and sold to raise money for George McGovern, the party's 1972 presidential candidate—featured not the visage of its subject but of his opponent, Richard Nixon.[6] Even in taking a stand, Warhol adopted the guise of advocating its opposite.

Warhol's statements and associations certainly provide little help in making sense of his political stands. He famously embraced Imelda Marcos and Ronald Reagan (whose 1980 inauguration he attended) just as McGovern or Jimmy Carter. Politics comes up rarely in his interviews, and when it does Warhol disavows any interest and quickly changes the subject. A 1973 interview with George Gruskin of the South African magazine *Scope* is typical:

[3] Theodor Adorno and Max Horkheimer, *Dialectic of Enlightenment*. Stanford: Stanford University Press, 2002, p. 94, trans. Edmund Jephcott.

[4] For a discussion of the conflicting impulses and interests working on Warhol during his studies and early career (including his devotion to Shirley Temple), see Blake Stimson, "Andy Warhol's Read Beard," *The Art Bulletin*, 83, 3, September 2001, pp. 527–547. Helpful biographical studies of Warhol include Wayne Kostenbaum's brief and engaging *Andy Warhol*. New York: Viking, 2001, and Victor Bockris's comprehensive *Warhol: The Biography*. London: Da Capo, 1989.

[5] On Warhol's conflicted response to AIDS and an account of his exchanges with Mapplethorpe, see Jennifer Doyle, Jonathan Flatley, and José Esteban Muñoz (eds.), *Pop Out: Queer Warhol*. Durham: Duke University Press, 1996, esp. pp. 5–6. As Maurice Berger has commented on the centrality of gay sexuality to Warhol's practice, "only in Andy's world would the spectacle of a leather-clad hustler receiving a blow job read as something that was both understandable and boring." See Maurice Berger, "Andy Warhol's 'Pleasure Principle,'" in *Andy Warhol: Social Observer*, exh. cat. (Philadelphia: Pennsylvania Academy of Fine Arts, 2000), p. 30.

[6] As Rainer Crone and Nan Rosenthal have noted, Warhol's poster design follows the model of Ben Shahn's 1964 poster in support of Lyndon Johnson, which implored "Vote Johnson" under the face of Johnson's Republican opponent, Barry Goldwater. See Nan Rosenthal, "Let Us Now Praise Famous Men: Warhol as Art Director," in Gary Garrels (ed.), *The Work of Andy Warhol*. New York: Dia Art Foundation, 1989, p. 43. As Stimson (note 4) discusses, Shahn was a central figure within Warhol's early training and provided a model for his pre-pop style.

GG: How do you feel about politics? Do you have any strong convictions?

AW: Just like everybody else.

GG: Can we have some particulars? Or would you rather stay aloof?

AW: Aloof.

GG: Are you trying to incorporate ideas of philosophy, of politics and outlook into your art?

AW: I guess so.

GG: Would you tell me what this philosophy and outlook is?

AW: No.[7]

Or here, with former *Interview* editor Glenn O'Brien in *High Times* in 1977:

GOB: Did you ever read Marx?

AW: Marx who? The only Marx I knew was the toy company.

GOB: Do you ever think about politics?

AW: No.

GOB: Did you ever vote?

AW: I went to vote once, but I got too scared. I couldn't decide who to vote for.

GOB: Are you a Republican or a Democrat?

AW: Neither.[8]

In both of these conversations, as many others, Warhol suggests a flirtation with politics—he *guesses* that he wants to paint with ideas in mind and tries to vote only to become scared once inside the voting booth—but characterizes his political beliefs most adamantly through a string of negatives: no, he won't discuss his "outlook"; no, he doesn't think about politics; no, he is neither Democrat nor Republican. When Warhol does offer more pointed political observations, these are characterized by a kind of emptiness, a reduction of everything to a matter of style or money-making possibilities. Asked whom he supported for president by a Mexican reporter in 1972, Warhol responded that "Nixon's just great" because "he travels so much—like a movie star, a Superstar . . . He's good friends with Bob Hope, Ronald Reagan, Bing Crosby, Frank Sinatra, and Shirley Temple."[9] And when objections were raised to his 1977 visit to the Shah of Iran for a portrait session—the *Village Voice* placed a picture of him and Iran's Empress on the front page, under the headline "Beautiful Butchers"—Warhol's chief concern was not the actual political conditions surrounding his trip but, in the words of Jonathan P. Binstock, "the possibility that he might offend someone who would then cancel a subscription to his *Interview* magazine, or, worse yet, cancel an advertisement."[10] Attempting to get a sense of Warhol's politics through the people he associated with or the statements he made is a fool's game, however. For Warhol was happy to work with just about anyone, and the most gripping element of his interviews is precisely the skill with which he avoids committing to a position on anything, much less the central political affairs of his day. It is in his *work*, ultimately, that a more compelling, if equally paradoxical, political vision emerges—one that critics and historians have struggled for decades to understand and articulate.

The German critic Rainer Crone, for instance, writing in 1970 and motivated by the ethos of the new German left, invoked Walter Benjamin and Bertolt Brecht (following, in the latter case, Warhol's own 1962 example) to argue that Warhol's work comprised a form of "documentary realism," its roots stretching from Gustave Courbet to Ben Shahn, that sought to overthrow ideas of both individual authorship and the auratic art object.[11] Writing a decade and a half later with his eye more precisely focused, art historian Thomas Crow also sought to position Warhol as an acutely political social observer. Limiting his concern to Warhol's pre-1965 work (before the artist became, in Crow's words, "this bizarre, right-wing media creature"), Crow sees in the artist's paintings of electric chairs, race riots, and automobile disasters a "partisan character [that]

[7] George Gruskin, "Who Is This Man Andy Warhol?" (interview), *SCOPE*, March 16, 1973. Reprinted in Kenneth Goldsmith (ed.), *I'll Be Your Mirror: The Selected Andy Warhol Interviews*. New York: Carroll & Graf, 2004, pp. 200–220. The remarks cited here appear on p. 217.

[8] Glenn O'Brien, "Interview: Andy Warhol," *High Times*, August 24, 1977. Reprinted in Ibid., pp. 233–264; the remarks cited here appear on p. 241.

[9] Cited in Bob Colacello, *Holy Terror: Andy Warhol Close Up*. New York: Harper Collins, 1990, pp. 118–119.

[10] Jonathan P. Binstock, "Andy Warhol: Social Observer," in *Andy Warhol: Social Observer, Op. cit.*, p. 17.

[11] See Rainer Crone, *Andy Warhol*. New York: Praeger, 1970.

is literal and straightforward," focused on "the open sores in American political life, the issues that were most problematic for liberal Democratic politicians" of the time.[12] Integrating this analysis with a careful study of Warhol's paintings of Marilyn Monroe (begun, significantly, in the immediate wake of her death-by-suicide) and Jackie O. (painted during the very public mourning of her slain husband), Crow argues for a fundamentally *humanist* Warhol, one who—at least until 1965—is motivated by perfectly legible concerns, passions, and sentiments: opposition to the death penalty; sympathy with civil rights protestors in the south; concern about the changing face of public culture in the age of the supermarket and television.

A number of recent historical studies have further explored Warhol's specific political investments, particularly around issues of race and sexuality. These have, like the work of Crow, focused on Warhol's early 1960s activities; his later embrace of such figures as the Shah and the Reagans—not to mention of the New York City disco Studio 54, where he congregated with designers and stars and celebrated his fiftieth birthday in 1978 by being showered with cash—has understandably proven anathema to many left-leaning art historians.

Anne Wagner, in examining Warhol's *Race Riot* paintings of 1962–1963, states flat out that he painted them "as a liberal." In adopting a series of well-known news photographs and arranging these according to a clear narrative logic, Wagner argues, the artist sought to create in these works a series of "mini-morality plays" directly commenting on the painful drama of race in America.[13] More complexly, Richard Meyer has demonstrated how Warhol's contribution to the 1964 New York World's Fair—the large-scale mural *Thirteen Most Wanted Men*, built from silkscreened FBI mug shots—can be understood as a reflection on the complicated interplay of sexuality and power in contemporary American life.[14] As Meyer brilliantly observes, the mural, with its exchange of gazes between both represented figures and these figures and the work's spectators, stages a scene of male cruising in which codes of desire and authority are not just cross-wired but co-productive. Sexual wanting, Warhol suggests in *Thirteen Most Wanted Men*, is deeply entwined with structures of legal wanting—with, that is, state power and the repressive force of the law. After objections to the mural were raised and fair officials sought to censor it, Warhol further intensified the work's political valences by painting over it with aluminum house paint. In doing so, he transformed *Thirteen Most Wanted Men* into a monumental testament to the closet, to the public policing of private desire.

As such readings illustrate, Warhol's early 1960s oeuvre is, indeed, among the most complexly political bodies of work of late twentieth-century art. And this is not to mention his insistent critique of American consumer society. Neither quite celebrating nor attacking the increasing mass-market homogeneity of American life, works such as *Two Hundred Campbell's Soup Cans* or the brilliant *Marilyn Monroe's Lips* (both 1962) simply confront their viewers with the fact of American culture's intensifying dominance by industrially packaged and infinitely reproducible commodities, from Marilyn and Elvis to Campbell's and Coke. What Clement Greenberg termed the "all-over" gesture of Jackson Pollock's abstract expressionist canvases is here transformed into a seemingly endless grid of corporate logos—this is the language of the American public sphere circa 1962. Warhol's works and statements of the early 1960s encapsulate a potent analysis of a consumer society in which participation in public life is largely limited to, and understood as, consumer activity—even as, as David Joselit has noted, the social inequalities structuring this system are largely left unexamined.[15] As Warhol wryly noted in *The Philosophy of Andy Warhol (From A to B and Back Again)*, "America is really The Beautiful. But it would be more beautiful if everybody had enough money to live."[16]

For both Meyer and Wagner, the political significance of Warhol's early 1960s images stretches to the present moment: his race riot paintings help us to dissect the ideologies opera-

[12] Thomas Crow, "Saturday Disasters: Trace and Reference in Early Warhol," in *Modern Art in the Common Culture*. New Haven: Yale University Press, 1996, pp. 61–63.

[13] Anne Wagner, "Warhol Paints History, or Race in America," *Representations*, 55, summer 1996, pp. 98–119.

[14] Richard Meyer, "Warhol's Clones," *The Yale Journal of Criticism*, 7, 1, spring 1994, pp. 79–109.

[15] See David Joselit, *American Art Since 1945*. London: Thames & Hudson, 2003, p. 75 ff.

[16] Andy Warhol, *The Philosophy of Andy Warhol (From A to B and Back Again)*. New York: Harcourt, 1975, p. 71.

tive in contemporary media representations of race, while *Thirteen Most Wanted Men*, as Meyer illustrates, foreshadows later strategies of gay self-fashioning as a form of resistance to the bodily dictates of heteronormative society. In both cases, Warhol's primary political concern is the politics of the body, and specifically the body within representation. Indeed, this is arguably the primary concern of Warhol's career *tout court*, stretching from his self-portrait-as-commodity-product of the 1962 Ferus exhibition to the race riot and electric chair paintings of the early 1960s, to his silkscreen grids of Elvis and Marilyn, even to his later celebrity portraits and the series of oxidation paintings—lusciously abstract panels made by urinating onto copper-paint-prepared canvases to initiate a process of oxidation and discoloration—made in 1978. And Warhol takes the body as his primary concern in project after project following his turn to film-making in the mid-1960s. Such works as *Sleep, Eat,* and *Blow Job* are, as their laconic titles suggest, nothing *but* studies of the body and its actions—and, of course, its mediation by the camera and perception by us, Warhol's viewers. For historian and critic Maurice Berger, the raw sensuality of Warhol's film works, together with the merging of bourgeois and underground in Warhol's studio, the Factory, constitute his greatest political legacy, one rooted in the pervasive social and sexual questioning of the 1960s: his "uncanny ability to transport his various audiences to the precipitous margins of the forbidden and the repressed [. . . and his attempt] to resolve the seemingly unresolvable gap between the potent darkness of our desires and the false light of bourgeois respectability."[17]

Perhaps the most striking of Warhol's films are the over 500 "screen tests" he made between 1964 and 1966, in which friends and associates, from Susan Sontag to Bob Dylan, were asked to sit before a tripod-mounted camera without moving, speaking, or blinking, while a single 100-foot roll of film was shot for each. The resulting footage, in each case lasting around four minutes, is consistently and oddly compelling: for what it presents is a series of prosaic bodily portraits rooted in the attempt, precisely, to deny bodily inhabitation itself. Sontag, Dylan, and others, that is, are asked not to blink, or move, or speak, or otherwise disturb their apprehension as disembodied *images*—as, as the films' labeling as "screen tests" betrays, potential commodities just like Marilyn or Campbell's soup. The aesthetic charge of Warhol's screen tests lies in precisely this tension: between the blinks and breaths and twitches of the bodies we see and the films' essential premise of reducing these to a kind of logo, to a mere projection of flickering light.

The structural tension of the *Screen Tests* is fundamentally political. In staging an essential confrontation between self and other—between a subject observed and the camera (and by extension viewer) that attempts to fix this subject as containable object—they illustrate the act of *policing* that French philosopher Jacques Rancière has isolated as the central operation of contemporary political life. The police, for Rancière, are all those forces within a society that attempt to maintain things as they are, to fix subjects and situations within a certain configuration of "the visible, the thinkable, and the possible through a systematic production of the given."[18] Politics, for Rancière, is thus a necessarily aesthetic activity, for political action resides in calling into question and ultimately expanding such a given configuration of knowledge and perception, what he calls a particular "distribution of the sensible." Within this situation, to be a political subject is "never the simple assertion of an identity; it is always, at the same time, the denial of an identity given by an other, given by the ruling order of policy. Policy is about 'right' names, names that pin people down to their place and work. Politics is about 'wrong' names—misnomers that articulate a gap and connect with a wrong."[19] It is just such a political process—of *denying* identity, of articulating a gap between a subject and his or her fixture by the productive force of the police (in this case the camera)—that Warhol's screen tests enact.

[17] Maurice Berger, "Andy Warhol's 'Pleasure Principle,'" in *Andy Warhol: Social Observer, Op. cit.*, pp. 29–30.
[18] Jacques Rancière cited in "Art of the Possible: Fulvia Carnevale and John Kelsey in Conversation with Jacques Rancière," *Artforum*, 45, 7, March 2007, p. 264.
[19] Jacques Rancière, "Politics, Identification, and Subjectivization," in John Rajchman (ed.), *The Identity in Question*. London: Routledge, 1995, p. 68. This passage is cited by David Joselit in his recent study *Feedback: Television Against Democracy.* Cambridge, MA: MIT Press, 2007, in relation to early television and the politics of "character," a discussion that encompasses Warhol's work in painting, film, and multi-media installation as well.

Even further, we could claim that Warhol's repeated denials of political commitment, and his parading of almost-but-not-quite opinions through a strategy of insistent negation (declaring "Vote McGovern" with a picture of Nixon; praising Nixon in turn for the non-reason that he travels like a "Superstar") comprise a refusal to conform to fixed categories of political identity or belief, and in this an attempt to call into question the operation of politics itself. This is unstable ground, to be sure—to refuse committed political alignments can easily slide, as it eventually would for Warhol, into a hobnobbing with dictators—but also appears a natural outcome of the time and culture in which Warhol emerged as both artist and political being. Growing up gay in a conservative Catholic family in Pittsburgh, attending art school at a time when instruction was rooted in the primacy of art's social functionalism, and beginning his career in the era of Joseph McCarthy's anti-Communist polemics and television's solidification of Cold War bourgeois propriety, Warhol seems to have developed an aversion to *all* allegiances and confinements—a belief that to have a firm allegiance was in itself a form of confinement, a manner of fixing oneself, in Rancière's terms, with a "right" name. Politics thus understood became a matter not of advocating established positions but of forging new conceptions of what a political action can and might be.[20]

The attitude I'm describing, of course, is not far from what Susan Sontag—herself profoundly influenced by Warhol—identified in her seminal 1964 essay *Notes on Camp* as that of the camp sensibility. Pithily described by Sontag as "dandyism in the age of mass culture," camp is characterized not only by an embrace of the ironic and artificial, the outmoded and exaggerated, but by a distinct aversion to politics: "It goes without saying that the camp sensibility is disengaged, depoliticized—or at least apolitical."[21] But for all its political aversions, the camp sensibility, Sontag stresses, is also fundamentally serious, if with a twist: "the essential element is seriousness, a seriousness that fails."[22] *A seriousness that fails*: this seems to me an essential description of the political engine driving Warhol's life and work. What better expression is there to characterize his politically charged but formally leveled paintings, or the awkward confrontations that constitute his *Screen Tests*, or the anti-political political pronouncements that fill his career? In each case, Warhol embraces the most serious of goals—to grapple with issues of race, celebrity, commodity culture, etc.; to isolate and represent the essential being of the friends and associates before his camera; to comment on the events and issues of his day—but foregrounds each time the necessary *failure* of his task: his comments are nonsensical or contradictory; his *Screen Tests* most forcefully represent the *disjunction* between subject and image; his paintings (through repetition, gaudy coloration, mis-registration, etc.) more effectively numb us to the situations they present than call us to any sort of committed action.

Perhaps the most pressing analysis we have of the political stakes of Warhol's media-age dandyism is the concluding discussion of the Dia Art Foundation's 1988 symposium on Warhol and his work. Calling into question the ease with which the artist came to celebrate reactionary and even brutal figures, Benjamin Buchloh asks:

> How far can we go with the dandy attitude? Where does it become more than simply implication and indifference? [. . . H]ow far can you go with this without sliding into the domain where you have to say putting Imelda Marcos on the cover [of *Interview* magazine] . . . is not simply an act of supercilious dandyism, but is more than that. It is an act of profound anomic cynicism, as I've called it, which simply says, there is no reality to any of these political questions. The only reality that counts is the glamour, the social life.[23]

This series of questions is, in Warhol's case, unanswerable. Yes, his flirting with dictators and

[20] In a related fashion, we can understand Warhol's original Factory—described by Stephen Koch as "the silver-colored other world of Warhol's loft on East Forty-seventh Street . . . where interlocking subcultures of the late 1950s—artistic, sexual, sometimes even criminal—were able at last to surface into the bright glamour of the 1960's affluent chic"—as a reimagining of any number of rigidified group structures, from the family to the corporation to community itself. For Koch's description, see his *Stargazer: The Life, World, and Films of Andy Warhol*. New York: Marion Boyers, 1991, pp. 3 ff.
[21] Susan Sontag, "Notes on 'Camp'" (1964), in *Against Interpretation*. New York: Anchor, 1990, p. 277.
[22] Ibid., p. 283.
[23] Benjamin Buchloh as cited in *The Work of Andy Warhol, Op. cit.*, p. 130.

absolute celebration of glamour throughout much of the 1970s *was* reprehensible, and yet his practice—even in the decade of celebrity portraits, *Interview*, and Studio 54—is more complex than a simple blanket embrace, a "doubled affirmation" as Buchloh terms it. If we look at Warhol's 1970s production, for instance, we see that his primary works, in addition to the dozens of commissioned portraits, include series of skulls, anonymous torsos, shadows, and Rorschach images as well as his oxidation paintings made by urinating on copper-paint-prepared canvases. In all of these images, we see a recognition and negation of the portraits' (and *Interview*'s) overpriced fetishization of "personality": a reduction of the subject to bare matter (anonymous skulls; faceless torsos; urine) and unformed psychological association (the Rorschachs), or a figuration, in the *Shadows*, of absence itself. As Ronnie Cutrone, Warhol's studio assistant at the time, commented, painting the skulls was "like doing the portrait of everybody in the world."[24]

Even at the moment of his most cynical, profit-driven, and ostensibly apolitical work, this is all meant to say, Warhol's oeuvre maintains the sharpest critical perspective of any artist of his generation. To match his sitters' portraits with images of their own debasement and death (just as the massive visage of Mao Zedong presided over the capitalist rich and famous in Warhol's 1979 Whitney Museum show of his recent portraiture) is, ultimately, a profoundly *political* statement: it is an undercutting of the very premise of the correct and singular portrait, of the sovereignty of the "right name."[25] Another mid-1970s series, *Ladies and Gentleman*, furthers this subversion, portraying drag queens whose very lifeblood is their "putting on" of identity. Such works not only take us back to the self-negating self-portrait of Warhol's 1962 pop debut, but illustrate the dialectical complexity that drives his practice across the board: just as he built a booming portrait business while subverting the very notion of a knowable self, so he based his artistic career on the destruction of traditional aesthetic categories and developed a political profile rooted in the refusal to adopt any specific political position.

These stances comprise neither a cynical withdrawal from the aesthetic and political debates of Warhol's time nor a position of simple affirmation within them, but rather a stance of dialectical negation that challenges the terms of both. Just as the greatest achievement of Warhol's artistic practice, in Crow's words, is arguably its "sanction[ing of] experiments in non-elite culture far beyond the world of art"—its opening of art to non-art, in other words—so his most compelling political contribution is his radical refusal to accept a politics of established positions, platforms, or actions.[26] Indeed, Warhol's insistently failed seriousness, his foregrounding of a kind of numbed political desire, appears strikingly prescient today. At a time when social disparities are rapidly growing, political polemics have rigidified to the point of near collapse, and social activism appears quaintly anachronistic, Warhol's self-conscious political refusal—not so much a withdrawal from politics as an insistent focus on its failed promises—bears reexamining. People care, it seems, even less—about torture, corroding civil rights, environmental destruction, economic inequality—and even the single largest day of protest in human history (the internationally coordinated actions of February 15, 2003 that brought tens of millions into the streets to speak out against Bush's and Blair's march to war in Iraq) had more or less no effect. In such a situation, do Warhol's closing words to Gretchen Berg in an interview of 1966—"I still care about people but it would be so much easier not to care . . . it's too hard to care"—not ring painfully true for us all?[27] Let's say it straight out, even more forcefully than Thomas Crow and Anne Wagner: Warhol was a liberal, a progressive, an artist with a deep desire for social and political change. But he also would have rejected each of these statements, and demanded—well, not quite demanded, but ingeniously insinuated—that we need to complicate our terms, to reimagine both the idea and practice of politics itself.

[24] Ronnie Cutrone as cited in Trevor Fairbrother, "Skulls," in Ibid., pp. 96–97.

[25] It should be noted as well that Warhol's portraits, in being based on photographs and appearing most often in duplicate (as at the 1979 Whitney show), themselves undermine the traditional notion of the synthesizing painted portrait. For a discussion of Warhol's engagement with portraiture throughout his career, see the excellent collection of essays in *About Face: Andy Warhol Portraits*, exh. cat. (Hartford: Wadsworth Atheneum, 1999).

[26] Thomas Crow, "Saturday Disasters: Trace and Reference in Early Warhol," *Op. cit.*, p. 49.

[27] Warhol cited in Gretchen Berg, "Andy Warhol: My True Story," *The East Village Other*, November 1, 1966. Reprinted in *I'll Be Your Mirror: The Selected Andy Warhol Interviews*.

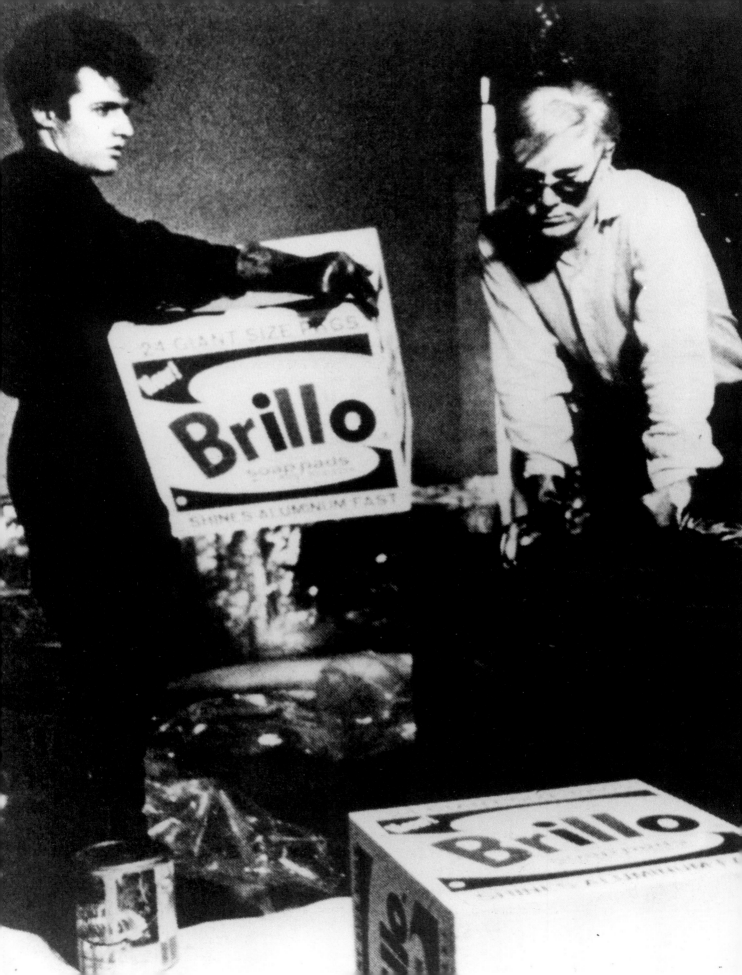

Rachel Baum **The Mirror of Consumption**[1]

Gerard Malanga prepping up to
silkscreen a *Brillo* box
Archives Malanga, 1964

[1] This title is a play on Jean Bau-
drillard's essay "The Mirror of Pro-
duction," in Mark Poster (ed.), *Jean
Baudrillard: Selected Writings*. Stan-
ford: Stanford University Press, 1988.
[2] Roland Barthes, *The Pleasure of the
Text*. New York: Hill & Wang, 1982,
p. 59.
[3] Ileana Sonnabend quoted by Paul
Taylor in "The Last Interview," *Flash
Art*, April 1987, reprinted in Kenneth
Goldsmith (ed.), *I'll Be Your Mirror:
The Selected Andy Warhol Interviews*.
New York: Carroll& Graf Publishers,
2004, p. 387.
[4] This is a pun connecting the word
"pop" used in pop art and derived
from the word "popular" with a com-
mon slang term for fizzy drinks. From
an Andy Warhol interview with a
small art journal. "Pop Art? Is it Art/A
Revealing Interview with Andy
Warhol," *Art Voices*, December 1962,
reprinted in Ibid., p. 5.
[5] Fredric Jameson, *Late Marxism:
Adorno, or the Persistence of the Dialec-
tic*. London: Verso, 1990, p. 113.
[6] This is, above all, an art-historical
narrative developed retrospectively to
describe the relationship between the
original avant-gardes and their rein-
terpretation by artists in the 1960s
such as Warhol. See Peter Bürger's
Theory of the Avant-Garde. Min-
neapolis: University of Minnesota
Press, 1984, Michael Shaw, trans.;
Benjamin Buchloh's "The Primary
Colors for the Second Time: A Para-
digm Repetition of the Neo-Avant-
Garde," *October*, 37, summer 1986,
pp. 41–52.

Imagine an aesthetic . . . based entirely (completely, radically, in every sense of the word) on the *pleasure of the consumer*, whomever he may be.[2]
For Andy, everything is equal.[3]
Question: What does Coca-Cola mean to you? Warhol: Pop.[4]

Mass Culture and Historical Trauma
They have nothing to say about fascism who do not want to mention capitalism.[5]

Andy Warhol has been identified as a figure of crisis within art history from every critical direc-
tion and faction. This crisis is always connected to an account of radical changes in the cultural
economy at large. Warhol is symptom and symbol of the total commodification of social life
and experience under advanced capitalism. In a sense, he has become the brand logo of post-
modernism, the trademark for art's irreversible fall from the realm of history and aesthetics into
the system of market exchange.

How Warhol came to represent the collapse of the boundary between artistic creation and
mass production, aesthetic reception and consumerism must be traced to the historical context
from which he emerges, which is that of American modernism. The experiments in collective
practice and the integration of art and life that characterize European modernisms from dadaism
to Bauhaus, cubism to constructivism, had been undermined by history itself, as personified by
Hitler, Stalin, and Franco. Ideals of collective production, social enfranchisement through par-
ticipation in artistic culture, and the political agency of creative practice were ultimately still-
born into a time of tyrannies.[6] The form of modernism that emerged in America during the
1940s in response to this pattern was specifically constructed to avert a similar totalitarian oc-
cupation of culture, the seemingly inevitable evolution of liberatory socialism into a violently
oppressive nationalism.

Fascism and Soviet Communism readily co-opted "popular" art and its modes of con-
sumption. The rhetoric of America's leading modernist critic of the period reflects a fear of al-
lowing such mass access to art and thereby opening it up to politicization. Clement Greenberg's
category of "kitsch" is key to understanding the importance for American modernism of the op-
position between avant-garde and popular art. Greenberg put forward this category in 1939 to
account for the new status of the "popular" as an inauthentic form of art that was no longer

emerging from within distinct cultural traditions. Rather, the popular had become a mass market generated by America's entertainment industry in which social identity in the form of products and fashions was sold to the everyday consumer.[7] For a range of critics from Greenberg to Harold Rosenberg, this American phenomenon of cultural self-definition via consumerism was tantamount to an infrastructure for totalitarianism, a system of access to and determination of the social will that could easily shift from the context of Hollywood and Sears to that of political violence. America's culture industries delivered people to the corporate power of advertisers, but the same system of mass culture also held the potential to deliver them to the political power of an autocratic regime. American modernist theorists proposed that advanced fine art had the potential to create authentic human experience and transcend the cultural forces of both politics and commodification. The experience of art for Greenberg relied upon the categories of taste and quality and, for this reason, it could be a resource of cultural distinction in both senses of the word—its highest achievements and, most significantly, the ethical capacity for judgment. This exercise of judgment stands for the agency to intervene within culture, for a mechanism of rational discernment that preserves some function of social independence over and against the operations of political authority and commercialization. Greenberg's retrenchment to this primary irreducible condition of Enlightenment humanism—of *cogito* as aesthetic judgment—was a radical means of contesting the expropriation of subjecthood by mass culture, be it through the forces of the market or the State. For Rosenberg, the means of attaining this authenticity were the opposite of Greenberg's.[8] It was an artist's experiments with process, performance, and physical engagement that produced direct, genuine experience and agency. Rosenberg's model for resistant art was based on acts of endurance and encounter. While mid-century American modernist theory encompassed disparate definitions of advanced practice, it was largely united in a rejection of mass culture.

The failure to distinguish between the European tradition and the American cultural context marked Theodor Adorno's judgment in a way that Benjamin Buchloh parallels decades later by insisting on an evaluation of a uniquely American artist through the lens of reconstruction Europe. The standard Eurocentric account begins with the pre-war avant-gardes and their proposal of a new anti-bourgeois subjectivity constructed in opposition to the Enlightenment tradition of the "centered," "unified" subject. This post-Enlightenment subject is self-consciously riven with social and psychic contradictions. Its culture is one of upheaval, of the recognition of uneven social effects, which manifests most broadly in the European socialist revolutions. This subject is a failure, its proposed culture discredited by nothing less than a period of annihilation. After 1945, there is only a vacuum, an interval of traumatic vacancy within which the market of reconstruction—literally the rebuilding of cities and economies—is the only producer of subjectivity. Given this condition of demolished paradigms—both Enlightenment and Revolutionary—post-war identity can be thought of only in terms of market culture. This post-war subject is a bourgeois cipher that generates and receives cultural identity through commodities. National tradition and cultural history have been invalidated by Fascism (or strategically liquidated by Communism). The "interior" of this subject is a site of loss, of alienation and nostalgia, and it is open to domination. Above all, it is a European subject, a bombed-out shell that becomes a container for ideologies of consumption and their contents: American popular culture and products, the American reconstruction of cities, markets, and images of self. The market-produced subjectivity of post-war reconstruction yielded distinct versions of a consumer bourgeoisie. It is clear that Europe can be described as replacing bomb rubble with American products and it is significant that many of Warhol's early collectors and advocates were German.[9] The European account of the end of history in 1945 does not translate to the American reception of the war as one of victory, pros-

[7] Clement Greenberg, "Avant-Garde and Kitsch" (1939) reprinted in John O'Brian (ed.), *Clement Greenberg: The Collected Essays and Criticism, Volume 1*. Chicago: University of Chicago Press, 1988.
[8] Harold Rosenberg, "The American Action Painters," *Art News*, 51/8, December 1952, p. 22.
[9] Germany was a center of pop art collecting, pioneered by Karl Ströher and Peter Ludwig. On November 27, 1970, after a Parke Bernet auction heavily influenced by German bidders, the *New York Times* ran the headline "American Pop Really Turns On German Art Lovers."

perity, and paternalistic humanism. The America that formed Warhol was not marked by traumatic amnesia and, indeed, America's triumph in modernist art was yet to come.

"Mass art is high art"[10]

Paul Taylor: What about your transformation from being a commercial artist to a real artist?

Warhol: I'm still a commercial artist.

Taylor: Then what's a commercial artist?

Warhol: I don't know—someone who sells art.[11]

The overdetermined historical moment of American modernism in which aesthetics became political ethics explains the reading of Warhol as destroying the distinction between "high" and consumer culture. But what features of Warhol's work can explain this considerable claim? What has Warhol done within the modern art tradition to bring about his identification with the break-up of the given cultural and artistic logic of value? Why is he associated like no other artist before or since with the collapse of avant-garde practices into the larger system of commodity consumption? The notion that it is the subject matter of Warhol's works that makes them commensurate with commodity objects cannot explain their power. The history of the historical modernist avant-garde is defined by the integration of mass-produced materials and commercial signs into works of high art—think of the newsprint, collage elements, and found objects that link cubism and Duchamp's readymades of the 1910s to Johns and Rauschenberg of the 1950s. It is not the image content of Warhol's paintings of Coca-Cola, Campbell's Soup, and Hollywood stars that threatens to dissolve the boundary between artwork and commodity, aesthetic experience and mass consumption. What causes a crisis in the status of the art object in Warhol's work is the unprecedented assimilation of original and reproductive media at every level. Painting, printing, and photography are fully conflated in each register of the work—concept, process, and format. Warhol's mode of silkscreening poses a complex set of challenges to the model of self-contained integrity for the medium of painting and, by extension, to the values American modernist criticism as a whole. This mechanical mode of printing transfer via a photographically rendered image is the antithesis of the historical tradition of painting, the unique relation of hand, eye, and canvas that lies behind each mark. In order to situate the scandal of Warhol's silkscreen process in larger cultural terms, it is necessary to foreground the contemporaneous modernist understanding of art as a crucial reserve of historical consciousness, agency, and meaning that is abstracted and erased by the equivalency system of commodity exchange. Based in European critiques of the effects of industrial production on traditional models of self and social authority, the American analysis of mass culture presented by Greenberg was structured around the precept of preserving modes of authentic experience against ideological co-optation. To privatize and encrypt such encounters as those between the audience and objects of high art was to resist the expropriation of aesthetic judgment into mass consumption, be it of politics or products. For modernist theorists, the model of independent, differentiated modes of experience produced an individual subjectivity and a collective culture resistant to totalization. This impulse to differentiation is the fundamental formula for the American modernist approach to art: the reduction of each medium to its defining conditions and the categorical separation of these conditions from those of all other media. The exemplar of advanced painting for various factions within American modernism was Jackson Pollock. For Greenberg, Pollock's drip canvases from the years around the turn of the 1940s to the 1950s were prolegomena of the material and conceptual parameters of painting. For Rosenberg, they were

[10] Statement by Andy Warhol from a 1985 interview. See "Andy Warhol: The Artist and His Amiga" an interview with Guy Wright and Glenn Suokko reprinted in Kenneth Goldsmith (ed.), *I'll Be Your Mirror: The Selected Andy Warhol Interviews, Op. cit.*, p. 339.

[11] Andy Warhol interviewed by Paul Taylor. See "The Last Interview," *Flash Art*, April 1987, reprinted in Ibid., p. 387.

manifestos of authentic engagement, sites of transformation, and recovered individuality. To segregate each medium formally or performatively was a means of insuring against equivalency and exchangeability, the logic of the consumer market. The collapse of contradiction and difference that occurs in the total integration of painting and photography in Warhol's art is the primary force of dedifferentiation that allows art historians to define him as destroying the distinct object status of art and its singular mode of experience. By fusing the materials, processes, and formats of mechanical, mass-produced photography and crafted, unique paintings, Warhol is read as also dissolving the boundary between aesthetic reception and commodity consumption. That is the radical and irreversible act his art performs.

Since the Enlightenment encyclopedists, but with mounting urgency under expanding capitalism, the modernist mission of investigating knowledge itself—the critique of reason—has taken the form of delimiting discrete categories of experience and practice, of skill and cognition based in the isolation of defining conventions. This process of specification and characterization among modes of knowledge depends upon a relation to the lived social context and this relation is one of oppositional duality: high/low, original/reproduced, authentic/alienated, analytic/commodified. Insofar as Warhol is aligned with the dissolving of contradiction, his project is not merely a dead-end negation or collapse of the modernist dialectical model, but rather the historical assertion that the economic and cultural order based on defining differences between objects and experiences is no longer valid.

The way in which Warhol integrates serial photographic transfer and paint on canvas is key to understanding his role in the integration of art production into the mass-culture industries of commerce and entertainment. Earlier avant-gardist practices had appropriated machine-made materials and mechanically reproduced imagery into the picture field as fragments of an external reality imported as elements of assemblage into a pictorial space. Warhol's silkscreening process, however, fully collapsed and imbricated the photographic with the painted surface. Fabric treated with light-sensitive emulsion replaces paper as the support for the exposure and transfer of a photographic negative. This initial stage of the silkscreen preparation already represents a violation of the separation of media prescribed by Greenberg insofar as the screen fabric is an intermediate surrogate for the painting's canvas. The stages of transition from camera to final artwork cannot negate the persistence of a trace of the real within the simulation of painted representation. The photographic image has jumped from its initial state as a record of the physics of light and shadow at a moment in time, has multiplied through mass circulation as a printed reproduction in advertisements and newspapers, and, finally, has embedded itself in paint as the unique production of an artist. This trajectory from photograph to painting, copy to original, public to private, mass consumption to artistic creation is recorded in the artwork itself, pressed onto its surface in the form of Marilyn or a mugshot.

Warhol's use of the grid format and serial printing reinforces this assimilation of the logic of mechanical reproduction and distribution into that of artistic craft. The initial reception of his product grids, such as the soup cans and Coca-Cola bottles, was that the painting depicted store displays, the row upon row of identical goods stacked on supermarket shelves. The multiple screen-printed fields from the early 1960s fall into the category of grids governed by the principle of additive seriality. This arithmetic logic is clearly invoked in the titling of many of his early works, including some in this exhibition, such as *210 Coca-Cola Bottles* (1962), and the multiple-canvas work *Sixteen Jackies* (1964).

There is no pictorial structure independent of the component images laid down in rows as separate screen printings. The grid is not a positive framework, but rather the unused, surplus, or remnant space unconsumed by the printed units. The picture space is therefore loaded

with its contents in a mode analogous to filling a refrigerator or placing objects in a cabinet. The paintings themselves become mock mass-consumers, acquisitive, and banal.[12]

The final violation of the model of artistic agency posed by Warhol's silkscreening process is that painted representation is divorced from a motivated touch, from the embodied subjectivity of the artist and the historical repertoire of traditions and skills that it conveys. The gesture in Warhol is the drag of the squeegee blade within the silkscreen frame, and the action is as likely to be performed by Warhol's studio assistants as by the artist himself. Warhol's "brushstroke" mimics the simple automated movements of an industrial press or the repetitive action of an assembly-line worker. For American post-war modernism, painting in particular had a crucial role in preserving the independence of aesthetic consciousness. In the intimacy of the artist's process and the viewer's reception, painting represented the possibility of externalizing and communicating an authentic subjective experience. In a sense, painting was symbolic of an enduring and transcendent humanity in opposition to the totalizing and dehumanizing forces of politics and mass-production, war and fashion, ideology and entertainment.

The Absolute Commodity

[I]nstead of avoiding alienation, art had to go farther in alienation and fight commodity with its own weapons. Art had to follow the inescapable paths of commodity indifference and equivalence to make the work of art an absolute commodity.[13]

The theorist who links Warhol most directly to a fundamental rupture in cultural history is Jean Baudrillard. Many art historians have read Warhol's work as symbolic of the shift from a society of production and objects to one of consumption and images,[14] but for Baudrillard Warhol does not merely illustrate or describe this transformation; his work is its active performance. In his collapse into one plane of photography and painting, consumer goods and the luxury object, serial production and artistic process, Warhol is enacting what Baudrillard identifies as a leveling of all forms of meaning and experience under advanced capitalism. If Warhol breaks down the differences between representation and reproduction, real and copy, he is simply making art that reflects the state of total equivalency that exists in the larger cultural economy where goods, values, relationships, and identities are abstract and interchangeable. How is this level of dedifferentiation between all registers of practice and subjectivity possible? For Baudrillard, it is not simply that social life has become fully fused to mass consumption and that the circulation of knowledge, experience, and authority are now simply replaced by the circulation of commodities. This is an oversimplification similar to the idea that Warhol's art represents commercial culture only at the level of iconography, of product logos, and of film stars. Instead, there is a structural homology between mechanical reproduction and painting in Warhol's artistic process that demonstrates the dissolving of boundaries in the social economy at large.

Baudrillard's analysis of consumption is the key to understanding both Warhol's art and the historical changes it exemplifies. The Marxist formula of production and consumption as opposing terms no longer holds. In advanced capitalism, the only formative practice is consumption. However, contrary to its definition in traditional industrial models, "Consumption is eminently social, relational, and active rather than private, atomic, or passive."[15] While material and cultural values now exist on a level plane of interchangeable signs, abstracted from their functional contexts, they are still deployed to construct social relations and identities. This is not difficult to understand when we consider the ways in which such intangibles as happiness are readily quantified, commodified, and displayed through products. For Baudrillard, the status of objects is a fundamental reflection of a political economy. Under late market capitalism,

[12] The assemblage work in this exhibition, *Silver Coke Bottles* of 1967, is therefore the logical extension of an earlier work also on view, the painting *210 Coca-Cola Bottles*, from 1962.
[13] Jean Baudrillard, *The Conspiracy of Art*. New York/Los Angeles: Semiotext(e), 2005, p. 99.
[14] See in particular the following: Benjamin Buchloh, "Andy Warhol's One-Dimensional Art," in *Andy Warhol: A Retrospective*. New York: Museum of Modern Art, 1989, and Benjamin Buchloh, "The Andy Warhol Line," in Gary Garrels (ed.), *The Work of Andy Warhol*. Seattle: Bay Press, 1989; Thierry de Duve, "Andy Warhol; or, the Machine Perfected," *October*, 48, spring 1989; Fredric Jameson, *Postmodernism or, the Cultural Logic of Late Capitalism*. Durham: Duke University Press, 1991; and Peter Bürger, "Theory of the Avant-Garde," in *Theory and History of Literature, Volume 4*. Minneapolis: University of Minnesota Press, 1984.
[15] Arjun Appadurai (ed.), *The Social Life of Things: Commodities in Cultural Perspective*. Cambridge: Cambridge University Press, 1986, p. 31.

where goods and practices gain value only through the process of exchange, objects have no natural, inherent value based on their function. They derive their meaning and worth only from their relational positioning within the social code, which is itself a system without any underlying or external motivations or causes: "Marketing, purchasing, sales, the acquisition of differentiated commodities and object/signs—all of these presently constitute our language, a code with which our entire society *communicates* and speaks of and to itself."[16]

This disengagement of experience from the real describes Baudrillard's infamous theory of the simulacra, the replacement of presence with appearance and the object world with intersecting streams of images and money. What we take to be agency, purpose, and use motivated by our intentions, by our production of ourselves and our lives, is instead a matrix of codes that we *consume as* functionality, need, and fulfillment. This disconnection between object and meaning has important implications for art in that if lived experience itself no longer reflects the real, the idea of representation as we have known it until now—as the mirroring or mediation of reality—is impossible. For Baudrillard, representation means our experience of the world, individual and collective identity, and all social relations. Once the idea of objective conditions supporting this field of "images" is withdrawn, all that is left is the simulacral reflection, an artificial imitation of the vanished real and copies for which no original exists.

Within the universe of objects, the artwork has an exceptional role in that it is the limit case of commodification, the cipher of pure exchange. It is not that the artwork exceeds the commodity due to some unique quality that sets it apart. That was the dream of depoliticized American modernism—that art and aesthetic experience might be held in historical reserve against the larger social forces of ideology and mass culture. In Baudrillard's account, there is no space outside of the sign system of the social, no separate register of authenticity or human truth exempt from market exchange. The concept of aesthetic value as an ideal or transcendental quality is merely an "alibi" for denying art's commodity status. The formula of aesthetic value mythologizes the art object, setting it above the relations of consumption that define all other aspects of material and social life under global capitalism. The "sign-value" of the artwork is absolute and reflexive; its function as class spectacle and its circulation in the market fall away as it condenses into a fetish. If there is a void where the real used to be, a feeling of vertigo that suggests there is nothing beneath the surface of mobile and arbitrary images and meanings, Warhol activates this void in the sense that his art enacts the disappearance of the real, demonstrating the process whereby signs of presence and lived experience are abstracted into depthless, interchangeable images. For Baudrillard, Warhol's art inhabits this moment of loss and marks this absence: "the 'truth' of the contemporary object is no longer to be useful for something, but to signify; no longer to be manipulated as an instrument, but as a sign. And the success of pop . . . is that it shows it to us as such."[17] Many of the works in the present exhibition can be read through this account of the disappearance of the real and the total relativity of symbolic value. Whereas by 1919 Marcel Duchamp already understood the Mona Lisa to exist almost exclusively as a small mass-produced copy that could be defaced without consequence,[18] for Warhol she is simply a transferable image with no substance outside of the event of printing. Therefore she is used as the indifferent material for an exercise in experimenting with synthetic paint colors, the acidic artificial hues of cyan, yellow, magenta, and black that combine in all industrial printing machines to approximate the full color spectrum (*Mona Lisa*, 1963). In *Blue Liz as Cleopatra* (1963), the title is a visual product description, implying that the painting is a commodity that might be available in a range of colors, like a dress or a car. The depicted figure exemplifies the loss of authentic identity and presence. The movie star represents the subject-as-product, here further erased by appearing in costume—declaring, in essence, that the self

[16] Jean Baudrillard, *The Conspiracy of Art, Op. cit.*, p. 48.
[17] Jean Baudrillard, "Pop–An Art of Consumption?," in *Post-Pop Art*. Cambridge, MA: MIT Press, 1989, p. 39.
[18] Duchamp's 1919 "assisted ready-made" *L.H.O.O.Q.*, consisted of the addition of a graffiti moustache and beard on the face of a color lithographic reproduction of da Vinci's *Mona Lisa*. For his 1965 New York retrospective (where Warhol met the creator of the readymade), Duchamp returned to this art-historical icon. Andreas Huyssen explains Duchamp's reply to Warhol's Mona Lisa paintings and the critical response that resulted: "As invitations to the opening, [Duchamp] sent out one hundred post-Warholian Mona Lisas. They depicted a Mona Lisa without moustache and goatee on the backside of a playing card bearing the title *Rasé L.H.O.O.Q.* 'Through this reconstruction of her identity the Mona Lisa has as a matter of fact completely lost her identity,' the critic Max Imdahl commented." See Andreas Huyssen, "The Cultural Politics of Pop," in *Post-Pop Art, Op. cit.*, p. 55. Baudrillard, in turn, connects the famous expression of Leonardo's unknown model to her modern commodification: "a *certain smile* is one of the *obligatory signs* of consumption . . . Ultimately, in this 'cool' smile, you can no longer distinguish between the smile of humor and that of commercial complicity. This is what also happens in pop art—after all, its smile epitomizes its whole ambiguity: it is not the smile of critical distance, it is the smile of *collusion*." See Jean Baudrillard, "Pop–An Art of Consumption?," *Op. cit.*, p. 44.

has become the consumption and performance of readymade images. Works that depict national symbols as exchangeable commodities, as brand images equivalent to corporate logos, are the most direct in presenting the collapse of cultural relations and politics into consumer ideologies. Works like *Race Riot* (1963), *Sixteen Jackies* (1964), *Atomic Bomb* (1965), and *Big Electric Chair* (1967) all share the status of test cases in demonstrating the loss of the real. If, as Baudrillard explains it, Warhol's art exposes as a void the ground of reference and meaning that we assume supports our material world, our experiences, and our desires, then his dedifferentiation between images of commodities and images of death and trauma is the logical conclusion of his project. Thus, for Baudrillard, "pop signifies the end of perspective, the end of evocation, the end of witnessing, the end of creative gesture, and, not least of all, the end of the subversion of the world and of the malediction of art."[19] Finally, works like *Mao* (1972), *Vote McGovern* (1972), *Statue of Liberty* (1963), and *Hammer and Sickle* (1976) could be read as manifestations of Greenberg's personal apocalypse, the total assimilation of art into the regimes of mass-culture and paintings that stage this assimilation as spectacle. Warhol's conceptual process demonstrates the equivalency of value between all categories of experience. Specifically, he shows the shift of experience and agency in late capitalism to modes of consumption. Baudrillard's thesis that there is no transcending or undermining the plane of consumption on which signs and commodities circulate, detached from any grounding in the real, nature, human need, or unmediated use, is posited against the dialectical forces and structural hierarchies of a century of Marxian social theory. In his explanation of Warhol's work as the critical display of this condition, Baudrillard explains Greenberg's crisis: "What happens when you no longer have a system of values suitable for judgment, for aesthetic pleasure?"[20] What happens is Warhol.

At the same time, Warhol defies the traditional modernist rule that consumption cannot be oppositional, that it cannot have a critical or disruptive function within society. The assumption is that with the collapse of contradictions between canvas and camera, original and copy, artistic aura and fashion, there is no outside to consumption from which a subversive intervention might be staged. The fallacy of this reading lies in its reductive definition of consumption as an inactive and submissive process. Art history does not characterize other forms of reception in this way, as foreclosing resistance and dissent. It is the ideological alignment with mass culture that has for so long disqualified consumption from being explored as a mode of cultural construction or agency. For Baudrillard, "consumption is a collective and active behavior, a constraint, a morality, and an institution. It is a complete system of values, with all that the term implies concerning group integration and social control."[21] Artworks, a category of objects that exist beyond the pretences of need, use, or inherent value, are not empty or meaningless as indexes of the social. Rather, they must be read "as goods whose principal use is *rhetorical*... goods that are simply incarnated signs."[22] What Warhol's art demonstrates is a shift from the political economy of production to the economy of signs, or more specifically, the manifestation of all production as the play of signs. No activity or object is exempt from this state of abstraction and exchangeability and works of art in fact register this process most clearly, making visible the notion that "the necessity to which they respond is fundamentally political" and only political.[23] Theorists of this new model of reality as pure surface find in Warhol a reflection of this image culture and the historical consciousness it creates. His art does not foreclose or exhaust the capacity for critical intervention within society; it does, however, destroy entirely the humanist myths of unmediated experience and natural values that still haunted modernism. Warhol's signature silver paint serves as a mirror that faces the mirror surface of our own flat world, but rather than showing a shiny void, we can see in it a "field of play that is specifically the field of consumption."[24]

[19] Ibid., p. 35.

[20] Jean Baudrillard, *The Conspiracy of Art, Op. cit.*, p. 61.

[21] Jean Baudrillard, "Consumer Society," in Mark Poster (ed.), *Jean Baudrillard: Selected Writings, Op. cit.*, p. 21.

[22] Ibid., p. 38.

[23] Arjun Appadurai (ed.), *The Social Life of Things: Commodities in Cultural Perspective, Op. cit.*, p. 38.

[24] Jean Baudrillard, "Consumer Society," in Mark Poster (ed.), *Jean Baudrillard: Selected Writings, Op. cit.*, p. 44.

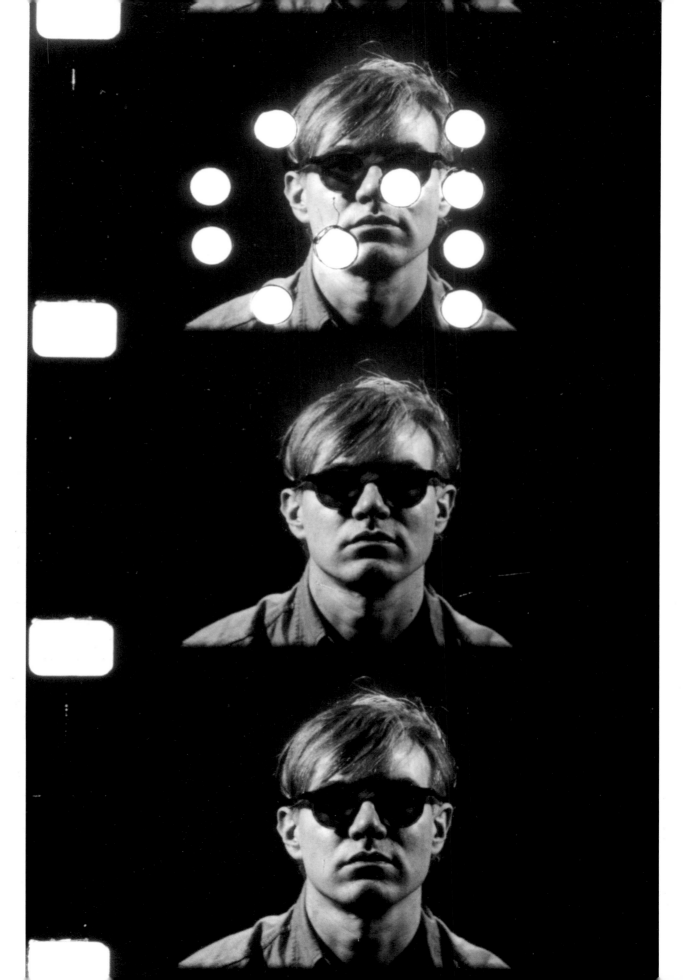

1956. On American TV screens, during a very popular program called "Wisdom Series," the National Broadcasting Company (NBC) aired an interview with Marcel Duchamp conducted by J.J. Sweeney, Director of the Solomon R. Guggenheim Museum in New York. In the course of a conversation that covered the artist's entire life, Duchamp remarked: "The danger is always of pleasing the most immediate public, the one that encircles and acclaims you, hallows you when all is said and done, and gives you success and . . . all the rest. . . . I regard painting as a means of expression, not as an end. One means of expression among many others and not an end destined to fill a whole life. . . . This goes for everything I like: I never wanted to restrict myself to a narrow circle and I've always tried to be as universal as possible."[1] The artist puts himself across as a thinking being, radical and quietly provocative.

Andy Warhol had by now been living in New York for about six years, and he had already shown his work in a gallery. Did he see that TV program? Nobody knows. But he had heard of Marcel Duchamp and his radicalness back in the 1940s, when he—Warhol—was attending the Carnegie Institute of Technology in Pittsburgh, the city where he was born. It was on television that Marcel Duchamp expressed the idea that you have to get away from the skin of the "artist and painter" in order to make your way toward universal expression—television being that image box oriented so perfectly toward the universal. His principle: to get to as many people as possible, in the pop—popular—sense of the term. What better medium than that? Marcel Duchamp was the master, Andy Warhol the excellent pupil. In 1985, Warhol the pupil would recount[2] that his project was a film about the master. "You know we are going to do this project called *24 Hours in the Life of Marcel Duchamp*, and we had someone to pay for it and everything. It was going to be like our *Empire State Building*, we were going to shoot him for 24 hours, it would have been really great, but then he died. But I still have a couple of three-minute rolls of film of him." That monument called Marcel Duchamp died in 1968, but in 1963 in Pasadena, and in 1966 in New York, Warhol nevertheless got to film him four times during sessions called "screen tests." In these approximately 4-minute silent black-and-white films, Duchamp pulls faces, smiles, asks for silence by putting his fingers over his mouth, lights a cigar . . . "I really like Warhol's spirit. He's neither a painter nor a filmmaker. He's a filmer," Duchamp would say of him.[3] Warhol behind the camera captures Duchamp. The main thread of part of twentieth-century art history. Let the artist get out of the canvas to be on the small, universal screen . . . Warhol would incidentally reuse the faces pulled during the

[1] Marcel Duchamp, *Duchamp du Signe*. Paris: Flammarion, 1994, p. 183.
[2] Callie Angell, *Andy Warhol Screen Tests, The Films of Andy Warhol*. New York: Abrams, 2006, p. 66.
[3] Bernard Marcadé, *Marcel Duchamp, Grandes biographies*. Paris: Flammarion, 2007, p. 488.

silent screen tests when he himself appeared in TV interviews. Others say they came from interviews of Jackie Kennedy. Andy Warhol knew what he said, and how. In his diary entry for September 13, 1981 he recounts one of his telephone conversations: "I've got a show? Me? Really? Where?" The dialogue was straight out of the 1960s. I heard myself saying "Oh really? Oh, oh. Really, oh." Faces . . .

1963. Andy Warhol made a 70-minute silent black-and-white 16mm film featuring Jane Holzer, called *Soap Opera* or *The Lester Persky Story*.[4] A young woman is chattering away and her—silent—words are interrupted by commercials provided by Lester Persky, producer of TV commercials. This was the first time that television appeared in (moving) images in Warhol's work.

1969. Warhol founded the film magazine *Interview*.

1970. Warhol purchased a Sony Portapak camera, "a new video system that consisted of a rectangular-shaped box camera with a built-in condenser microphone and a long lens."[5] It offered mobility and made it possible to record in so much as it was battery-operated. Technical details were important. With this camera, without too much wherewithal, you could produce films in small spaces. These two facts combined—founding a magazine giving pride of place to face-to-face interviews and the existence of an extremely mobile camera—were the future tools for TV programs. *Interview* was a future model for TV interviews. In this regard, the journalist Bob Colacello thought that all Andy's projects contributed toward an overall strategy. This is what we see, today, as a great body of work.

1971. Warhol recruited the person who would produce all of his TV films, Vincent Fremont. But he also drove the film crew's van and took part in the creative side, and so on.

1973. Vincent Fremont, whom Warhol had asked to think about program ideas for TV, was working on *Vivian's Girls*. This was the story of a group of girls living in the same building . . .

Let the Adventure Begin . . .

Andy had always dreamed of having a TV show. He explained this in a witty roundabout way, talking about his muse, the young woman hailing from one of the great American families, pathologically obsessed by food and her weight, a weird and capricious creature, shameless, with masses of ideas—Brigid Berlin. About it all Vincent Fremont wrote: "For years he always joked that he should marry Brigid Berlin because her father ran the Hearst Empire and he could have a TV station."

As for the artist's *Diaries*, they are peppered with frequent observations about the small screen.

July 4, 1978. He started his day watching a famous sitcom: "National holiday. Rain. Watched 'The Brady Bunch' before going to the office." "The Brady Bunch" was a sitcom that aired on NBC from 1969 to 1974, dealing with a mixed family of six children and stepchildren from America's suburban middle class. A TV myth targeted at a young audience, and enlivened by meetings with pop stars and sports celebrities. In 1985, incidentally, the program was broadcast on cable MTV, "Andy Warhol's Fifteen Minutes," which borrowed the credits of "The Brady Bunch." In the sitcom the screen is squared off to make it

[4] *Andy Warhol, cinema*. Paris: Les éditions du Centre Pompidou, 1990. This is the date given by this 1990 filmography. But others date *Soap Opera* to 1964.
[5] Vincent Fremont, *Reel-to-real Video. Warhol and TV*, exh. cat. (Queensland Art Gallery, Brisbane, 2007–2008), p. 115.

look as if each protagonist's head is in a box. In Warhol's program, too, the head of each invited guest is put into one of these little boxes.

January 25, 1980. His TV addiction: "When I got home, I was still tense because of the intruder, so I poured myself a cognac. That led me to the candy drawer which led me to the TV, which I then watched all night."

May 19, 1980. On this day, Warhol wrote at the top of his notes, like a major entry: "I watched the 'Today Show' [a morning news program] and I saw a volcano erupting." And further on, talking about the pleasure he got from watching the world living in his own home by way of TV: "I was sitting beside Mrs. Tony Curtis. Then I said: 'Oh, how I'd love to be at home watching Tony Curtis on my VCR.'"

February 15, 1987. Watching TV seems to be a way of expressing extreme loneliness. "It was freezing cold at home. I stayed in bed upstairs watching TV . . . I watched *Agnes of God* three times. A pain in the ass. And I saw the *Will Rogers Story* with Will Rogers Jr. and Jane Wyman. The son was playing his father. The son was on the CBS 'Today Show' when I did the drawings dealing with time in the 1950s. I stayed awake to watch 'Andy Warhol's Fifteen Minutes' on MTV."

Warhol's diary stopped on February 17, 1987. He died on February 22, 1987, in the morning.

During his life as a "universal" creative artist, Andy Warhol was always looking for ideas. And it cannot be denied, nor can he deny, when he talks day by day about snippets of his life, nor can his friends, when they also talk about his life, that the early 1980s was a difficult time for his reputation as an artist. He was suffering from a loss of credibility. TV could be seen as one of the many solutions needed to relaunch his career.

Andy Warhol, erstwhile poverty-stricken child of Pittsburgh, was obsessed by money, and the possibility of not having any one day. So he introduced a principle: that each member of his team must bring in some money for him. Vincent Fremont was on a salary, but he sold advertising and portraits. Curiously enough, though, the rest of the television crew dodged this principle. Sue Etkin, the "director" Don Munroe's assistant, maintains she was well paid for someone of twenty-two. "I was paid by the hour and we often worked from eight in the morning to four o'clock the following morning." Keeping his little team, so dedicated to their work, afloat did cost Andy Warhol money, but he accepted it. So TV was important, over and above his day-to-day obsessions.

Warhol's television work can be seen as the real reflection of his personality. In an initial phase, meaning from 1973 onward, he would create one-off series which would never be aired, but which helped him to come up with a TV format, albeit an experimental one. The principle went along with the sitcom principle, with a unity of place, comic content, and a short time frame of around 30 minutes. At that time, television was already being experimented with among certain artists in Europe, such as Valie Export and Peter Webel, and in the United States by Chris Burden and Richard Serra. But they turned it into a social and reactive terrain. Warhol, for his part, used it as a basic pop object with a silent distance revealing that TV is not reality, but a well-documented dream machine. And this is undoubtedly why it was so fascinating. Bob Colacello observed that ". . . we used to say Andy loves beauties and talkies." The same applied to his TV tests. You had to be beautiful—or handsome—or talk a lot to take part in his early imaginary television work. So this included *Vivian's Girls* (1973) and then *Phoney* (1973)—a

compilation of telephone conversations, with Andy himself talking throughout on the phone, as his diaries show us—and *Fight*, a report on quarrelling couples (1975).

The art historian John Richardson, who was a friend of Andy's, took part in one of those small films, *Vivian's Girls*. "One day Andy said to me: 'I'm going to put you in one of my films, in a 'soap opera.' I didn't know what that was. He told me that was perfect, it was much better if I'd never seen one. Andy was not a man to give orders. He would say: 'Oh, you, stand over there. You don't do anything. You're mysterious. Oh that's just great! Wow!' Andy thought that his films would be distributed all over. That they would bear fruit. For him, film was a movie camera. Andy identified himself with the camera. He was a recording angel." John Richardson would make a last appearance in Warhol's TV work for the final airing of "Andy Warhol's Fifteen Minutes," which rebroadcast the funeral oration for the artist in February 1987. Today, when you ask the historian about Warhol's TV work, he doesn't see any artistic or philosophical justification for it. "TV was Warhol's obsession with recording things. There's no point in looking for any other reasons. His idea consisted in recording life around him in that period." According to Vincent Fremont in 1975: "Andy was only interested in developing ideas and not putting our material on cable TV—at least not yet."[6]

1979. Then came a key event in the "Warhol TV Story." Lorne Michaels, executive producer of "Saturday Night Live," went to see Andy and proposed that he take part in a show. Coup de theatre: he refused.[7] "After Michaels left the studio, Andy explained that we weren't ready and that he felt he would not have enough control over the show. He said it was his name that would be on the show, and if it failed it would harm his reputation. He told me that we had to learn to make a real TV show from the ground up, and he asked me to put a production team together. This was the beginning of our cable TV productions."

Don Munroe[8] had run the Bloomingdale's video studio. This key figure in Warhol TV studied videomaking at the Rhode Island School of Design and, according to Sue Etkin—who worked with him—he was "one of the most creative people I've ever met. He had a keen sense when it came to filming fashion."

1979. Launch of the program "Fashion." Vincent Fremont bought airtime from the Manhattan Cable TV Channel 10. Ten episodes were produced between 1979 and 1980. With our twenty-first-century eyes it's hard to say if the product came full circle. But people in the Warhol world make their appearance on screen. There was Warhol himself, needless to say, Debbie Harrie of Blondie, Diana Vreeland, high priestess of New York fashion, and Henry Geldzahler of the MoMA.

1980. The program's theme grew broader. The show was renamed "Andy Warhol's TV." Eighteen shows were produced between 1980 and 1982. One or two gems came out of this program, which helped Andy to move ahead, but the broadcast still remained not altogether satisfactory. On August 9, 1980 he remarked, as if outside the project: "I think they're going to call it 'Andy Warhol TV.' It's interviews with people, just people talking into the camera."

In 1982, for example, Steven Spielberg was interviewed by Bianca Jagger while he was in the thick of promoting his film *Poltergeist*. Spielberg was reclining. He was tired. Bianca Jagger found his position too compromising. She was seated. She and him like at a shrink's. An anthological sequence.

[6] Ibid., p. 117.
[7] Ibid., p. 117.
[8] Now deceased.

In 1981, a friend of Andy's, Nelson Lyon, now producer of the famous "Saturday Night Live" show, suggested that they work together. "They wanted to do something one week, but I told them that if I couldn't be a regular, I wouldn't do it." Vincent Fremont thought that "Andy was too shy at the time to appear live on show." He wanted to be in charge of his image. Let's put things in context. John Richardson had this to say: "Andy was very aware that he wasn't handsome. His hair was a disaster. One time his wig came off . . . He also had a skin disease. His relationship with his own body was very special. He couldn't bear anyone to touch him." But for some months he had been "desperately trying to make himself look more attractive," according to Bob Colacello.[9] "He never wore his glasses anymore, only his bright blue contacts. He tried mascara to look prettier. He wore Cub Scout pants to look younger." And—which was even crazier for his entourage—he enrolled in a modeling agency, called Zoli, on the pretext, according to Vincent Fremont, that he would meet young people to interview there.

In the end the crew managed to negotiate three 1-minute sequences, which it produced and which would be aired during "Saturday Night Live." The artist was the star. First sequence: he eats an apple and wonders how people can stay quietly in their own homes on Saturday night. Second sequence: he applies a make-up foundation, mentions modeling as a job, talks about death, and the image grows more and more blurred. Third: he talks on the phone about how his evening is being organized, going from disco to disco, etc. Pithy but historic sequences, in which he helped to construct this figure who, officially, wanted to be artificial—the reference to make-up—superficial, and a socialite, despite a brief lyrical flight of fancy, with the disappearance of the image. The day after the show was aired, on Sunday, October 4, 1981, he jotted this in his diary: "Lots of people must watch 'Saturday Night Live' because instead of having people in the street saying: 'There's Andy Warhol,' I heard: 'There's Andy Warhol from Saturday Night Live.'" Sue Etkin adds: "As far as I know, at that time nobody watched our programs. Those "Saturday Night Live" sequences were a big thing. No one had ever done anything like that."

The culminating point of Andy's TV work is "Andy Warhol Fifteen Minutes." Five episodes broadcast on MTV at that time when the music channel was broadcasting on cable, between 1985 and 1987. The artist was more and more at ease on screen. The programs were organized by Vincent Fremont and Don Munroe and the guests participated in relation with the *Interview* panel and with Andy, needless to add. The most important factor had to do with the way the artist managed to winkle out talents. Glamour at all times. In episode 2, of 1987, there's a twenty-four-year-old fashion designer, Marc Jacobs, interviewed with his long hair, on a ladder, Jacob's ladder. And in episode 3 of "Andy Warhol TV" in 1983, there was a young twenty-nine-year-old artist called Cindy Sherman. "He had a radar system for detecting talented people. He could pick out bright people," is how Sue Etkin, referring to Warhol, sums it all up.

The final episode, dated 1987, obviously enough, was the funeral oration for the artist in St. Patrick's Cathedral, in New York. There were four eulogies, including one by Yoko Ono, a star surrounded by a great deal of heavy security, and one by John Richardson, who revealed the fact that Andy went to mass nearly every day. "Vincent and Don were totally shattered. I had a bit more distance. I tried to make sure everything worked. This particular time, it really wasn't normal work," recounts Sue Etkin. It was Warhol's final farewell in the form of a TV program. The reality of his death treated like a fine play with the absent person in the leading role. He couldn't have dreamed of anything better.

Andy Warhol: "I always suspected I was watching TV instead of living my life."

[9] Bob Colacello, *Holy Terror. Andy Warhol Close Up.* New York: Cooper Square Press, 2000.

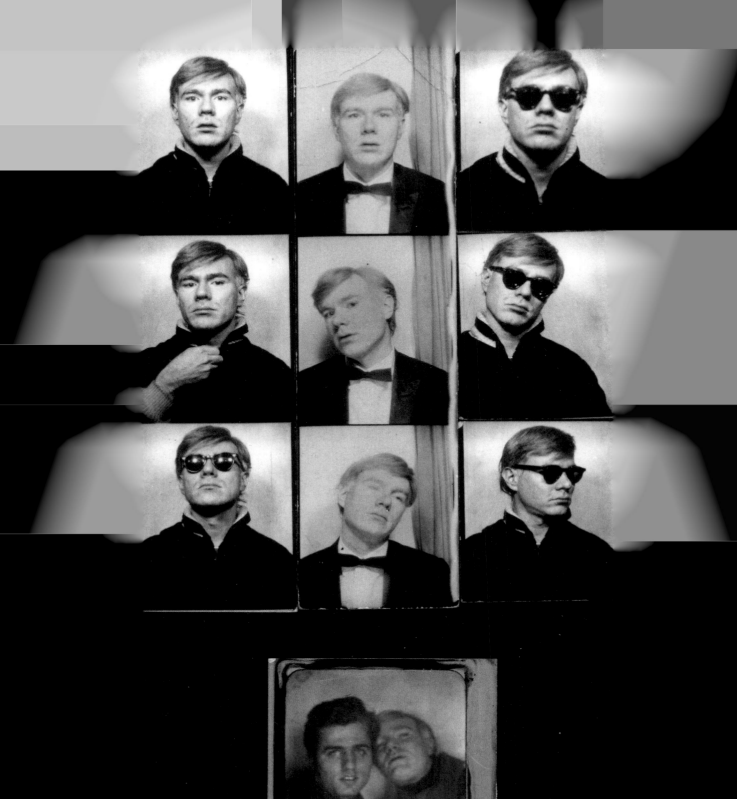

Andy Warhol Assemblage Portrait
© Gerard Malanga, 1964

"If you want to know all about Andy Warhol, just look at the surface of my paintings and films and me, and there I am. There's nothing behind it."
Andy Warhol[1]

Often artists reveal themselves most intimately in their self-portraits. Nicolas Poussin did not paint portraits. But when his patron Paul Fréart de Chantelou wanted an image of the painter, Poussin reluctantly made the picture now in the Louvre. The artist holds a book in front of a number of canvases, with an inscription giving his name, place of origin in Northern France, and the date: 1650. On the left, as Poussin's biographer Giovan Pietro Bellori explains, is an odd detail: "A woman's head is depicted in profile, with an eye in the diadem over her brow: this is painting; and two hands appear there embracing her, standing for love of painting and friendship, to which the portrait is dedicated."[2]

Poussin's body casts a shadow on the inscription. This self-portrait depicts an austere intellectual who placed a high value on friendship and loved esoteric symbolism. When viewing this picture Chantelou, who lived far away in Paris, could experience the presence of his friend. Poussin often kept his distance from patrons. The picture has its mysteries. Why is the woman turned to the side, embracing someone to the left of the picture frame? As for the inscription, can it be part of some painting in progress? But perhaps these words are on the back of a picture. It is impossible to know how large are the three paintings whose frames we can see. This system of verticals and horizontals may comment on how Poussin's art reduces nature to an orderly system of horizontals and verticals.

Andy Warhol's large late *Self-Portrait* (1986) shows him with an unusually wild wig. Like most of his celebrity portraits, it shows only the head. Warhol invented a technique that allowed him to manufacture portraits quickly. He took as many as one hundred Polaroid photographs, silkscreened the best to create an acetate, cropped that image, and transferred it to a canvas with prepainted background. Here, Warhol painted over his face with the camouflage found, also, in a number of paintings from the 1980s, *The Camouflage Last Supper* (1986), for example. In another late *Self-Portrait (Camouflage)* (1986), the right half of his face is totally obscured by camouflage.[3] There is no self-revelation in these portraits.

Poussin painted only two self-portraits. Andy Warhol made many. In 1942, in high school he drew a self-portrait, which he gave to his art teacher. Not an especially attractive man, she

[1] Quoted in Gretchen Berg, "Nothing to Lose: An Interview with Andy Warhol, 1967," in Michael O'Pray (ed.), *Andy Warhol: Film Factory*. London: BFI Publishing, 1989, p. 56.
[2] Giovan Pietro Bellori, *The Lives of the Modern Painters, Sculptors, and Architects*. Cambridge: Cambridge University Press, 2005, p. 324, trans. Alice Sedgwick Wohl.
[3] Dietmar Elger (ed.), *Andy Warhol. Selbstportraits/Self-Portraits*. Ostfildern-Ruit: Hatje Cantz, 2004, p. 136. Because there is no full catalogue raisonné of Warhol's paintings, or his drawings and photographs, generalizations about his self-portraits are subject to correction.

43

recalled, he "seemed to pal with no one."[4] In the 1960s, that changed dramatically. He was, she added, "hard to know personally." That never changed. In 1948, at the Carnegie Institute of Technology, Warhol did a pencil and watercolor *Self-Portrait*. He looks withdrawn and inhibited. These early drawings are typical student work. Seeing them, no one would have predicted a great future for the artist. *Boy Picking His Nose* (1948–1949), which caused controversy in Pittsburgh, does, however, anticipate his fascination with transgression.[5]

Once Warhol became famous, he went through some changes. In 1958 Duane Michaels photographed Warhol standing and smiling behind his mother Julia. The painter did portraits of her but never, so far as I know, included her in his self-portraits. And in a remarkable photograph by Christopher Makos (1981), Warhol wears jeans, a buttoned-down white shirt, checked tie, and longhaired wig. With the help of a make-up artist, "Andy became an extraordinary woman."[6] In fact, in the Factory, there was a great deal of interest in cross-dressing. This picture does something more, turning Warhol into a woman posing in male clothing, a double transformation. Possibly, it alludes to Man Ray's photograph of Marcel Duchamp as a woman, Rrose Sélavy. Warhol admired Duchamp, collected his art, and made a short film on him.

In the 1960s portraiture was moribund. Neither the abstract expressionists nor the minimalists nor the other pop artists made portraits. In 1963 Warhol did a commission, *Ethel Scull Thirty-Six Times*. He made photographs in a Times Square photo booth in a variety of poses and used seventeen printed in varied colors for the painting. "The photomat machine did the work for him: standardizing the image."[7] His later celebrity portraits employ a similar technique, but typically they have just a single large image. Warhol also did many self-portraits in a similar style. In 1963 and 1964 he painted self-portraits showing himself with sunglasses and a tie. Portraits of celebrities, friends, and rich people supported the expensive Factory. His paintings, Warhol wrote, contain "images that anybody walking down Broadway could recognize in a split second—comics, picnic tables, men's trousers, celebrities, shower curtains, refrigerators, Coke bottles—all the great modern things that the abstract expressionists tried so hard not to notice at all."[8]

His portraits also show another subject that anybody would immediately recognize: famous people. In his self-portraits, Warhol often appears expressionless on a blank, solid-colored background. Frequently, *Self-Portrait* (1967) is an example; he shows his fingers touching his lips. Occasionally he does multiple, overlapping images, as in *Self-Portrait* (1978) or images with his face casting a shadow, *Self-Portrait (With Shadow)* (1981). Many celebrity portraits comment in obvious ways on the sitters. *Jean-Michel Basquiat* (1985) presents his sexy collaborator almost nude; *Julian Schnabel* (1982) shows that painter outdoors. And *Brigitte Bardot* (1974) frames her face with long blue-white hair. By contrast, Warhol's self-portraits mostly are more straightforward. But in *Self-Portrait: Strangulation* (1978), ten large paintings, shows him being strangled from behind.

Rembrandt, the old master artist most famous for his self-portraits, painted himself at least forty times, and did thirty-one etched self-portraits as well as some drawings.[9] His *Small Self-Portrait* (1627–1628) shows an anxious, boyish-looking young man; in *Self-Portrait with Plumed Beret* (1629), he plays at being elegant, with a gold chin, silk scarf, and beret with elegant plume; *The Painter in His Studio* (1629) depicts him in the background, facing a panel on the easel which is hidden from view. And in *Self-Portrait as Zeuxis* (1662), he identifies with that Greek painter. The circles in his *Self-Portrait with Two Circles* (1665–1669) may be associated with legends about Apelles or Giotto, but they could be just designs. His self-portraits show Rembrandt aging and demonstrate how ambitious he was.

[4] David Bourdon, *Warhol*. New York: Harry N. Abrams, 1989, p. 18.
[5] See Dietmar Elger, "'The Best American Invention—To Be Able To Disappear,'" in *Andy Warhol. Selbstportraits/Self-Portraits*, *Op. cit.*, p. 119.
[6] Christopher Makos, *Andy Warhol*. Milan: Edizioni Charta, 2002, p. 2.
[7] Keith Hartley, "Andy Warhol. The Photomat Self-portraits," in *Andy Warhol. Selbstportraits/Self-Portraits*, *Op. cit.*, p. 45.
[8] Andy Warhol and Pat Hackett, *POPism: The Warhol Sixties*. San Diego: Harcourt, 1980, p. 3.
[9] See Christopher White and Quentin Buvelot (eds.), *Rembrandt by himself*. London: National Gallery, 1999.

Compared with Rembrandt, Warhol seems hardly to reveal himself in his self-portraits. He famously claimed that he had no inner life. As a friend said: "He's an observer. *He's outside of himself.*"[10] Most of his self-portraits have blank backgrounds. After 1962 he made his painted self-portraits by silkscreening photographic images. So far as I know, he never portrayed himself painting. If you want to see him in his studio, you need to look at the photographs of him with the Factory workers.

Ernst Kirchner's *Self-Portrait as a Soldier* (1915) shows the artist after dismissal from military service. Wearing a uniform, he stands in front of a nude female model, his right hand amputated. What more traumatic injury for an artist than the loss of his painting hand? In fact, this is a fictional wound. Kirchner suffered a nervous breakdown but no physical injury. Alice Neel's painting *Andy Warhol* (1970) and Richard Avedon's photograph *Andy Warhol, Artist, New York City, 8.20.69* (1969) show the brutal injuries caused by Valerie Solanas. But most of Warhol's later self-portraits reveal nothing about how he understood that trauma. (One exception is the photographic self-portrait he made in the hospital [1968]. But he did not turn that image into a painting.[11]) And so the scene on October 30, 1985 at a book signing when a woman pulled off his wig is astonishing: "I don't know what held me back from pushing her over the balcony. She was so pretty and well dressed. I guess I called her a bitch or something and asked how she could do it. But it's ok, I don't care—if a picture gets published, it does. . . . It was so shocking. And it hurt. Physically. And it hurt that nobody had warned me. (Pat Hackett) told me she was proud of me and that I was 'a great man.' And (*laughs*) *that* sure was a first."[12] Warhol depicted many extreme scenes without blinking, so it is a little surprising that this loss of face wounded him deeply. This diary entry is more revealing than his self-portraits.

The self-portraits of Poussin and Kirchner, and many of those by Rembrandt, show them in their studios. Another painter who provided a close-up record of his working practice is Henri Matisse. *La séance de peinture* (1919) shows him making a picture of the model and flowers. *Intérieur au phonographe* (1924) uses mirrors to bring him into the picture. Some drawings explore this motif in a more daring way. In the foreground of *Reclining Nude in the Studio* (1935), we see Matisse's hand as he makes the very drawing which we view. These self-portraits with model ask us to imagine becoming Matisse. By contrast, Warhol's self-portraits never tempt viewers to respond in these terms.

When Warhol learned that Stephen Koch was writing a novel, he was puzzled: "But you need an awful lot of people for that, don't you?: I answered that I didn't really need a very large crowd. 'Oh . . . oh . . . uh, you mean you just make people *up*?' A nervous incredulity spread over his face. I was speaking of a literally unimaginable artistic process."[13]

After 1962, Warhol hardly invented any of his materials. He silkscreened his pictures, tape recorded his novel, dictated his diary, and in his movies made little use of scripts or trained actors. His self-portraits are based upon photographs. "With Andy," Billy Name says, "you had to be able to do something practical for him." "He would ask almost everyone he met what he should do, what he should paint, what colors he should use, what film he should do, what Superstars he should use, as if he were taking a poll, and then he would do exactly what *he* wanted to do."[14]

The Andy Warhol Diaries were dictated to Hackett, his perfect collaborator, for she "had the uncanny knack of sounding like Warhol."[15] He thus totally transformed art production. Mass-producing the painting. Warhol created the processes and controlled the results, but let his assistants do the work.

Traditionally, painters making self-portraits used mirrors.[16] The artist must momentarily turn from the mirror to view the surface on which he paints, and thus appears evasive, not

[10] Quoted in Patrick S. Smith, *Warhol: Conversations about the Artist.* Ann Arbor, Michigan, 1988, p. 219.
[11] Roland Wäspe, "The Construction of a Pop Image," in *Andy Warhol. Selbstportraits/Self-Portrait, Op. cit.*, p. 82.
[12] Pat Hackett (ed.), *The Andy Warhol Diaries.* New York: Random House, 1989, pp. 689–690.
[13] Steven Koch, *Stargazer: The Life, World and Films of Andy Warhol.* New York and London: Marion Boyars, 2002, p. 30.
[14] Quoted in Steven Watson, *Factory Made: Warhol and the Sixties.* New York: Pantheon, 2003.
[15] Wayne Koestenbaum, *Andy Warhol.* New York: Phoenix, 2003, p. 180.
[16] See my "Poussin's Self-portrait," *Word & Image*, 7, 2, 1991, pp. 127–148.

looking us in the eye. The right-handed painter has the brush in his left hand. We cannot see our own eyes, so the self-portrait pretends to do what is impossible, showing the artist as he would appear could he see himself from a distance. A realist self-portrait thus is "a contradiction in terms. For either it represents the image in the mirror, in which case it reverses the ordinary appearance of the artist-model, or it reverses that reversal in the interests of a broader, more impersonal or 'universal' kind of truth, in which case it is no longer faithful to what the artist-model sees."[17] Seeing a traditional self-portrait, the artist takes an impossible external point of view on himself.

Because Warhol worked from photographs and not mirrors, his self-portraits are different. He depicted himself as seen from outside, using democratically accessible technology. Of course, many artists used photographs. But only Warhol fully understood the radical implications of this new technology. He depicted famous people who paid him for their portraits, the grim fame of accident victims shown in newspapers, or just anyone who stood out even momentarily from the crowd. If whenever you step into public everyone looks at you, then you are a star.

Warhol's fascination with success and fashion created violent animosity. When he is called a "weird cooley little faggot with his impossible wig and his jeans," or described as "an auntie. The family he documents is one which adopted him rather than giving him birth," then you see how deep hostility runs.[18] Consider a small selection of the people interviewed in his magazine *Interview*: Rock Hudson, Warren Beatty, Mick Jagger, Ginger Rogers, David Bowie, Salvador Dalí, Bruce Nauman, Fred Astaire, Mae West, Al Capp, Martin Amis, Gore Vidal, Robert Rauschenberg, Spiro Agnew, Arnold Schwarzenegger, Lou Reed, Tennessee Williams, Muhammad Ali, Jasper Johns, and the Dali Lama.[19] No other artist cultivated such an assortment of celebrities.

Warhol wanted to become one of the beautiful people, like the movie stars he adored as a child and the privileged rich he met in the 1950s. He succeeded beyond his wildest dreams, becoming an intimate of celebrities, politicians, and rock stars, famous enough for his death to be front-page news in his favorite paper, *The Post*. Warhol's self-portraits show another glamorous subject, like the pop stars and rich people he portrayed. But he never thought himself beautiful. Since what for him defined beauty was fame and glamour, he had every reason to think himself beautiful. And Warhol had a very generous view of beauty: "I've never met a person I couldn't call a beauty."[20] Or as he once said, "all is pretty."[21] John Giorno, a friend and lover said: "He was physically unattractive. But I loved him and he was the most fascinating person in the world in every way. He happened to be ugly, he understood that."[22] Warhol, so generous at seeing others as beautiful, thought himself homely, and so unlovable. That was his blind spot. How odd that a man whose art and life are associated with extreme narcissism was unable to believe himself desirable.

Here we return to our epigraph, whose significance now needs to be examined. When Warhol claimed that everything of interest in his visual art lay on its surfaces, he was not saying that his art is superficial. After all, the surface is all that we normally see of any painting, whether by Poussin or Warhol. But once we understand how that surface is made, then it can provide us with a great deal of information about the artist. Properly interpreted, Warhol's self-portraits are very revealing.

Warhol was apolitical, not interested in communes, feminism, or the struggle for gay rights, to name three of the most important American movements of the late 1960s. And yet, the Factory was very much a product of that era. He found a way to paint without touching the canvas. His art, a sympathetic writer says, "is not touching because, with the exception of the line

[17] Michael Fried, *Manet's Modernism: or, The Face of Painting in the 1860s.* Chicago and London: University of Chicago Press, 1996, p. 372.
[18] Quotations from Calvin Butt, *Between You and Me: Queer Disclosures in the New York Art World.* Durham and London: Duke University Press, 2005, p. 115, and Jeremy Gilbert-Rolfe, *Beyond Piety: Critical Essays in the Visual Arts, 1986–1993.* Cambridge: Cambridge University Press, 1995, p. 128.
[19] *Andy Warhol's Interview.* Paris: edition 7L, 2004, vol. 3, p. 9.
[20] Andy Warhol, *The Philosophy of Andy Warhol (from A to B & back again.* New York and London: Harcourt, Brace, Jovanovich, 1975, p. 61.
[21] *Andy Warhol*, exh. cat. (Stockholm: Moderna Museet, 1968), np.
[22] John Giorno, *You Got To Burn To Shine/New and Selected Writings.* London: Serpent's Tail, 1994, p. 132.

drawings, he rarely touched it."[23] That conclusion is mistaken. Warhol would not be the most famous late twentieth-century artist if his art did not touch many people. His art touches us because it responds in a deep way to fascination with celebrities and to new technologies.

To grasp Warhol's conception of the self, you need to understand how he made his self-portraits. Unlike Poussin, Kirchner, and Matisse, Warhol made art employing a collective production system. Factory life was centrally concerned with role-playing. "When an individual plays a part he implicitly requests his observers to take seriously the impression that is fostered before them," Erving Goffman wrote in his classic analysis published in 1959.[24] "They are asked to believe that the character they see actually possesses the attributes he appears to possess."

Warhol's scale of operations, mechanical techniques, and employment of collaborators in the Factory were untraditional. But it is impossible to understand his self-portraits without seeing how they develop in a very extreme way an old tradition of role-playing. "As an artist," Svetlana Alpers is describing Rembrandt, "he bestows his love not on a real family, but on a surrogate one of his own making."[25] Deconstructing the traditional views of his art, which now seem far too pious, she describes one stage in the long history that leads to Warhol's self-portraits. "Velázquez," she has said, "sees himself as part of the very court he sees through," while Manet, who greatly admired the Spanish master, "had neither a court nor Velázquez's sustaining trust in representation."[26] Warhol's impersonal mode of art making from photographs shows that he certainly has no trust in visual representation. And yet, his self-portraits extend this tradition. Like these earlier masters, he reveals the self in his art.

Alpers is interested in how "Rembrandt in the studio was spectator to a world of people he brought in to perform before him."[27] Rembrandt, she writes, "contrived to see or at least to represent life as if it were a studio event."[28] "It is not . . . surprising," Alpers adds, "that a tradition of European realist painting—Velázquez, Hogarth, Courbet, Manet . . . Rembrandt—has been fascinated by the playing of roles."[29] Warhol should be added to this list, for he too "painted as if he were the director of his own theater company."[30]

Role-playing has always been associated with seeing the world as a theater. The older Renaissance view in which "the theater of the world was often thought to have an audience of one, a god who looked on in anguish from the heavens at the strutting and masquerades of His children below"[31] was succeeded in the eighteenth century by a tendency to think "of the world as a theater . . . the divine anguish giving way to the sense of an audience willing to enjoy . . . the playacting and pretenses of everyday life." Once the community no longer takes so much interest in a higher world, then the theater of the world comes to have an entirely different significance. When Alpers notes that Rembrandt "loved only three things: his freedom, art, and money," she identifies a commercial viewpoint which was, also, Warhol's.[32] But treating art as a commodity is not incompatible with using it as a vehicle for self-expression.

Refusing to subordinate himself to collectors, Rembrandt used the art market to establish aesthetic value. For him, the painter's touch played a crucial role in that process. Deconstructing that manner of art making, Warhol as well made self-portraits. How amazing that this dysfunctional man, whose human relations were always frail, created richly suggestive art. Warhol, so it seemed to everyone who knew him before he became a star, was the person least likely to become famous. But this shy person invented a radically original social system for art production: the Factory. Extraordinarily creative at finding ways to productively use his limitations, Warhol made self-portraits, which are deeply revealing.

This essay is dedicated to Svetlana Alpers, with thanks for her insightful comments on a draft. However, she is not responsible for how I have used her ideas.

[23] Wayne Koestanbaum, *Andy Warhol, Op. cit.*, p. 48.

[24] Erving Goffman, *The Presentation of Self in Everyday Life*. Garden City, New York: Doubleday Anchor Books, 1959, p. 17.

[25] Svetlana Alpers, *Rembrandt's Enterprise: The Studio and the Market*. Chicago and London: University of Chicago Press, 1988, p. 29.

[26] Svetlana Alpers, "Interpretation without Representation, or, The Viewing of *Las Meninas*," *Representations*, 1, 1, February 1983, pp. 40, 42 no. 14.

[27] Svetlana Alpers, *The Vexations of Art: Velázquez and Others*. New Haven and London: Yale University Press, 2005, p. 53.

[28] Svetlana Alpers, *Rembrandt's Enterprise: The Studio and the Market, Op. cit.*, p. 58.

[29] Ibid., pp. 56 57.

[30] Ibid., p. 83.

[31] Richard Sennett, *The Fall of Public Man*. New York: Vintage, 1978, pp. 34–35. I incorporate here several sentences from my "Nicolas Poussin's Theater of the World," *Kunsthistorisk Tidskrift* (forthcoming).

[32] Svetlana Alpers, *Rembrandt's Enterprise: The Studio and the Market, Op. cit.*, p. 122.

Excerpts from Jane Daggett
Dillenberger, *The Religious Art
of Andy Warhol.* New York:
The Continuum Publishing
Company, 1998, pp. 11, 13, 17,
29, 33, 39, 41–42, 45, 58, 63, 71,
73–77, 99, 101–102, 120.

There are few artists who have left as massive a record as did Andy Warhol. Hundreds of photographs and self-portraits, film and television takes, and miles of tapes from the Sony recorder that accompanied him at work and at parties document him and his world. Warhol's public persona, his obsession with money, fame, and glamour, his voyeurism, and his unflappable coolness are well known. He has been viewed as immoral or amoral, and as an avaricious entrepreneur by many. Again and again colleagues have challenged me: how could such a dissolute and superficial artist produce genuinely religious art?

But there is another Andy, a private Andy, who is stunningly opposite to his public persona. This Andy is shy, reclusive, and religious. Hidden from all but his closest friends, John Richardson said, was "his spiritual side," and despite the fact that many "knew him in circumstances that were the antitheses of spiritual," that side existed in Andy and was the key to the artist's psyche. The enigma of Warhol's two-sided personality remains, but with some knowledge of the spiritual side of the artist, our viewing of his art is given another dimension.

Ultimately, however, it is the paintings that, when studied searchingly, yield up their burden of meaning and disclose their religious content.

Born into a fervently Catholic family and brought up in the Catholic "Ruska Dolina," the Ruthenian section of Pittsburgh, his father was a hard-working, thrifty, severe man who said prayers before meals and led the family on the six-mile walk to church for the Sunday liturgy. Brother Paul, the eldest of the Warhola sons, recalled: "You weren't allowed to pick up a pair of scissors on Sunday—no playing, nothing . . . He was firm— if you didn't go to church on Sunday you didn't get out at all on that day." Brother John observed that the immigrants who came from Eastern Europe had as their first priority their religion. Julia Warhola had brought with her many of the religious folk customs of her native home . . . In the Warhola home most rooms had icons; a picture of the Last Supper hung in the kitchen where the family ate.

Andy's earliest experience of art was of religious art—it may not have been very good art, but unlike for many Protestants or those outside the churches whose experience of religious art may have been limited to museums, for Andy, art and religion were linked from a very early age.

While Warhol was working on his huge series of paintings of the *Last Supper*, showing Jesus surrounded by his apostles at dinner before a table laden with bread, wine, and fish,

Andy Warhol on the Factory
pay phone (detail)
© Gerard Malanga, 1964

Warhol himself was quietly helping to serve meals to the homeless at the Church of the Heavenly Rest in New York. . . . The poverty of his own early years may have come back to him, and he said that a lot of the ladies looked like his mother. It is a typically Warholian oddity that his fame began with Campbell's Soup paintings and at the end of his career it was in a soup kitchen that he found satisfaction in serving the homeless anonymously.

During the 1970s, years of extraordinary productivity for Warhol in film, silkscreened works, his magazine, *Interview*, and the writing of his book *The Philosophy of Andy Warhol*, Andy lived quietly in his home and frequented the church of St. Vincent Ferrer for Sunday Mass and for several visits during the week—Father Sam

Andy Warhol
Camouflage Last Supper, 1986
Silkscreen ink on synthetic
polymer paint on canvas
6'6" x 25'6"
The Menil Collection, Houston,
Gift of The Andy Warhol
Foundation for the Visual Arts, Inc.
Photo Paul Hester, Houston

Matarazzo, a Dominican and the prior of St. Vincent's, revealed in an interview that although Warhol never went to confession or communion, he visited the church two or three times a week and sat or knelt alone in the shadows at the back of the church. It was apparent that he did not want to be recognized. Father Matarazzo said that Warhol's spirituality was private even within the confines of this bustling parish church. He speculated that "Warhol was bonding with a God and a Christ above and beyond the church"; he remarked that Warhol's lifestyle was "absolutely irreconcilable" with the teachings of the Catholic Church . . .

Christopher Makos wrote: . . . "His religion was a very private part of his life. In church he was Andrew Warhola and not a cool pop star. I think it took a lot of pressure off him. It restored to him a perspective of the world that he had grown up with. In church he was the anonymous Catholic."

The paintings done by Warhol in the last years of his life are little known. . . . In these late paintings the seemingly distanced artist abandoned his cool stance. Warhol finally created paintings in which his secret but deeply religious nature flowed into his art. Technically he achieved a freedom and a virtuosity that are analogous to the mastery seen in the late work of some Renaissance and baroque masters. As with these earlier artists, Warhol's virtuosity served a profound spiritual vision. In the *Last Supper* paintings, he was engaged at a level deeper than his habitual piety. Warhol made new Leonardo's mural, recreating it and making it accessible to twentieth-century sensibilities, widening its meaning beyond the particularities of Christian belief to a more encompassing, universal affirmation.

Crosses

Nothing in Warhol's previous work prepares the viewer for his astonishing first large religious painting, the scarlet *Cross* (1982). Its grandeur, its spiritual resonance, and its sheer beauty are striking. The glowing cross levitates against a velvety black background. The feathering of the black paint along the edge of the cross delineates its side and then merges into the encompassing blackness. Warhol, with his usual sense for drama, made the size of the painting taller than the average adult, and its width greater than the average arm span. Thus, the cross is large enough to bear an adult human body, but rather than suggesting the cross of crucifixion, this cross seems ethereal as it levitates before the viewer. It is a stunning painting, a joyous and breathtaking painting.

The scarlet *Cross* was based on a photograph of a simple, small wooden cross, the kind available at religious supply houses, which are said to be from the Holy Land or blessed by the pope. The Warhol Archives have a group of these small crosses that Warhol used in another series of paintings in which the small crosses were multicolored, arranged in rows or randomly placed.

They suggest the simple crosses used in military cemeteries, row on row, an appropriate association for the Spanish Civil War. The lively staccato pattern of the small crosses against a dark ground seems decorative and two-dimensional in contrast to the majesty of the large single *Cross* paintings. They were done for an exhibition in Madrid, a show entitled *Guns, Knives, and Crosses*—guns and knives for the Spanish Civil War, said Warhol, and crosses for "the Catholic thing."

Shadows

Warhol's most enigmatic paintings of the last decade before his death are the *Shadow* series of 1978. In January 1979 Phillipa de Menil and Heiner Friedrich acquired from Warhol 102 paintings entitled *Shadows* and they were exhibited in a SoHo gallery. . . . The *Shadows* unfold on walls, creating a nighttime world, a shifting kaleidoscope of brilliant, life-full color set against the black shadows of a final darkness.

Another series of *Shadows*, vast horizontal landscape-like expanses of velvet black forms enveloped by phosphorescent white or golden tones, speaks another language, the light penetrating the darkness like clouds concealing, then revealing. The viewer experiences "the moment of grandeur . . . when you're overwhelmed." (Ronnie Cutrone)

Warhol's virtuosity with the silkscreen medium led him further and further into abstraction, and with the creation of these majestic and numinous *Shadows* he was close to the style and content of the abstract expressionists, particularly Barnett Newman and Mark Rothko, both of whom aspired to creating paintings that expressed the Sublime. Warhol's large *Shadow* paintings have the grandeur of conception and the delicacy of the abstract expressionists' most profound works . . .

When one studies *Shadows*, the eschatological question of mortality and the end of time arises. For the artist Julian Schnabel, "these paintings hover as the shadow of life's edge."

Skulls

In 1976 Warhol did a series of paintings of *Skulls*. The resurgence of skull imagery accompanied punk culture and is related to anxiety over the spread of AIDS as well as the escalating threats of nuclear war and ecological disasters . . . Particularly apt in regard to the *Skulls* is this statement: "Few people have seen my films or paintings, but perhaps those few will become more aware of living by being made to think about themselves. People need to be made aware of the need to work at learning how to live because life is so quick and sometimes it goes away too quickly."

. . . In what sense are the paintings discussed "religious"? The *Skull* paintings are related to a long tradition in art and in Christian iconography. Jesus was crucified at Golgotha, "the place of the skull," and those works of art which picture the crucifixion often have a skull conspicuously located at the foot of the cross. This skull has a special identity: it is the skull of Adam, who was buried, legend tells, at the very spot where the cross of Jesus was erected. Warhol's anonymous Parisian skull must have had some resonances for him with the traditional teachings of the Church, in addition to the profound and complex musings on mortality that are common to us all but were exacerbated in this case by his history and his survival of the assassination attempt of Valerie Solanas.

Electric Chair

In the *Electric Chair* paintings, the ugly, death-dealing instrument of execution is transformed and bathed in supernatural light. Like the cross of crucifixion, which was the object used for criminal executions but which is seen in Christian art as a symbol of salvation, the *Electric Chair* suggests transcendence.

Last Supper

The *Last Supper* series was Warhol's last major cycle of paintings, and the opening of the Milan exhibition [January 22, 1987] was his last public appearance. The French art critic Pierre Restany, who was at the opening with Warhol, told how this "series appeared as an extension of the now-inaccessible message of Leonardo's famous masterpiece: a sort of replay and reactualization of the original fresco, an act which took on all its symbolic value on the white walls of the Palazzo delle Stelline,"[1] which was a defunct convent that had been made into a gallery situated fifty meters from the Leonardo *Last Supper*. . . . At the time of Warhol's exhibition, the right side of Leonardo's mural had been cleaned as far as the left hand of Christ, leaving the cleaned area drained of color, a substanceless mirage.

Even this most recent tampering with Leonardo's original, which had accretions of overpainting accumulated during the nearly five hundred years since its completion, has not diminished in any way the hold Leonardo's painting has on the collective Western imagination. Many copies of all sizes have been made, some during Leonardo's lifetime. Engraved copies had carried the composition all over Europe. The printing press and modern reproductive techniques have made the image ubiquitous. There are beautiful paintings of the Last Supper by other great artists—Giotto, Sarto, Titian, Rubens, Tiepolo, to name a few—but none of these have achieved the widespread familiarity of Leonardo's composition.

Why is it that Leonardo's *Last Supper* is the one imprinted on our consciousness? Art historians and art critics have provided illuminating analyses, but while they help us to see more deeply into the painting, they do not seem to account for the appeal of Leonardo's work across centuries and cultures. By the time Warhol appropriated Leonardo's *Last Supper*, it had long been part of popular culture.

[1] The Palazzo delle Stelline Gallery was across the piazza from Santa Maria delle Grazie, where Leonardo's famous mural covers a wall of what was in the late fifteenth and sixteenth centuries the refectory of the Dominican friars.

Andy Warhol took the cheapened and distorted copies, and with the alchemy of an artist, he transformed Leonardo's *Last Supper*, recreating it again and again in ever new variations. Warhol gave the vulgarized and secularized image a new seeing. . . . In these last paintings the cool and distanced artist abandoned his mask. Warhol finally created paintings in which his secret but deeply religious nature flowed freely into his art. . . . In the *Last Supper* paintings, Warhol was himself engaged at a level deeper than his habitual piety.

Warhol's cycle of paintings ranges from the freely painted boxing bags and the ink drawings of the Christ and the apostles to the subtle interplay of light and shadow and unexpected juxtapositions of color of the *Last Supper* paintings. In content, they range from the startling and playful *Last Supper (Dove)* to the somber and mysterious *Camouflage Last Supper*. Warhol's recreations infuse Leonardo's familiar image, which had become a cliché, with new spiritual resonance. In these last works Warhol's technical freedom and mastery and his deepened spiritual awareness resulted in paintings that evoke what the romantics and the abstract expressionists called "the Sublime." His final series on the Last Supper is the grandest and most profound cycle of paintings by this prolific, enigmatic, and complex artist, whose importance defies the test of time.

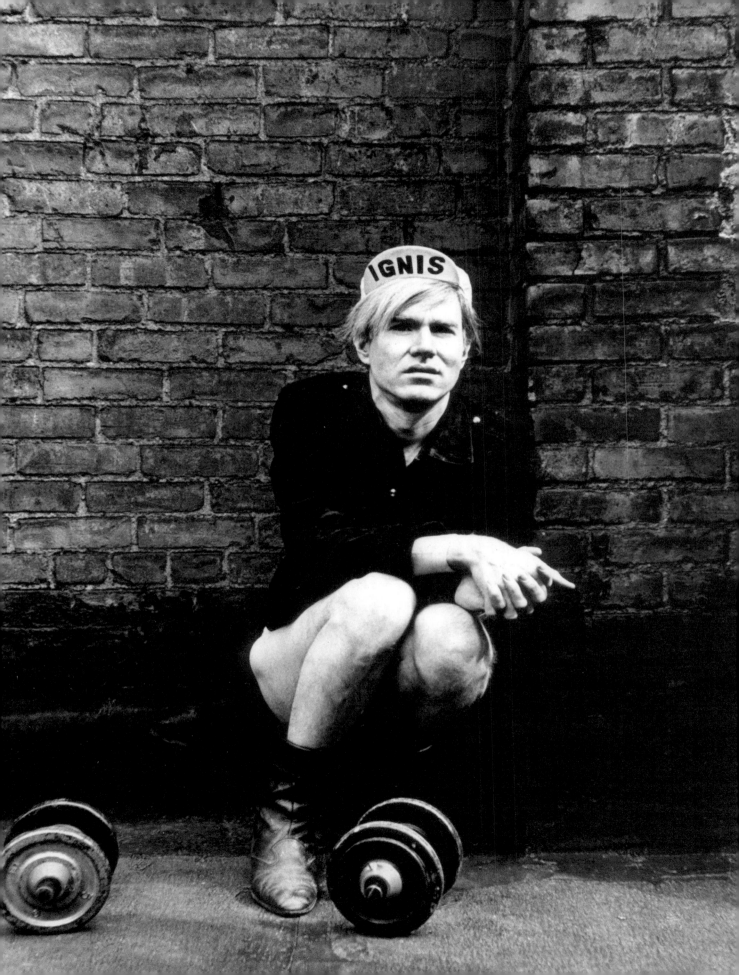

Andy Warhol as he appeared
in the underground movie, *Joan
of Arc*, by Piero Heliczer, 1966
Photo by John Palmer/Archives
Malanga

Gee, that sounds like a cool band. That name would have worked for the band Warhol tried to start with Claus and Patti Oldenburg, Lucas Samaras, Walter de Maria, and La-Monte Young back in the 1960s. It's funny to think of Warhol as a singer in a rock band, but those were the days when the band was the thing, and even the biggest stars knew that the way to stand out was in a group. Maybe Warhol, who made record jackets for The Rolling Stones and The Velvet Underground, the band he managed, understood better than any artist that to be a star in the future you were going to have to hook up with others who have the same idea. As they sang in the musical *Hair*: "One is the loneliest number that you'll ever do."

The topic "Andy Warhol and the Self" was suggested to me. I myself don't think much about the Self. Maybe I'm too selfish. Or maybe I'm not self-involved enough. But basically it's not how I think. And as I thought about the topic I realized that Warhol really did redefine the role of the individual artist, and in a way he created a new model for "the Self," one that illuminated an appropriate path through a capitalist world revolutionized by the all-seeing eye of electronic media.

At first I assumed this subject would involve relating Warhol's artistic practice to psychology, and perhaps the psychology of the Self, as promulgated by post-Freudian theorists such as Heinz Kohut. I must admit that's a whole school of thought that I have avoided rigorously. And then there's the philosophy of the Self, which gets into nuances of theory on consciousness. Is the ego real or is it an illusion? Or does it matter? I must say that this subject also is something I would cross the street to avoid. When I started thinking about the Self as a theme for an essay, I started getting confused about the idea of the Self. Then I got a headache. I think Andy Warhol would have wanted it that way. He would have thought the idea of the Self boring. I think he would have preferred the topic "Andy Warhol and The Others." But then, as I pressed on, I realized that in Andy's case "The Self and The Others" are pretty interchangeable at times. Essentially, Andy Warhol would have considered the idea of the Self simply so obvious that it wasn't worth talking about.

It would have gone like this:

Q: What do you think of the concept of the Self?

Warhol: The Self? Who me? Oh, uh, gee . . . I don't know. What do you think, Vincent?

When he needed an answer, Andy Warhol often put the question to his staff or entourage, the workers at the Factory, or whatever friend happened to be there, and through a division of labor almost unprecedented in the arts, they would come up with an answer, something that would work. Warhol always surrounded himself with enough people to provide the answers, to provide a division of labor that was up to any task required for success. Through his Factory, Warhol was the artist who challenged most significantly the romantic notion of the great artist as a loner, a renegade, a misunderstood solitary genius working in isolation.

Early in the twentieth century there had been examples of artists working in groups or movements, sometimes in collaboration, but invariably the solitary, misfit artist was cast as the principal instigator in the development of modernism. Genius was seen as an individual thing—and the history of progress in the arts and sciences was inevitably linked to the great inventor, the visionary researcher, or the virtuoso. Art movements were clubs composed of these extraordinary individuals, but their accomplishments were considered as parallels and not convergences or collaborations. And auction records would demonstrate that the market agrees with the historians, collaborative works never quite compete in value with works produced by the artists alone.

Yet the notion of the solitary artist was increasingly in stark contrast with the nature of how work was done in society as a whole. The modern era, though its social history was marked out in tycoons and moguls, dictators and inventors, was above all the era of the corporation. Still, the artist was supposed to be different, above the fray of collectives and corporations. He was the exception, the genius who stood head and shoulders above the anonymous corporation. He put the capita in capitalism. Even the greatest promoter of capitalist hegemony, the Central Intelligence Agency, saw such seemingly un-bourgeois avant-garde cultural manifestations as abstract expressionism and bebop as individualist challenges to the collective culture of communism and a rationale for the Western system.

The abstract expressionists provided a sort of apotheosis of the artist as exemplary sufferer, that intrepid soul in search of the true Self who sacrificed that Self on the altar of aesthetics. Art history had forged a chain of artists as outsiders that began, perhaps, with Caravaggio, but began to really gather neurotic steam with the approach of modernism and the idea of progress in the arts, from Van Gogh, Gauguin, Modigliani and Lautrec, Rimbaud and Artaud. The artist was no longer the visionary master craftsman, but the individual out of step with society who was ahead of time, the artist who represented the future in a world clinging to the past.

The abstract expressionists as a group codified the drama of drinking, brawling alpha heterosexuals, driven to the edge of madness by their commitment to theory and the haunting visions that possessed them. Alcoholism became a visionary method, depression became inspiration. Pollock and Rothko were cast as legendary self-immolating idealists, and this tendency continues today in conventional wisdom, in a pop tradition extending through Charlie Parker to Brian Jones, Jimi Hendrix, Janis Joplin, and Jim Morrison, and now to Basquiat and Cobain: the artist as self-destroyer.

This dramatic image of the artist in turmoil was the exact opposite of how Warhol represented himself in his art and in his elaborately manufactured personal posture. Andy Warhol wanted to be happy. "Success is a job in New York." Warhol didn't consider himself a shaman or a mystic. He was an artist, but also a worker, a businessman, and a fan. He was an artist who recorded the world around him. Warhol, although he was interested in flamboyant personalities, didn't see self-destruction as a creative process. He wasn't looking for mystical illumination, but a good idea and hard work.

When I went to work with Andy Warhol I was twenty-three years old and I was always interested in his attitudes. The Factory was visited by all sorts of art-world characters, and sometimes the subject of the abstract expressionists would come up (such as when Jackson Pollock's girlfriend Ruth Kligman would visit the place, apparently with the fantastic ambition of igniting a romance with Warhol to cap off a triumvirate of Pollock, de Kooning, and Warhol) and Andy would talk about how that generation, in whose shadow he came up. They were too complicated. There was too much theorizing. On Jackson Pollock Andy would say: "He was great but he was too introspective," or "He thought too much, that's why he killed himself."

In a 1990 interview with Paul Taylor, Robert Rauschenberg said of himself and Jasper Johns: "We were the only people who were not intoxicated with the abstract expressionists. We weren't against them at all, but neither one of us was interested in taking that stance. I think both of us felt that there was too much exaggerated emotionalism around their art."

I believe that in their own oblique ways, Warhol, Rauschenberg, Johns, and the other pop artists like Ray Johnson were committed to being the very opposite of Pollock. Whereas the macho hard-drinking, rowdy abstract expressionists seemed to be on an existential journey inward, a sort of alcohol and psychoanalysis driven trip down through the Ego toward the Id and the core of consciousness, Warhol and his pop cohorts seemed determined to bring matters back to the surface. Instead of engaging their demons, the pop artists would ignore them by concentrating their vision on surfaces, exteriors, and appearances. In their work the tragedy of the ego was replaced by the comedy of the collective unconscious.

The pop artists recognized that the abstract expressionist generation was dominated by critics like Clement Greenberg, Harold Rosenberg, and Thomas Hess—that the success of the work depended on theory and explicatory texts, on intermediaries. They knew that the critics wielded enormous power to make and break, and they also must have sensed that the theory used to justify their paintings, theory that dragged in political movements and schools of philosophy and psychology, in addition to the entire canon of modernist art, became, at some point, a heavy load of baggage. It seemed like time for a change. Critics? Who needed them? The pop artists just needed collectors and fans.

Warhol challenged that heroic posture in a gentle but persistent manner, by deliberately shunning the prevalent emotional grandstanding of genius. Where the abstract expressionist had been macho and outspoken, he was fey and elusive. Where their art was personal and exotic to the extreme, Warhol borrowed his subject matter from existing sources—newspapers, packaging. He embraced the ordinary and transfigured the banal. Where the abstract painters had been dead serious Warhol was funny. Where they were earnest or mystical, he was ironic

The public had come to expect artists to pretend to be beyond their understanding, doing the old *épater le bourgeoisie* at every turn and making art that defied popular understanding and that was even mocked in the mass media as being pretentiously highbrow. But Warhol and the other pop artists began to chip away at this posture just as other pop phenomena, like the British Invasion and Motown and Nouvelle Vague cinema, began to capture the imagination of a new generation, presenting a real alternative to the dead seriousness art was assumed to entail. Probably the biggest explication of this sea change is to be found in the famous flowers catalogue, published on the occasion of the Warhol exhibition at the Moderna Museet in Stockholm in 1968 where, along with his works and Factory photos by Billy Name and Steven Shore, his most controversial statements appeared.

"The interviewer should just tell me the words he wants me to say and I'll repeat them after him."

"I'm not more intelligent than I appear."

"I still care about people, but it would be so much easier not to care . . . it's too hard to care . . . I don't want to get involved in other people's lives . . . I don't want to get too close . . . I don't like to touch things . . . that's why my work is so distant from myself."

"Machines have less problems. I'd like to be a machine, wouldn't you?"

"I think it would be terrific if everybody was alike."

"I love Los Angeles. I love Hollywood. They're beautiful. Everybody's plastic—but I love plastic. I want to be plastic . . ."

"All my films are artificial, but then everything is sort of artificial. I don't know where the artificial stops and the real starts . . ."

"If you want to know all about Andy Warhol, just look at the surface of my paintings and films and me, and there I am. There's nothing behind it."

And, of course:

"In the future everybody will be world famous for fifteen minutes."

Even these deliberately provocative statements were not entirely Warhol's own product. His aphorisms were a group effort. When he was interviewed he would often ask others, like Henry Geldzahler or Billy Name, to answer the questions. But these statements were Warhol works as much as his team produced Brillo boxes. His Factory manufactured these aphorisms in the same way it turned out paintings and sculptures, and he fully understood the importance of his contrarian aphorisms. They were as controversial as the similarly contrarian sayings that Oscar Wilde had amused the public with almost a century before ("The first duty of life is to be as artificial as possible . . ." "It's only the superficial qualities that last. Man's deeper nature is soon found out"). Warhol's words challenged the notions that modernism seemed to be built upon and they changed the world to take notice as much as the Coke bottles, the Campbell's Soup cans, and the Brillo boxes The artist's quest had suddenly reversed polarity. Here was a new way of looking at the world. It was no longer an inner journey but a play of surfaces and exteriors. And it didn't pretend to be something you had to work hard to get, if you could ever get it; pop presented itself as, well, itself. What you see is what you get.

Dave Hickey proposes an interesting theory about Warhol's cool soup cans as a reaction to the hot paintings of the abstract generation. He says that the pop generation referred to abstract expressionist paintings as "soup." With his breakthrough Campbell's series, Andy was putting the soup back in the can.

"Pop art is about liking things," said Warhol. And it was as simple as that. Warhol and the other pop artists didn't overtly challenge abstract expressionism or the theories behind it. They simply ignored it, ostensibly, and changed the focus and reversed the polarity of art. They showed the world as it appeared to them on its surface, and evoked its spirit from that surface. Liking things allowed Warhol to use everything as material. It seemed that he embraced the world with all its flaws in a sort of campy, uncritical, but almost Buddhist acceptance. But it was more complicated than that. Andy had his own way of liking things.

In 1980 Mary Harron, who would later direct the film *I Shot Andy Warhol*, visited the Factory and interviewed Andy for the British paper *Melody Maker*. At one point she asked me if Andy meant it when he said everything is great. "Andy does like everything," I replied. "The only thing he wouldn't like would be something that was boring or imposed on him. But it's also a very intelligent, Machiavellian politeness. If you say everything is great, some people will

take you at your word and some people will think you're being ironic. The people who think it's great will think you're saying it's great, and the people who think it's awful will think you're really saying it's awful. So you're always saying the right thing."

Andy Warhol had a completely studied way of playing the dummy. He pretended to be less articulate than he was and he would mumble and dissemble in front of the cameras, denying he had anything to say. His calculated blankness was a cover for his acute intelligence. He knew how the media could and would twist any position an artist took, so he preferred to leave them guessing, to position himself as a sort of cryptic blank. I remember I once asked him how he could do a portrait of the Shah of Iran when thousands of Iranians were in the streets protesting him. He said, "Oh, didn't you notice? I cut his head off." I guess Andy meant that he put the head from one Polaroid on the body from another, and today when I look at that painting I think I can see that oh so subtle symbolic decapitation, but either Andy was thinking very fast or he had thought of the political implications while he was making the portrait and taken an odd, artistic step to answer them.

Warhol became widely observed by being the eternal observer. He became the subject by being the object, and vice versa. He turned his camera on the cameras, and his tape recorder on the tape recorders, creating a feedback loop of meaning that generated a kind of metaphysical white noise throughout the wired culture. He created his larger than persona through his entourage and through his cultivated function as the recorder of what was going on around him—always running a cassette recorder and popping Polaroids and snapshots. Through a reflective blankness he created a personality that was entirely open to interpretation and always under construction. His camouflage paintings show him for what he was—an ultimate chameleon that shifted shapes to match the expectations of his audience. He was the Warhol you wanted him to be. He could be the artist who painted soup, the filmmaker who made *Blow Job*, or the socialite who dined at the White House. He could be the idiot or the intellect, the naïf or the art historian, the establishment or the revolution. There were as many Warhols as people who thought about him. David Bowie put the artist's reflective quality rather nicely in his song "Andy Warhol": "Andy Warhol . . . silver screen . . . can't tell 'em apart at all."

The fact is that Andy Warhol was a fabulous spectator and he enjoyed human drama without, perhaps, bringing as much judgment to bear on what he saw than most people do; certainly he was far less judgmental in a moral sense than most, but tremendously more judgmental in appearances. The distance he put between himself and what he observed was seen by some as amoral or cold and by others as positively Buddhist in its acceptance, but in fact Warhol was probably simply more realistic than most, correctly judging his inability to intervene in the lives of others. And his suspension of judgment seemed intimately connected with his aversion to theory and generalization. If he could have invented any very current saying it would have been: "It is what it is."

In *Against Interpretation* Susan Sontag wrote: "None of us can ever retrieve that innocence before all theory, when art knew no need to justify itself." But just because innocence can't be retrieved doesn't mean we can't try. The innocent eye can't be feigned, but the objective eye can be pursued, or perhaps the public eye can be a source of inspiration. As Warhol put it "Everything was just how you decided to think about it."

Warhol started out "other directed," making work that he thought people would like. He did it in school, where it was his only tactic to achieve popularity, and long before he became a force in fine art he was a great success in commercial art, producing illustrations for popular magazines, newspapers, books, and record covers, and doing store window displays. The reason he was a success in these things had nothing to do with criticism or analysis, but the sim-

ple fact that people liked it. The commercial work had enormous charm. Warhol appealed to the broadest audience, the general public, the marketplace. As a commercial artist, sometimes his work was signed—he became Warhol rather than the Warhola he was born—due to a misprinted byline; but often Warhol's work, like most commercial art, was anonymous and thus succeeded entirely on its appearance

While Warhol was certainly well versed in the ethos of the fine art world, and while it was always his ambition to succeed there, his instincts were perhaps even more attuned to the practice of a commercial artist. He loved commissions, while he considered the pressure to come up with self-created original work a chore. As he developed as a fine artist, he retained certain aspects of the commercial artists' manner that tend to conflict with the ivory tower ideals that seem to prevail in fine art. Warhol had a strong sense of self, as is evident in his highly evolved style, but he demonstrated early on an interest in collaboration with others and openness, even eagerness to use the ideas of others, including collectors who commissioned work. As a commercial artist, Warhol had made a great success simply drawing what he was asked to draw. The shoes weren't his idea, they were an assignment, and he would always be grateful to be relieved of the responsibility of initiating work.

Warhol made a point of asking others for ideas throughout his career, constantly broadcasting a semi-feigned deficit of ideas, and constantly soliciting friends like Henry Geldzahler, Emile de Antonio, and others, including dealers like Elinor Ward, for ideas for paintings. He had spent years working with art directors and he knew that art could be a collaborative medium and that sometimes the best ideas came from advisors with the same goal (sales!). When he made his Elvis paintings he shipped them to his dealer, Irving Blum, in one big roll of canvas, leaving it to the dealer to decide how many and how big the canvases would be.

Warhol was a natural collaborator. He could take others' ideas and make them shine. His first collaborator was his mother, with whom he'd made art as a child, and he valued that experience enough that he continued to collaborate with her when she came to New York, using her distinctly eccentric handwriting as his own in highly successful commercial works and in his books. Warhol wanted success as a fine artist showing in galleries, but he was also educated first-hand in commerce and he learned how big corporations worked. Maybe his best strategic idea was turning himself into a corporation and developing the concept of "business art."

The Factory itself was perhaps Warhol's most brilliant work. It seems to have happened almost as a series of brilliant accidents. The large studio that Warhol took on East 47th Street was a former industrial factory and in discussion with Billy Linich a.k.a. Billy Name and the superstar Ondine, it just came to be called the Factory. Warhol had seen Billy's apartment, which he had covered in aluminum foil, and he asked him to repeat the decor in the Factory. Gerard Malanga arrived to assist in the silkscreening process and friends began to drop by, and people began and suddenly the Factory had a staff and was a new kind of art studio—one that combined traditional studio practices with industrial techniques, a film studio ambiance, and a salacious salon. By the time Warhol got his fourth Factory, an entire building on Madison Avenue between 32nd and 33rd Streets, the Factory included an art studio, a film post-production studio, a video production facility, and *Interview* magazine. The lone artist in his garrett couldn't compete with such glamour, and a new model for artistic practice was born—one that has today grown into the large-scale operations of artists like Murakami and Jeff Koons, both of whom employ hundreds of workers and engage in a wide variety of projects.

But in the 1960s the Factory was something revolutionary. Some took its revolutionary nature literally. I remember in the early 1970s Andy asking me to show visiting European journalists around the Factory. One day one of them, who seemed to assume that we were a com-

mune, said: "So, where do you sleep?" Of course it was a time when many communes existed, and collectivism had many faces, from the hippy Hog Farm to the Manson Family and the Baader-Meinhof group. In that sense the Factory was often over-interpreted (that journalist concluded his questions with "We fuck now?" and I concluded my answers with, "No, not now, thank you"). Pop art had threatened to remake art—especially in the beginning when it was identified with the production of multiples. But the test case for the Factory as a communist plot, or for that matter for Warhol's belief in his glib assertions that anyone could make his work, came to an abrupt conclusion when Warhol refused to put his name to a series of Che Guevara silkscreens that his painting assistant Gerard Malanga made in Italy, in order to get money for a plane ticket back to New York. The Factory was not a commune, it was a corporation, a corporate person, and the person was Andy Warhol, Andy Warhol Inc. And pop art was not to be confused with populism; the line would be drawn wherever necessary to defend the price of the work. It was art capitalism at its best.

Warhol realized that to achieve major success he had to model his studio on a conventional corporation, because contemporary art involved a tremendous division of labor. Today many artists employ a variety of assistants and fabricators, but when Warhol opened his first Factory on East 47th Street in 1963, it was the start of something new. Gerard Malanga was an assistant hired for the manufacturing of silkscreens. Billy Name, who helped name the new studio the Factory and who came up with the silver decor, served as a sort of resident general manager, handyman, and house photographer, who also brought in the nucleus of personalities who would make up the "superstars" when the Factory became an underground film studio. And as the Factory organization grew, Warhol seemed to find employees who were able to do the things he couldn't. In Paul Morrissey he had an organizer who could handle money, direct a film in a more conventional manner, and, not the least of his skills, was able to ask people to leave. In Fred Hughes, Warhol found a supremely skilled social facilitator who could orchestrate his painting sales, his social climbing, and his own collecting of art and antiques. Every personality added to the Factory became a part of the collective Warhol persona.

And the Warhol persona was all about personality, which was a somewhat endangered quantity and quality according to the orthodoxy of the psychedelic revolution whose mandate was "turn on and tune in." Andy Warhol and his crowd seemed to be a sort of polar opposite of the simultaneous hippie movement. They were making radical art, films, and music about individuality and being different—hardly tuning in to some common wavelength. The hippies were about communal living, losing the ego, dissolving personalities, breaking down the boundaries between people, rejecting material things, and getting back to the land. To that end the hippies dropped acid, studied Eastern religions, and dabbled in mystic philosophies. The Warholites seemed to embody precisely the opposite and they tended to consider the hippies complete phonies and the West Coast bands tedious and untalented. When The Velvet Underground played on one of the San Francisco scenes, the Fillmore, its famous proprietor, Bill Graham, lashed at them as "disgusting germs . . . with your disgusting minds and whips!" For Andy Warhol's *Exploding Plastic Inevitable*, flower power was a joke. The only flower they empowered was the poppy.

The famous "superstars" who populated the many films the Factory produced during the 1960s were a collection of outrageous personalities (many of whom were using drugs like speed and heroin to accentuate their outrageousness). They weren't acting. They were the real thing. The Factory didn't encourage socially deviant behavior, but it didn't discourage it either; it simply documented personality in all its extremes—and in the process it created a new brand of realism whose appeal was in providing a powerful alternative to the

plasticism and superficiality of Hollywood. Hollywood films simulated extreme personalities. Warhol captured the real thing in simulated dramas.

Warhol realized that the Factory was a perfect strategy for engaging the public. It was, in a sense, one big publicity stunt. Everything it produced had a way of generating outrage and so outrage became the method. Warhol wrote a novel by tape recording his superstar Ondine talking on speed for 24 hours and transcribing it. Warhol rented out Factory superstars for parties. He tried to create a perfume that came in a Coke bottle that was called "You're In!" And he continued to accept whatever commercial art jobs would come in. He realized that ultimately any publicity was good publicity. And that personality was the essential foundation of creativity.

It was appropriate that Warhol was central in the revival of the portrait as an art form. Although portraiture had been practiced in the avant-garde early in the twentieth century, by such artists as Picasso and Wyndham Lewis, by mid-century it was widely considered a dated form. By the time Warhol revived portraiture in the mid-1960s there were only a few out-of-step artists like Alex Katz and Fairfield Porter putting personalities on canvas. Warhol's approach was, perhaps appropriate for a son of Eastern Europe, iconic. It also reflected Warhol's lifetime obsession with the icon as viewed by Hollywood—the star as saint.

Warhol understood that portraiture was fundamental to painting. His Jackie, Marilyn, and Liz paintings were modern Madonnas, meditations on the meaning-laden images that moved the world. Warhol's early films were literally moving pictures, and essentially they seemed to be moving paintings. It is especially evident in the screen tests that he saw film as a way to extend portraiture into another dimension. In the screen tests he portrayed the people who fascinated him, from close associates like Gerard Malanga, Barbara Rubin, and Jonas Mekas to icons of the avant-garde like Salvador Dalí, Bob Dylan, Ted Berrigan, and Willard Maas. With his portrait paintings and films, Warhol almost single-handedly revived one of the most ancient practices in painting as well as returned the focus of art to the human being. It's almost ironic, since Andy Warhol was widely characterized as cold and inhuman, but clearly he was fascinated by personality.

In the self-portraits we see Andy as the reformulator of his own image. In the early portraits he seems to mimic iconic photographs of Truman Capote and Gore Vidal. He is clearly striking the pose of the sensitive artist. In his final self-portraits he is more comfortable with his image and less derivative in his pose, wearing a wild wig, apparently styled by Jean-Michel Basquiat, and peering through a dense layer of camouflage. The wig and the camouflage amount to the same thing, the gestures and disguises that wind up being as much a part of the person as their natural face and body. Warhol's mask became his face.

From the 1970s on portraiture became a vital part of Warhol's practice. It was how he "brought home the bacon," as the commissioned portraits provided funding that allowed him to make films and a magazine and employ a large staff. He would often protest that he wanted to find another way to make money, but the portraits hold up as paintings and as incisive commentary on the times. And oddly the portraits became the medium in which Warhol began to practice the elements of abstraction that he had banished from his pop paintings at the direction of Emile de Antonio in the early 1960s. Observe the abstract elements, the drips and squiggles in his portraits of Julia Warhola. It is in the portraits that Warhol is ultimately liberated as a painter. He is at his freest here, slathering the iconic faces of his time with pure color abstraction.

Perhaps there was emotion, a psychic soup in Warhol that ultimately the hard edges and cans couldn't contain. And finally, in the late 1970s, Warhol managed to make completely ab-

stract works, urinating on bronze metallic paint on canvas. It must have been the act of urinating that made it possible, the liberation of the penis allowing him to do Jack the Dripper one better, with, instead of drips, a manly flow more intimate and authentic than anything generated by the Cedar Tavern crowd. And in the same year he created the masterful shadow paintings, banishing image to an abstraction and achieving a purity that was all personality.

For Warhol, the façade was far more important to the personality than the reality. The reality was the past, the pose was the future. Warhol was a realist about fakery—it's something one notices about some of his best paintings, like *Ladies and Gentlemen* where he renders transvestites, exotic illusionists, with both a straightforward clarity and a wild painterly approach obviously inspired by their fabulous impersonations.

As his popularity grew in the 1960s there were offers for him to make personal appearances and speaking engagements at colleges and other venues. He did a few for the money but then decided to put one of his film stars, Allen Midgette, in a wig and glasses and send him out as Andy Warhol. "I wasn't getting any work done," Warhol told me, "and every time I did go, I didn't do any of the things the kids had read I would do. So we thought we'd send somebody who was more what they really wanted. He was more entertaining and better looking and he could keep up and go to 18 different parties afterward. The people were happy with him."

Warhol, the unpopular kid in high school, the loner, the nerd, had become a vortex of glamour. He said of his superstar entourage: "I don't really feel these people with me every day at the Factory are just hanging around me. I'm more hanging around them." But they were hanging around him; he was the camera, the recorder, the witness to their genius. And even his management style was the reverse of the usual techniques. He didn't tell his Factory workers what to do so much as withhold approval if they didn't please him. Andy Warhol could have invented passive aggression. At least he exhibited the most aggressively passive posture ever to go public.

Warhol understood that in a world of monumental egos, where brashness and aggressive ambition were taken for granted, he could stand out through clever self-effacement. Andy Warhol has nothing to say. Andy Warhol is a chatterbox. Both were true. It all depended on who said it. Essentially, Warhol realized that in the age of all-seeing media that ultimately the Self is the product of the perception of others. You are beautiful because other people think you are. You are powerful because people give you power. Warhol knew that different people saw him differently, but he didn't deny those perceptions or contradict them, he encouraged them. He didn't see any conflict in being all Warhol's to all people, and in the end he became the Warhol that the public wanted. And there was enough wiggle room left over to be the Andy that he was, alone in his room. The whole spectrum; from A to B.

Toward the end of his life, Warhol almost realized his ambition to be a machine. Alvaro Villa built a complex Warhol robot that was to appear in a Broadway show produced by Lewis Allen (the producer of the hit "Annie"). The show was to be titled "Andy Warhol: A No Man Show." The robot, which was built using casts of Warhol's head and hands, would have been even better than Allen Midgette, having Warhol's own voice and unlimited endurance. It could have even performed in two places at once.

When asked what he would have on his tombstone, Andy Warhol expressed what could be the summation of his idea of himself; he said he'd like his tombstone to say "figment." But was he the figment of his own imagination, or was he the figment of our collective imagination? Or is there a difference, really?

Note: Certain remarks about Gerard Malanga in Glenn O'Brien's essay printed here are not the position of the Astrup Fearnley Museum of Modern Art.

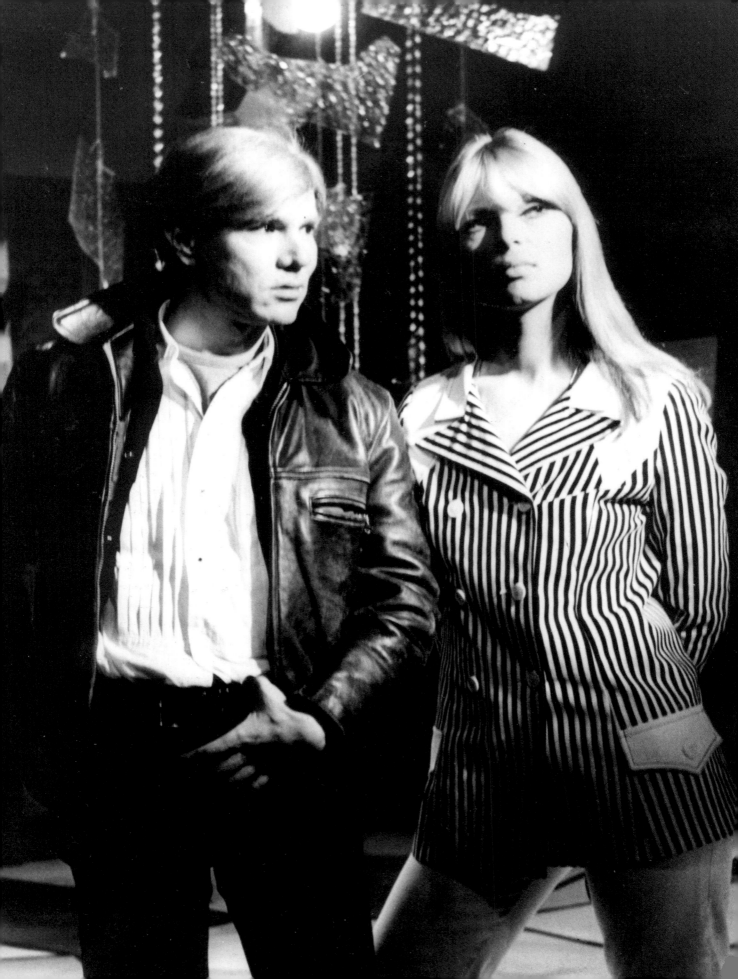

Aram Saroyan

Andy Warhol: I'll Be Your Mirror

Andy Warhol accompanying Nico, MC for a "Late Night Horror" movie series on Boston TV Archives Malanga, 1966

During the 1960s, Andy Warhol was interviewed on television by the art critic Alan Solomon. Warhol was seated on a bar stool and dressed in dark jeans and a black leather jacket, and as always had a gentle demeanor and spoke softly. Solomon was asking questions from a chair in front of the artist, Warhol seated above him as if on a makeshift pedestal. The questions were the art-savvy currency of the critic, but Warhol answered monosyllabically, mostly with "umm" or "yes." Then after a third or fourth exchange, he broke this pattern. "Would you," he said softly to Solomon, "give me the answers to the questions, too?" A passage in John Giorno's memoir, *You've Got To Burn To Shine*, tells of the poet's visit to Warhol's earliest New York studio in the East 80s, where he encounters for the first time a giant "star" portrait (of Elvis). How exhilarating that breakthrough must have been to the young transplanted native of Pittsburgh. A year or so earlier Warhol had been hand drawing advertisements for women's shoes. He drew the best shoes of anyone in the business, the legend runs. A graduate of his native city's Carnegie Institute, he moved to New York with his classmate the painter Philip Pearlstein and was making ends meet. As he evolved as an artist, he put aside painting and drawing to make silkscreens of public domain photographs, effectively abandoning a personal hand in his work, except that his sense of color remained brilliantly in play. He also continued to make color accents by hand throughout his oeuvre. Most crucially, what he took from his commercial into his fine art was commercialism itself—ramping it up to portray an electric civilization in which fame is both subject and product. A deceptively quiet-spoken imperialist, anything was fair game for his oeuvre: Marilyn Monroe and the electric chair; car wrecks and Elizabeth Taylor; the ten most wanted men (by the FBI, surely a Warhol joke); a life-size wood replica of a Brillo box (in fact hundreds of them); a Campbell's soup can utilized as a grid for a color-field workout also seen in his multi-paneled self-portrait. Using iconic images, he made more multiples of them, enacting on a smaller scale the process that had produced their fame in the first place. Today images he made are on refrigerator magnets. A guest at Warhol's first "Factory" on East 47th Street would be invited to sit down for a "screen test" in front of a movie camera on a tripod. The artist would set the lights and then let a 3-minute reel of film run from beginning to end. There were no lines to read and nothing otherwise to do, as if the subject were asked to sit for a still portrait but instead was filmed. While a single image can suggest the visceral inner nature, these portraits comprise neurological *narratives*. How many times a subject blinks, or swallows, or moves his or her head renders the portrait extraordinarily intimate, as if a Rembrandt were to start breathing. If Warhol presents electronic time in multiplying a single image in

his works on canvas, in the "screen tests" we see and feel linear time nakedly—like Beckett without words. In *Sleep*, John Giorno, Warhol's boyfriend at the time, sleeps for 6 hours while the camera records it from a single angle. In *Empire State*, another silent epic again from a single camera angle, we see the tallest building in Manhattan go through the night and into the dawn. It is curiously comforting to know these films were made, and more or less unnecessary to watch them, as if we now have mortality packaged, in the can, if we should ever need to confirm it. Next came "talkies." *My Hustler* features Paul America and Ed Hood, a Cambridge professor. There's the buff America at the bathroom mirror and the rumpled balding professor nearby—and the beach just outside. It's dazzlingly off-kilter and dead-on. Our America. In the split-screen magnum opus *Chelsea Girls*, there are things going on in various rooms of the Chelsea Hotel. The soundtrack comes from one or the other of the two separate rooms that divide the screen. Mostly inchoate or incomprehensible dramas unfold while the camera finds subjects of its own to contemplate: a bureau and the back of someone's head in the frame . . . zooming in on a corner of the room with nothing in it. Here is the disinterested mind of the artist apprehending a culture in a seismic shift. An equal-opportunity observer, if someone wanted to make a scene Warhol would oblige by filming it, i.e. Ondine's explosive rant in *Chelsea Girls* when a young woman offends him—a dramatic high-point in a goofily routine chronicle, perhaps Warhol's own testimony to his famous statement: "In the future, everyone will be famous for fifteen minutes"—a prediction likely to prove out only in the event that the mechanics of fame were in the hands of Warhol himself. *Beauty Number 2*, starring Edie Sedgwick, and *Nude Restaurant*, starring Viva and Taylor Mead, are, literally, situation comedies. In *Beauty Number 2*, Edie lies on a bed with a young-man/boy-toy while Chuck Wein, Edie's Cambridge friend and Svengali, is off-camera making increasingly provoking comments to her. On her way to getting upset, Edie and her partner on the bed assume fetching poses in *déshabillé*. *Nude Restaurant* is a place where nude patrons are served by nude waitresses. The situation is given in the first frame and, dramatically speaking, after an initial jolt, seems stillborn. But this is to underestimate those two inveterate troupers of underground cinema: Taylor Mead, the fey Chaplinesque figure of dozens of films never shown above 14th Street; and Viva, the elegant and witty young lapsed Catholic, a sort of psychedelic Mary McCarthy. The final sequence—a large portion of the film—was another single-angle shot trained on Viva's talking head, while in a lower corner of the screen Mead alternately listens and zones out. She is speaking exhaustively about the clitoral versus the vaginal orgasm: whether there is a real distinction, the pros and cons of both. Mead, neither riveted nor quite willing to detach, takes in particular turns in the argument and is otherwise occupied with his own thoughts, but always with companionable good humor, a half-smiling elf. If there's a single scene in American film that can stand with anything in world cinema since the Nouvelle Vague, this one gets my vote. A talking head, even a brilliant one, can get old after a few minutes. A talking head with a silent but intermittently responsive companion also head-on in the frame is something else. It affected one with the same kind of exhilaration one knew in, say, hearing Jimi Hendrix for the first time. On June 3, 1968, Warhol was shot and critically wounded in the offices of his new studio on Union Square by a marginal figure among the Factory crowd, Valerie Solanis. A militant lesbian feminist who had a script she wanted Warhol to film, Solanis was the author of *The S.C.U.M.* [Society for Cutting Up Men] *Manifesto*, an often incisive rant against the patriarchy, which, she wrote, reduced a woman to nothing more than "a hot water bottle with tits." While Solanis did not succeed in killing Warhol, her attempt on his life put an end to his career as a filmmaker. Henceforth all Warhol's films would be directed by Paul Morrissey, a gifted but more conventional filmmaker who succeeded in commercializing the line—*Trash*, *Flesh*, *Heat*, etc.—at the expense of most of what made the artist's own films both ineffable and unforgettable. In a few years Warhol had created his own studio sys-

tem and concomitant "super-stars": Ultraviolet, Ondine, Ingrid Superstar, Jane Forth, Gerard Malanga, Mary Woronov, Taylor Mead, Paul America, Edie Sedgwick, Eric Emerson, Candy Darling, Viva, Joe Dallesandro, Brigid Polk, Holly Woodlawn et al.—and they comprised his repertory company. The template being the Hollywood studio system, the artist presided over it like a taciturn, very permissive L.B. Mayer. Instead of entreating his stars to stay out of trouble (Judy Garland said Mayer could cry "ball-bearing tears" at will), Warhol would hasten the mischief on. In his multi-paneled *Self-Portrait*, we see Warhol's face as if in the serial exposures of a strobe light show—red, green, blue, etc., the features at times almost lost, the face becoming a medium of light. The artist, as the Solomon interview attests, was unable or unwilling to talk in art-critic parlance about the significance of his work, and rather became its living annex. Then, too, he famously allowed the actor Allen Midgette to impersonate him for a scheduled college appearance: he made a living multiple of himself. The attempt on his life, and the subsequent days when his life hung in the balance, was a strange reversal of fortune. Now Warhol, who had created a wizardly miniature of our media, became the real-time focus of the New York daily tabloids—as if his oeuvre turned inside out. From Claes Oldenburg to Roy Lichtenstein, Tom Wesselman to James Rosenquist, pop art, the new movement in painting, was an efflorescence of sensibility and technical accomplishment that quickly claimed a large public. At the same time, among the major figures, Warhol stood apart. While there was a pervasive sense that the movement put paid to abstract expressionism's romantic image of the artist as a tortured outrider of his time—Jackson Pollock being Exhibit One—Warhol went the farthest in the other direction, in the process claiming attention that exceeded everyone else's. A leading pop artist, he became a pop *figure*, appearing with members of his entourage on "The Tonight Show." Paradoxically, he accomplished this by making a public spectacle of having not only no obvious personal demons to wrestle, but being perhaps the mildest, least assertive personality ever to assume a central position in public consciousness. While his work had presence that rivaled anything in the museums, his own presence was a study in low-wattage affability both benign and inscrutable. Who was he, exactly? He showed up, becoming a familiar face at New York parties and openings, and reliably lent a hand on holidays at his church soup kitchen. At the end of the night, he went back to a home kept for him by his mother, Julia Warhola, a Polish immigrant whose beautiful handwriting he'd imported for the copy in his shoe ads. While his pop art colleagues were demonstrably masters of their craft, Warhol made the *mechanics* of reproduction central to his oeuvre. No one else did this, or surely not to the degree that Warhol did, and his industrialized, depersonalized means might have eclipsed his ends, except for the power and beauty of what he made. That is to say, whatever his medium or its means, he remained preeminently an artist—the lone visual artist of his day to rival in impact the leading figures of the music scene: The Beatles, Bob Dylan, and The Rolling Stones. In their different ways all laid down a template of consciousness and sensibility that would impress an international public as forcefully as Picasso and Gershwin, Sinatra and Pollock had earlier. In the Kleinian, post-Freudian school of psychoanalysis, the Good Enough mother (a designation of the British analyst Donald Winnicott) is one who takes in the infant's projected terror, and, in meeting it with both empathy and equanimity, detoxifies it. The great artist may be doing something similar: giving back to us an image of ourselves that while it acknowledges our full range of colors, dark as well as light, allows beauty into the equation. "He had a mind so fine," T.S. Eliot famously wrote of Henry James, "that no idea could violate it"—a line that might also apply to Warhol. Not that either James or Warhol would disdain ideas per se, but that they would apprehend them perceptually—James tracking with his character's thoughts with the same equanimity as he would describe a landscape, and Warhol benignly asking Alan Solomon for the exact intellectual responses the critic wanted to hear, in effect being available to make a copy of Solomon's mind.

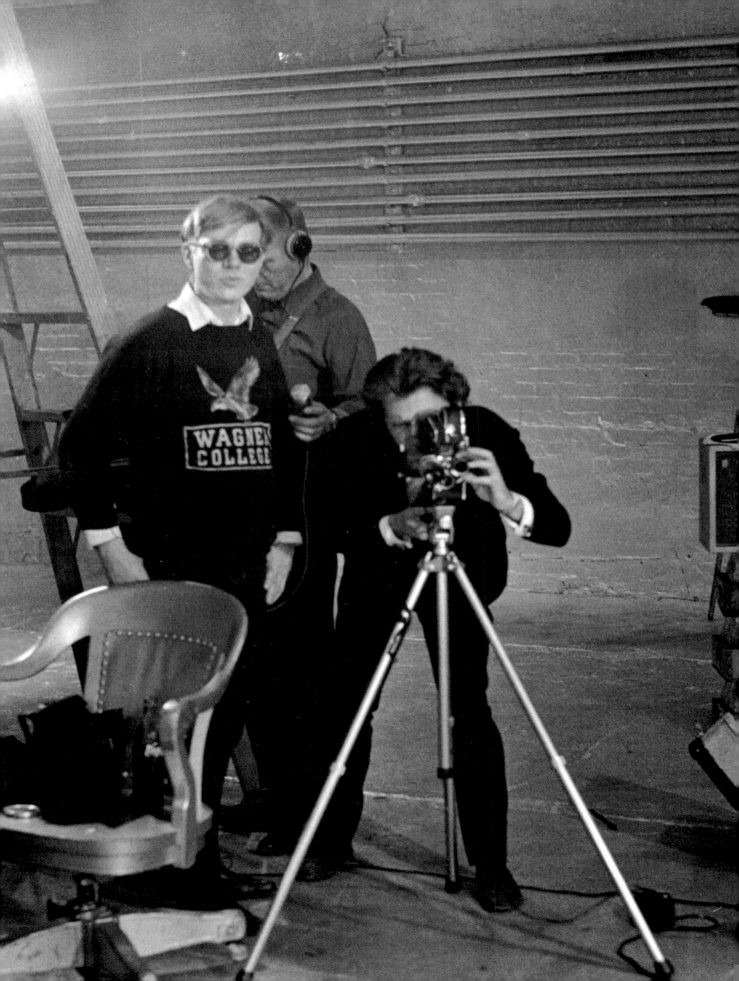

Svein Inge Sæther　　　　**Andy Warhol's "Minor" Cinema**

Gerard Malanga shooting a "screen test" collaboration as Andy Warhol looks on Archives Malanga, 1964

"Minor" Cinema

In 1975, Gilles Deleuze and Félix Guattari published their book on Franz Kafka, *Kafka: Pour une Littérature Mineure* (published in English in 1986 as *Kafka: Toward a Theory of Minor Literature*). In it, they describe this "minor literature" as undermining and subversive, working in opposition to what we know as Great Art, or the literary canon. They consider Kafka's literature as a machine, and they set forth to investigate the functions of this machine, instead of interpreting the meaning of its content.

The films of Andy Warhol can be considered along the same lines, and the collective film work can, in a very Deleuzian way, be viewed as a "rhizome."[1] This is a non-hierarchical, horizontal structure, whose parts are interconnected, without any privileged starting points. Seeing the work in this way allows us to enter it at any chosen point, and makes each of the different elements of Warhol's films equally important. We can consider the various parts of the machinery, the out-of-focus images, the white-out end of reels, the misread lines of actors—everything that a "normal" film would hide by cutting away—as equal and integrated. And each film made—just by virtue of the fact it *was* made—is important to our understanding of how the Warhol film-machine works.

Warhol cinema can be considered "minor" when compared to the two classic traditions with which it is normally associated: classic Hollywood cinema and American avant-garde film of the 1950s and 1960s. This does not mean that it is less significant, but instead implies that Warhol's films are not classifiable within either of these two canons. Hollywood created both the studio system and the movie-star industry, elements that fascinated Warhol, and right from the outset he wanted to portray stars in his films. But his approach was to proclaim that his subjects *were* movie stars. In his glamour-obsessed mind, the star was everything, and the stars in his films didn't have to *do* anything but be on the screen. This is one of the main reasons why Warhol's films rarely contain any traditional "plot" or "action." At the same time, there is no symbolism in his films. The "minor" cinema is liberated from the constraints both of the commercial movie industry and the artistic conformity of the modernist American avant-garde film.

The Warhol Films

Warhol's film oeuvre can roughly be divided into three parts: the early silent films, the mid-period sound films made after 1964, and the later, more diverse films from *The Chelsea Girls*

[1] "Life has always seemed to me like a plant that lives on its rhizome. Its true life is invisible, hidden in the rhizome. The part that appears above the ground lasts only a single summer. Then it withers away—an ephemeral apparition. When we think of the unending growth and decay of life and civilizations, we cannot escape the impression of absolute nullity. Yet I have never lost the sense of something that lives and endures beneath the eternal flux. What we see is blossom, which passes. The rhizome remains" (Carl Jung, *Memories, Dreams, Reflections*, New York: Random House, 1965).

69

(1967) onwards. He made his very first film, *Sleep*, in 1963, shot with a static camera without sound and projected at the slowed-down speed of 16 frames per second. This would become the aesthetic staple of the first period: silent black and white films of 30 to 60 minutes. The films were unedited, thus portraying an event in real time, the length of the reel dictating the duration of the resulting film. Exceptions to the format were the very long *Sleep* and *Empire* (1964), the former comprised of looped footage and running for nearly 6 hours. Thus the portrait of the sleeping John Giorno is in fact an illusion of continuous time, a device that Warhol rarely repeated until the last days of his career as a filmmaker in 1968. When Warhol first got hold of a camera in 1963, he started to make his so-called "screen tests." Friends and associates, casual visitors and big celebrities: everybody was urged to sit in front of the camera for a screen test. In Hollywood, aspiring actors use their brief screen tests to impress the studio—by performing, acting, reading, or singing—to be cast in the part of their dreams. The Warhol screen test was more or less the opposite. His subjects were required to do nothing, and although they *could* do whatever they wanted, most of them sat still, looking straight into the camera. Hundreds of screen tests were made at Warhol's Factory from 1964–1966, and as a complete body of work, these films are without comparison in film history. Shot on a 3-minute reel and slowed down in projection to 4 minutes each, these silent portraits are beautiful and provoking, sometimes almost painful in their brutal scrutiny of the subjects' trapped faces.

Another significant theme of the early films is that they show a deep interest in the human body and in singular bodily functions. Films like *Sleep*, *Kiss*, *Eat*, and *Haircut* (all 1963) focus almost entirely on the activities described in the films' titles, while another significant work, *Blow Job* (1964), is an intense study of a man's face, apparently while he is being sexually "serviced" off screen. Furthermore, the films are about positioning oneself for the camera, in many instances as if posing for a painting. This extreme focus on the "placed" body is a trait that continues throughout Warhol's films.

When sound was introduced into Warhol's films, the basic themes of stardom and posing for the camera continued within a format where an incident (or perhaps, a non-incident) took place over the course of two half-hour 16mm film reels, with sound being added both as off-camera speech and as regular dialogue among the actors. Initially, the scenarios for the films (there were, of course, no conventional scripts) were written by Ronald Tavel, an author and playwright with a keen interest in the Theatre of the Absurd. One of his most significant contributions was the dialogue for the very first sound film of this type, *Harlot* (1964). This film shows the main star, drag-artist Mario Montez, on a couch surrounded by three other people. Off screen, an intricate and elliptical dialogue is performed, commenting on the motif of the picture but still maintaining a certain autonomy. The result is an astonishing counterpoint between a rigidly framed, motionless "movie" and a stream-of-consciousness-like flow of words.

Warhol also made *Vinyl*, *The Life of Juanita Castro*, and *Screen Test #2* (all 1965) with Tavel's assistance, while *Poor Little Rich Girl*, *Beauty #2*, *My Hustler* (all 1965), and others were written by Chuck Wein. The films made with Wein work in a slightly different manner, with the off-screen dialogue more actively addressing and communicating with the people on screen. In these films we find what was to become the defining aspect of the last period of Warhol's films: talk. Here, the sound (i.e. speech and dialogue) works as an aesthetic material or a formal element on a par with the images.

Warhol continued to make screen tests parallel with his other films, which gradually contained more and more dialogue. The seed of a new kind of Warhol film was sown with *My Hustler* in 1965, and fully realized with *The Chelsea Girls* in 1966, widely recognized as Warhol's masterpiece. The film is an expansion of the format that had been established in the earlier

sound films, where the camera statically records an event for the length of a 35-minute reel. In *The Chelsea Girls*, however, we see these sequences two at a time, projected side by side on an extra wide screen, the sound alternating between each film. Although there are no narrative connections between the two halves of the screen, the film gradually develops a narrative rhythm, an exchange between the dual image, the sound on one side and the silence on the other. The common culmination of the film (whose reels can be shown in any random sequence) is the extraordinary dialectic between the raging Ondine on one side and a silently weeping Nico on the other. The artistic and commercial success of *The Chelsea Girls* paved the way for a more professional kind of filmmaking at the Factory. The films of the final, short phase of Warhol's directing career are less concerned with the artifice and the thoroughly constructed style of the most successful earlier works (*Sleep, Empire, Haircut, Blow Job, Harlot, My Hustler, The Chelsea Girls*, and the entire *Screen Test*-project) and more about sex and words. Films like *I, a Man, Bike Boy*, and *Nude Restaurant* (all 1967) are excessive works that were aimed at the liberal late-1960s cinema market, already rife with daring European, and particularly Scandinavian, "arty" sex films. Warhol's final film was *Lonesome Cowboys* (1968), which is a culmination of his depiction of masculine narcissism. In this Western pastiche, everything is about male appearance, how to fit inside a masculine body and how to present it. This is, undoubtedly, a theme that concerned Warhol as much in real life as in his art, and of course the two can hardly be separated. However, it is noteworthy that he never appeared in any of his films himself. Here, he remained in the observer's role, much as he did in his own social life. The voyeuristic tendencies of his films are often over-interpreted, but the reflections of his self in his films cannot be overlooked.

Becoming-film

Both Gilles Deleuze and Jean Baudrillard would consider Warhol a simulacrum. In Deleuze's opinion, the simulacrum differs from a copy of an original in that it is not a representation of something, and therefore cannot be seen as less valuable than an original. The Deleuzian simulacrum functions through repetition and by increasing a series of similar images or forms so that new ideas and new meanings can be created when the reader interacts with the text. According to Deleuze, these texts, or works of art, are non-hierarchical condensations of simultaneous events and existences.[2] For Baudrillard, Warhol himself is a simulacrum that breaks the rules of the art "game" and the conventional aesthetics of our culture. Both he and his works possess no secrets; they are pure artifice—and pure immanence.[3]

Warhol's film known as **** (a.k.a. *Four Stars*, 1966–1967) was originally 25 hours long, and was only screened once in its entirety, in December 1967. The film consisted of series upon series of images, double-exposed in pairs on the same screen (one image on top of the other). Warhol's own description of the experience of seeing the film is an accurate account of how his films work as simulacra: "Seeing it all together that night somehow made it seem more real (I mean, more *un*real, which was actually more real) than it had when it was happening."[4]

Everything is surface, and Warhol is the surface itself. As Baudrillard said, Warhol is a part of our world, not through representing it, but quite simply by being a pure fragment of it.[5] This is also the function of "minor" cinema: to be a fragment of the world without representing any "idea." The Warhol cinema has to be taken literally, as a completely immanent simulation. It is all about becoming, in the sense that existence is a process of production. "Becoming is an antimemory," said Deleuze and Guattari,[6] a statement consistent with Warhol's own insistence that he was concerned only with the here and now: "I have no memory. Every day is a new day because I can't remember the day before. Every minute is like the first minute of my life. I try to remember but I can't."[7] In the same way, his film work is *becoming-film*.

[2] Gilles Deleuze, *The Logic of Sense.* London: The Athlone Press, 1990, p. 262.

[3] Jean Baudrillard, *Den maskinelle snobbisme.* Copenhagen: Det Kgl. Danske Kunstakademi, 1992, p. 7.

[4] Andy Warhol and Pat Hackett, *POPism: The Warhol Sixties.* New York: Harcourt Brace Jovanovich, 1980, p. 251.

[5] Jean Baudrillard, *Den maskinelle snobbisme, Op. cit.*, p. 24.

[6] Gilles Deleuze and Félix Guattari, *A Thousand Palteaus: Capitalism and Schizophrenia.* Minneapolis: University of Minnesota Press, 1987.

[7] Andy Warhol, *The Philosophy of Andy Warhol (From A to B and Back Again).* New York: Harcourt Brace, 1975, p. 199.

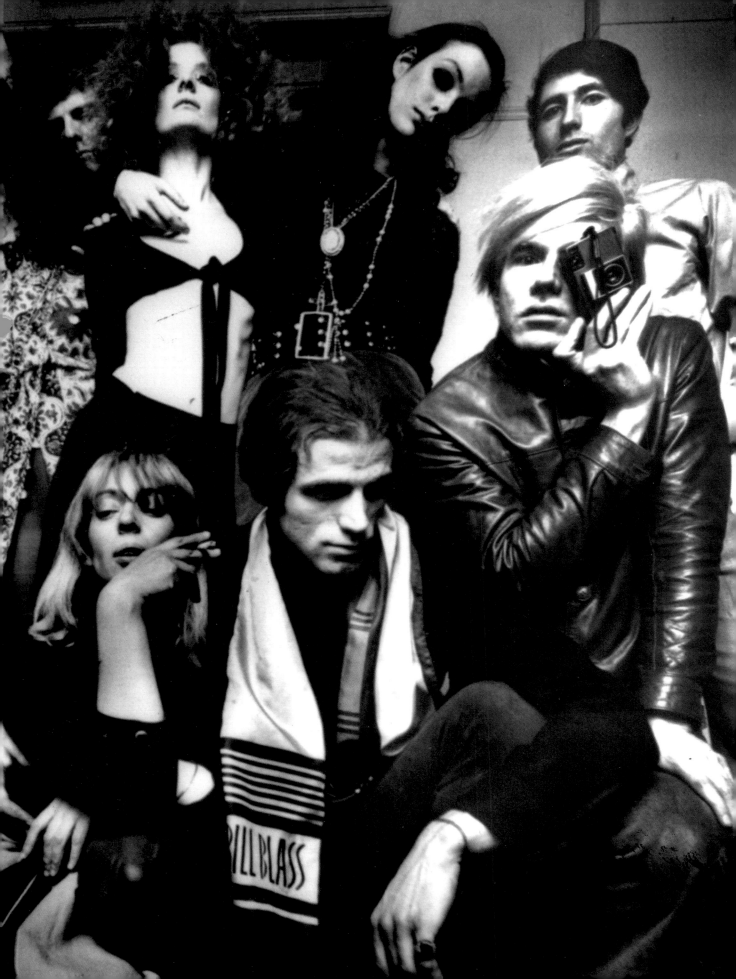

Andy Enigma

When the Astrup Fearnley Museum asked me to write an essay on the personality of Andy Warhol, I became excited, curious, daunted, and hopeful that something new could still be said. Even after the many thousands of words that have been written about Warhol, he remains Andy Enigma.

Does it make sense to try to pin Warhol down?

Or is that exactly the wrong approach?

It took me at least three minutes to forge a hopeful plan to present the Andy Enigma.

It would be a conversation among the people who knew him: an "essay" in video. The sources would be my talks with people from the Silver Factory era.

The emotional tenor of the Silver Factory—roughly 1963 to 1968—can best be constructed from interviews. Endless words have been written, but putting words on paper was not the style of Warhol and his friends. The Factory culture was oral. And for the first time it became a culture in which new technologies—informal film and audiotape—provided the primary sources for the telling of history.

A researcher who focused solely on written things could perhaps get out of this life alive. Once a researcher decides to witness everything in audio and film/video, it becomes an exponentially more demanding chore.

But that is where the treasures lie.

While writing a book, *Factory Made: Warhol and the Sixties*, I interviewed dozens of Factory people, many of them several times.

Over many years, these repeated encounters led to a method that I call "Talk Back."

The process, in short: I videotaped an initial group of Silver Factory interviews. I edited a set of video clips, designed for specific viewers to watch and respond to. They were shown on a laptop. The watcher was encouraged to respond, in any way that he/she wished.

I hoped to create an interview process that reflects current technology. In this case: Silver Factory talks to Silver Factory on video.

In my video essay, *Andy Enigma*, many of the same ideas come up, as they would in a written essay.

He was generous.
He was parsimonious.
He was a life giver.
He was a vampire.
He was full.
He was empty.
He was a genius.
He was an idiot.
He was a humiliator.
He was an encourager.
He was a manipulator.
He was chaotic.
He was controlled.
He was rich.
He was poor.
He was a voyeur.
He was a parent.
He was carnal.
He was asexual.
He was transparent.
He was opaque.
He was commercial.
He was spiritual.
He was trivial.
He was brilliant.

Watching Silver Factory people respond to one another is a more complex matter than these simple, often contradictory descriptors.
The viewer decides what to believe. This is not simply a matter of understanding words, but assessing body language, emotion, and all the things that contribute to being human.

Andy Warhol with The Velvet
Underground and Nico,
Hollywood Hills
© Gerard Malanga, 1966

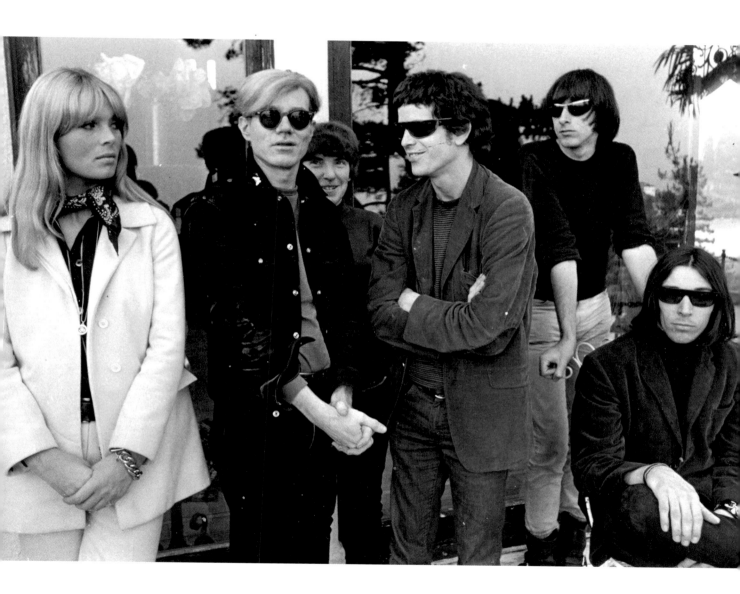

Works

1. *210 Coca Cola Bottles,* 1962

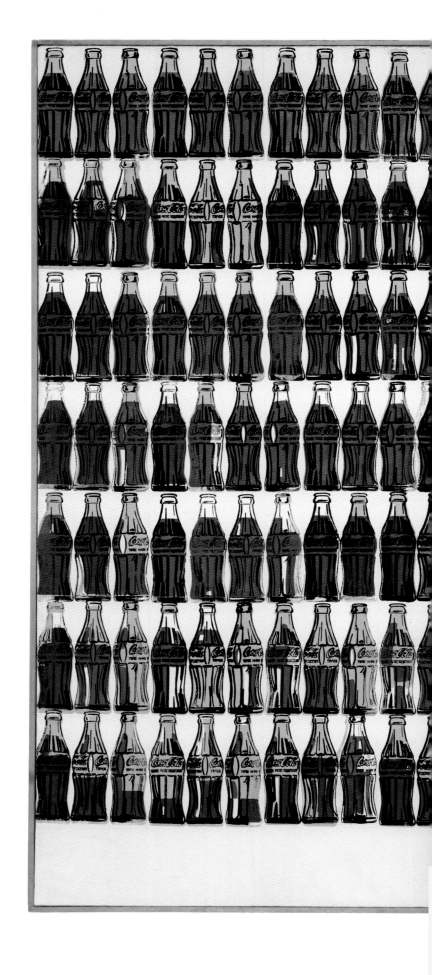

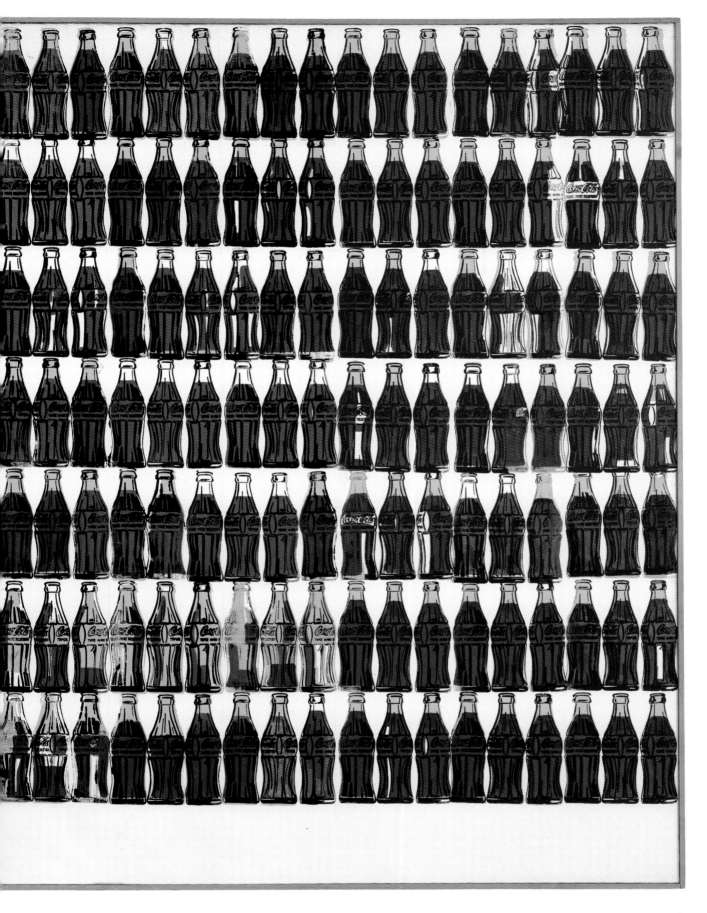

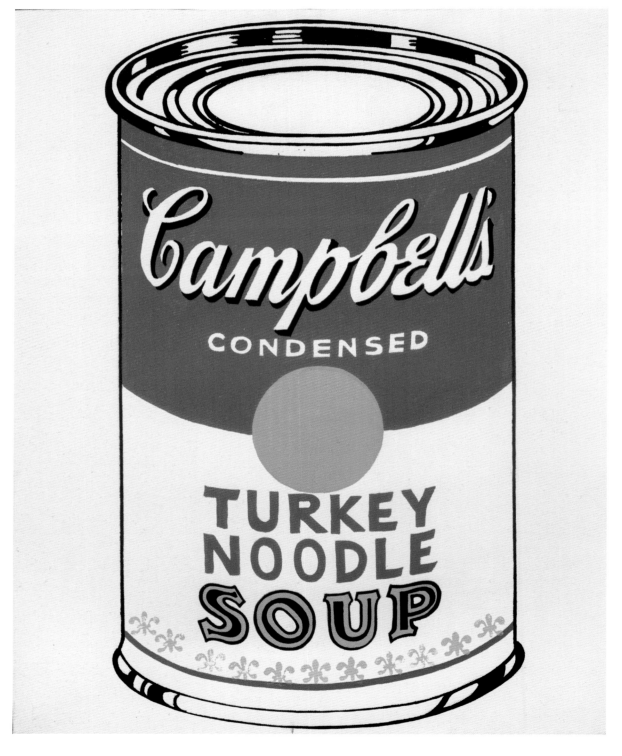

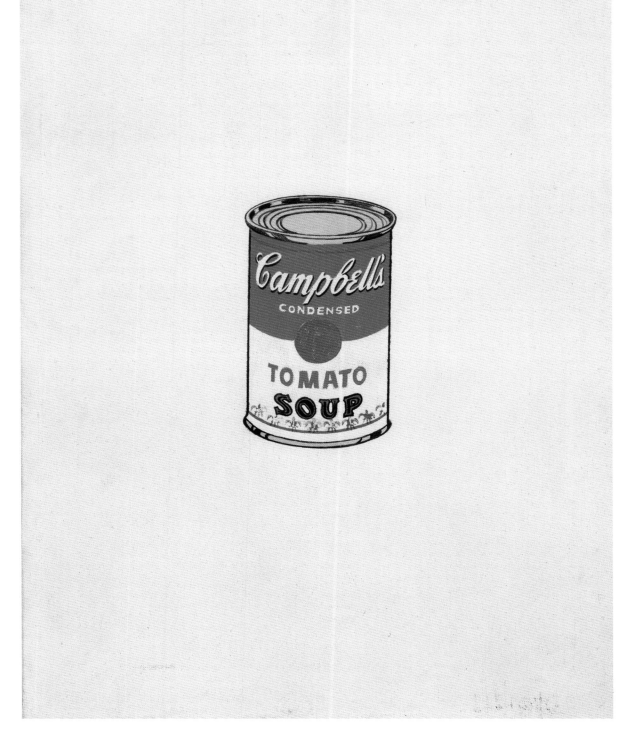

4. *Dollar Bill*, 1962 5. *Mona Lisa*, 1963

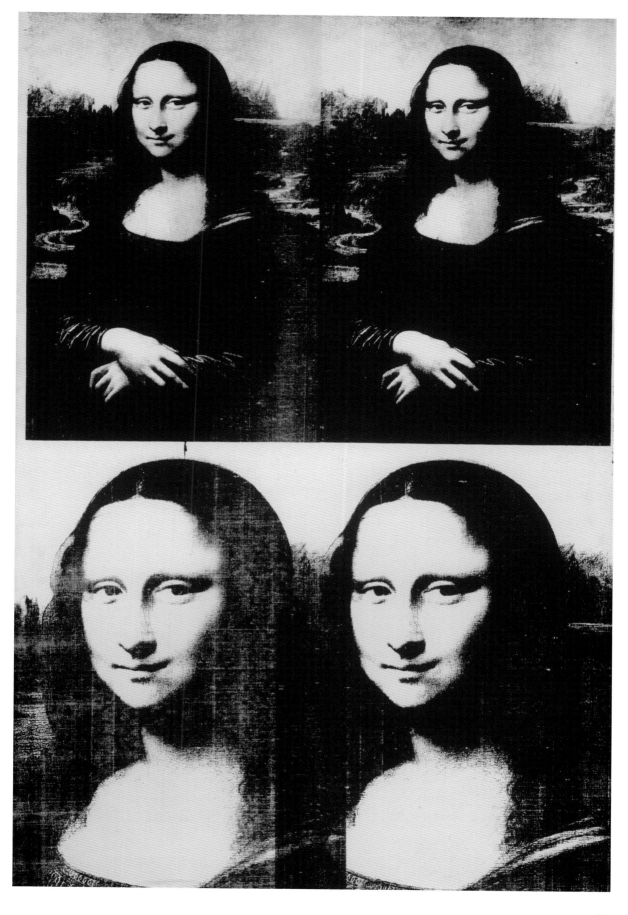

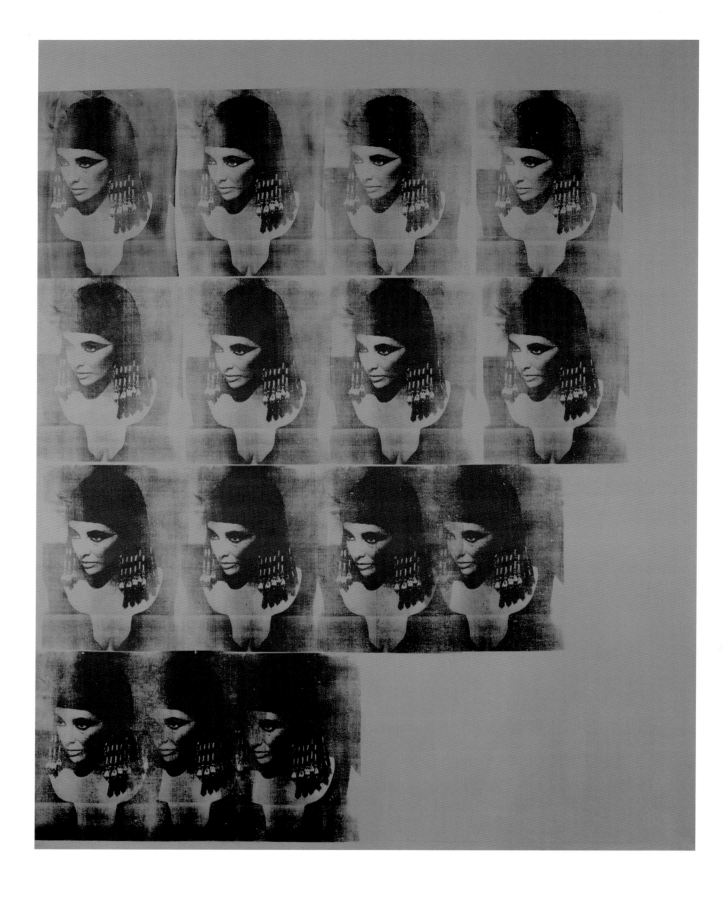

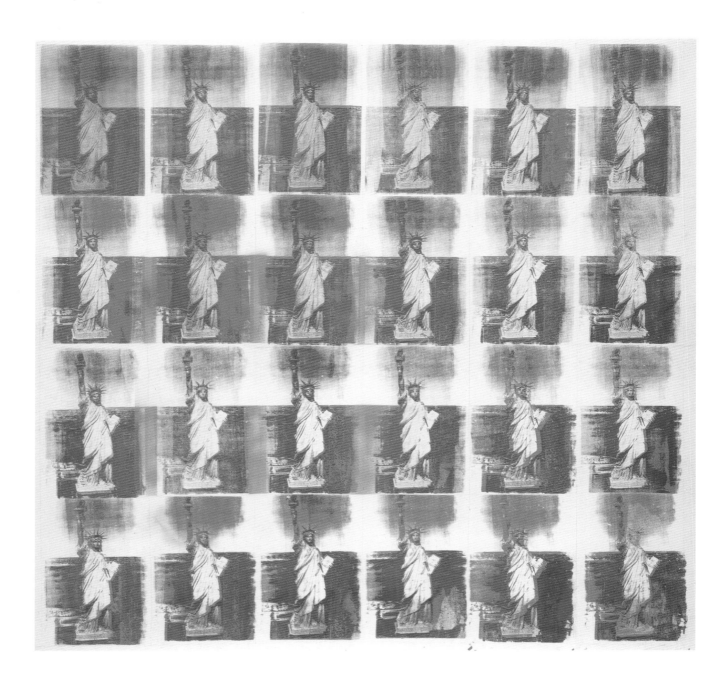

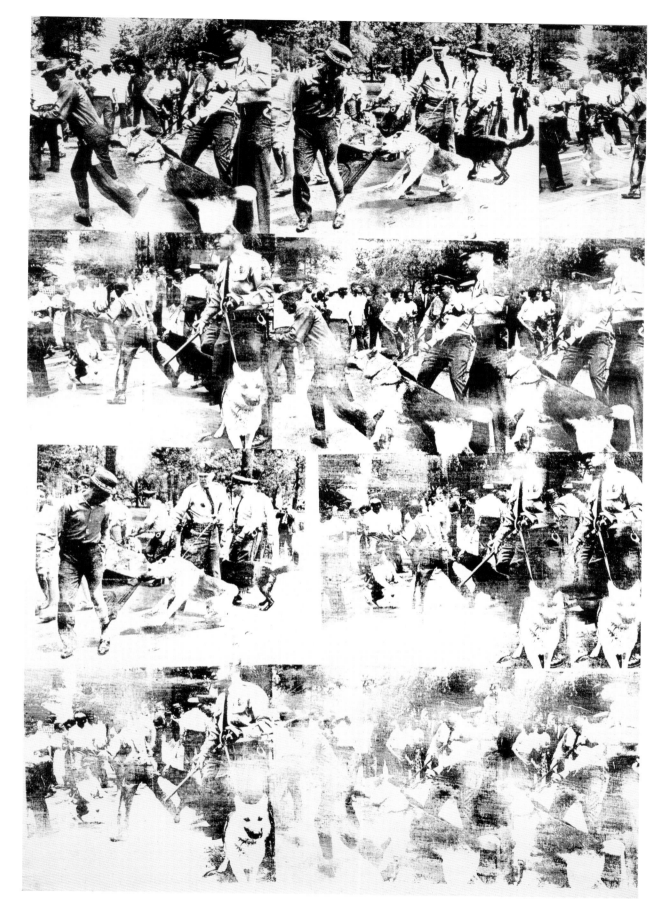

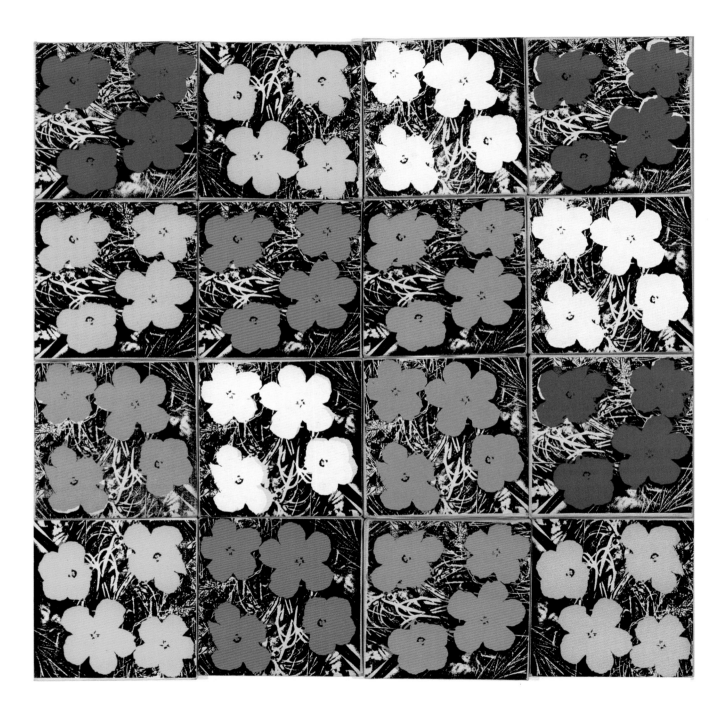

11. *Jackie (Gold)*, 1964

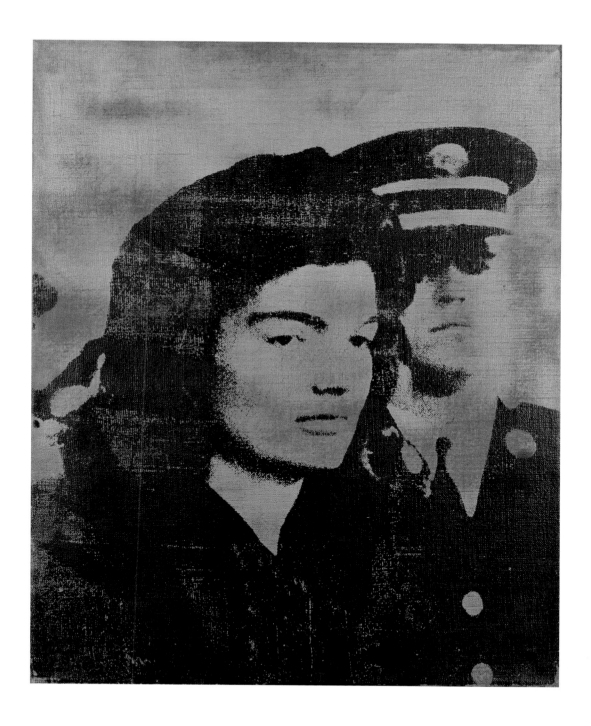

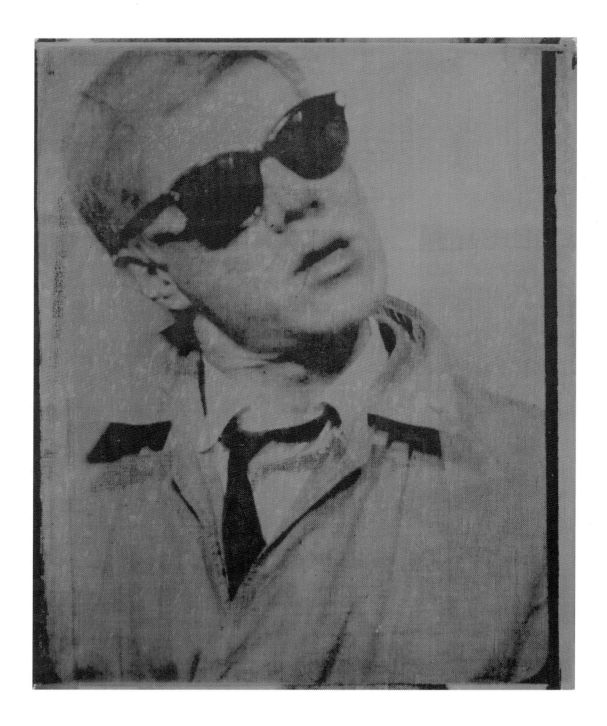

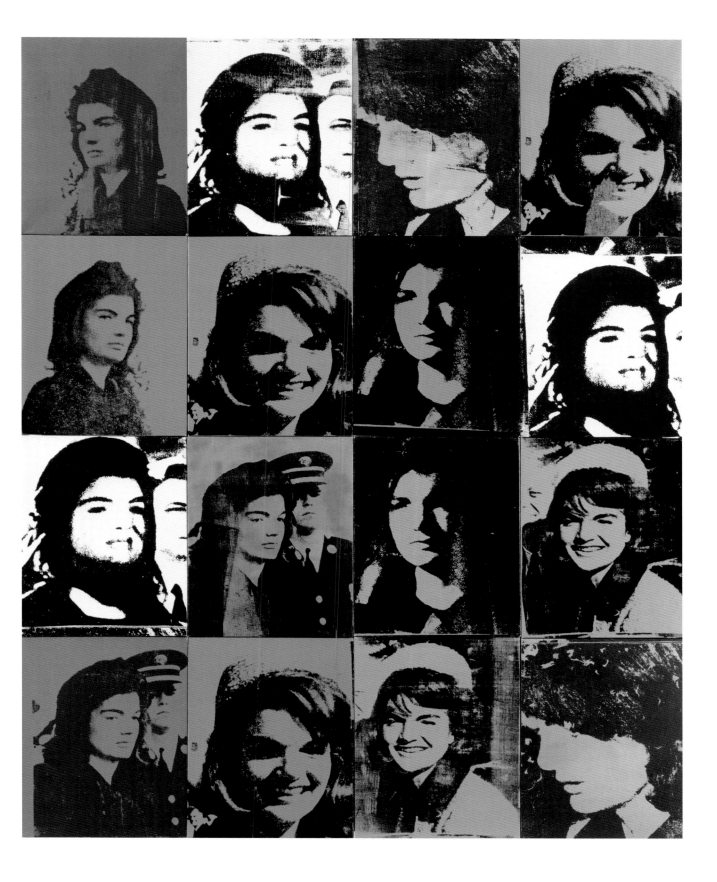

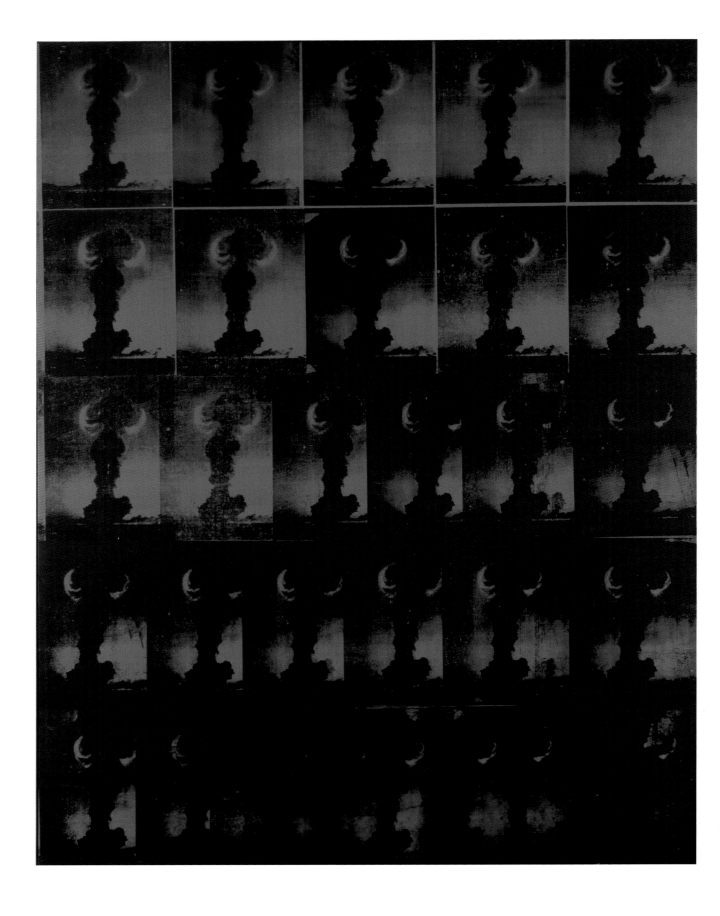

14. *Red Explosion*
(*Atomic Bomb*), 1965

15. *Big Electric Chair,* 1967

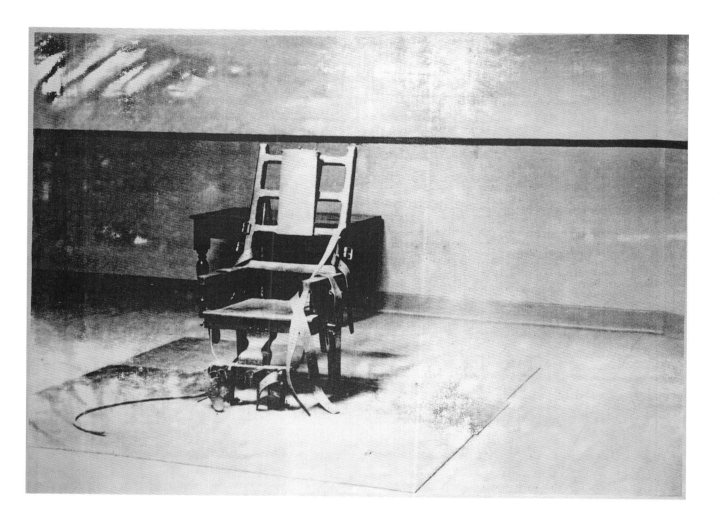

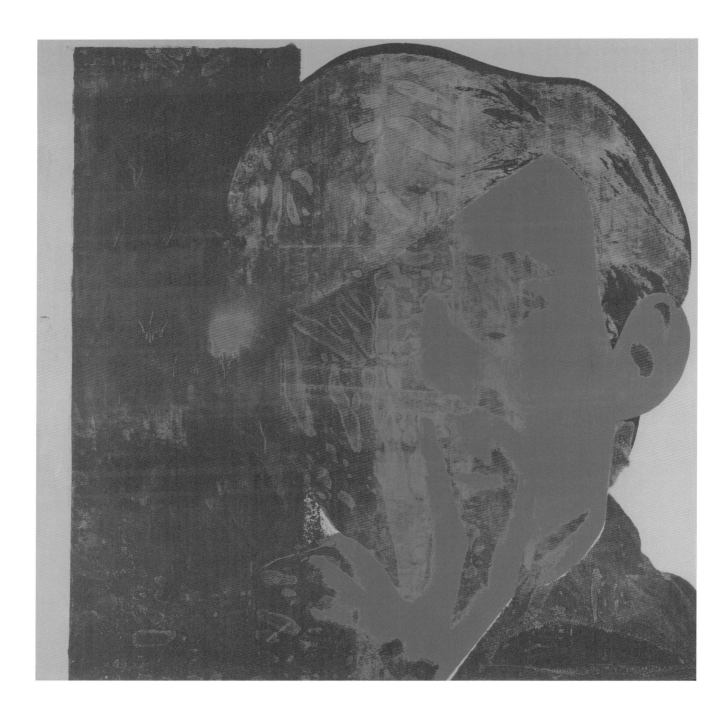

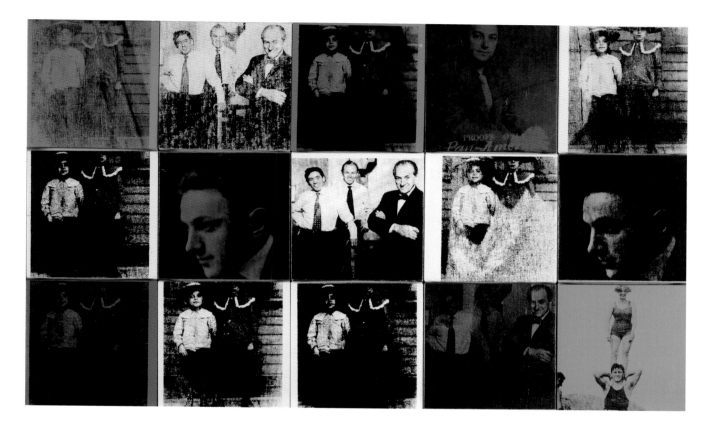

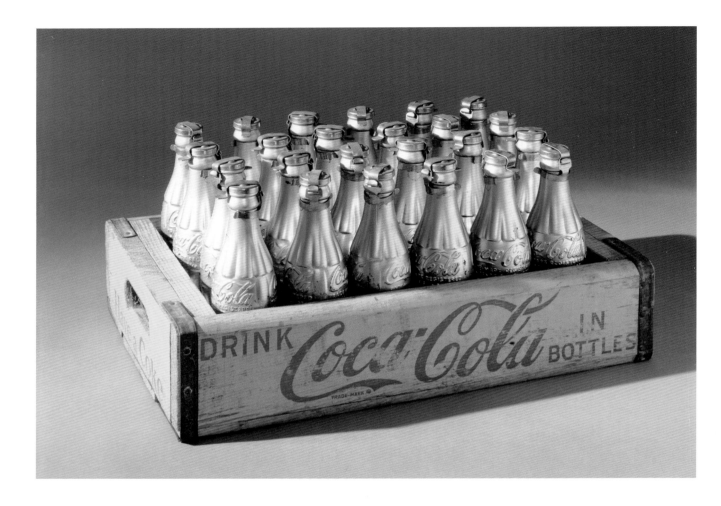

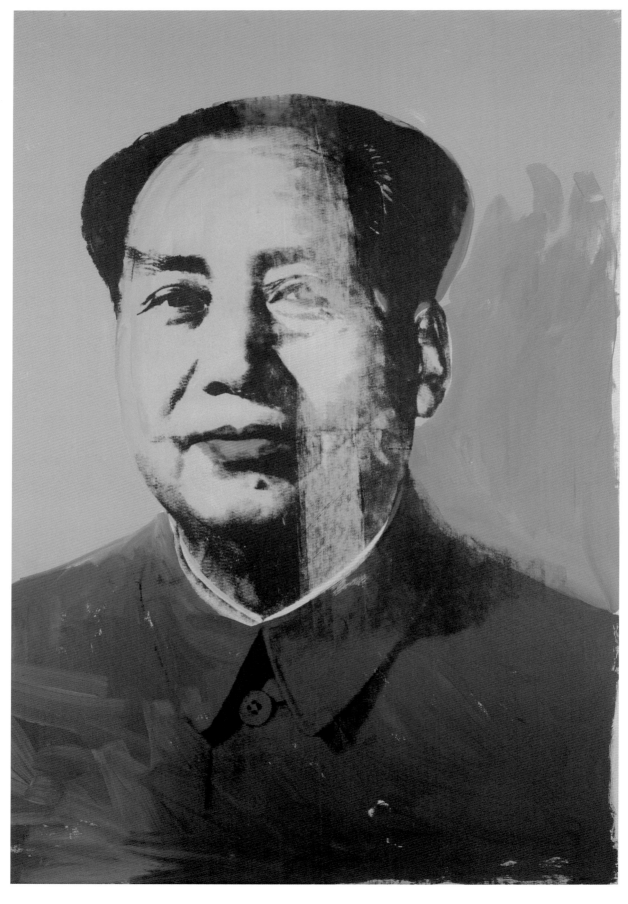

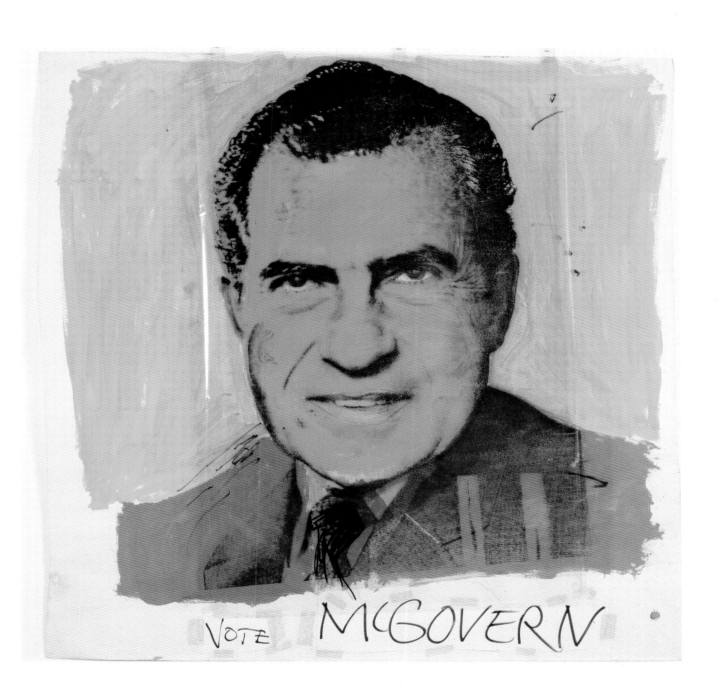

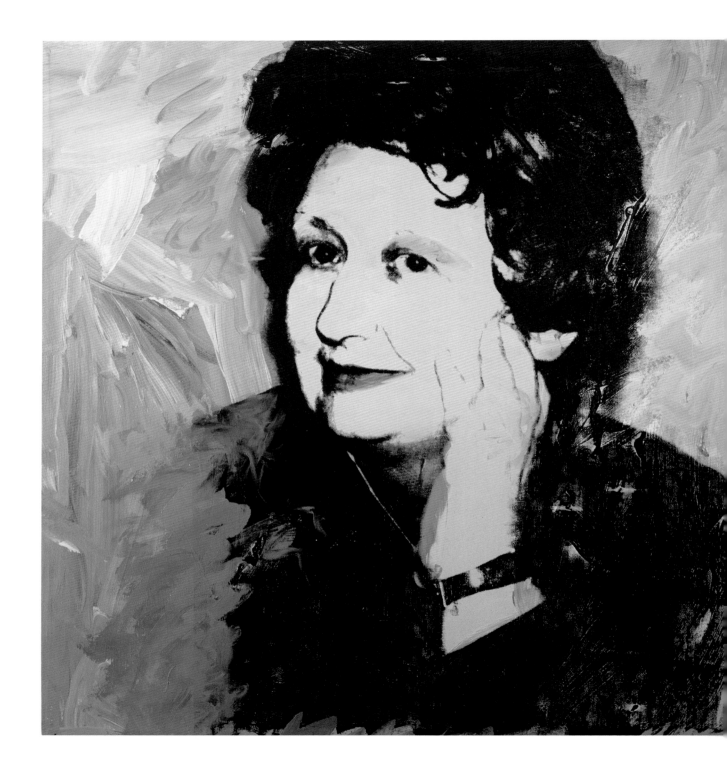

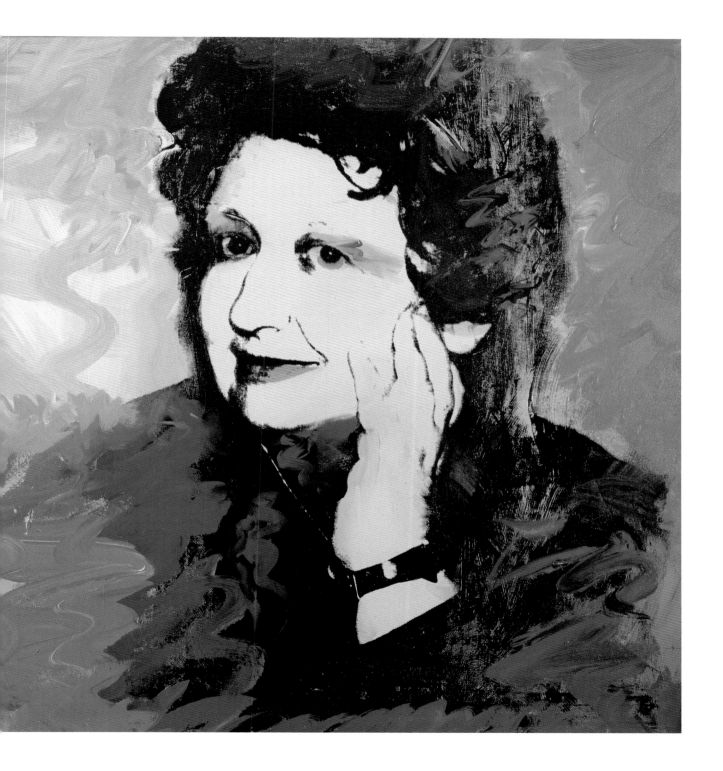

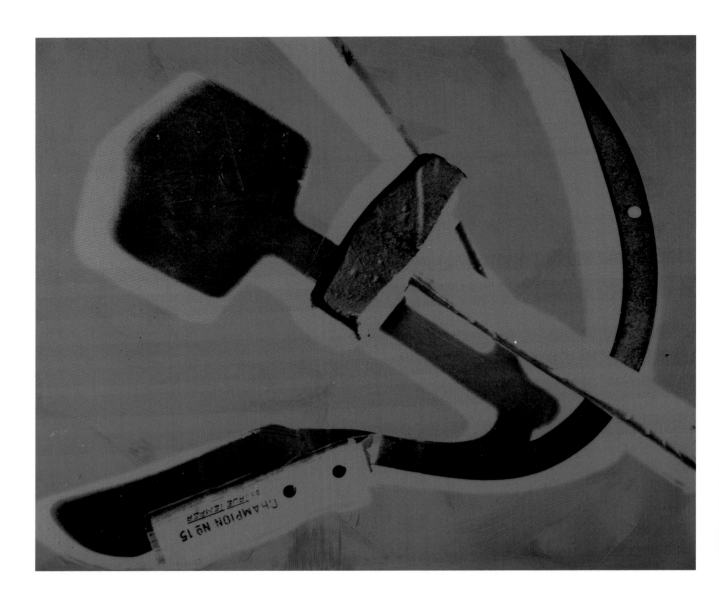

23. *Hammer and Sickle*, 1976

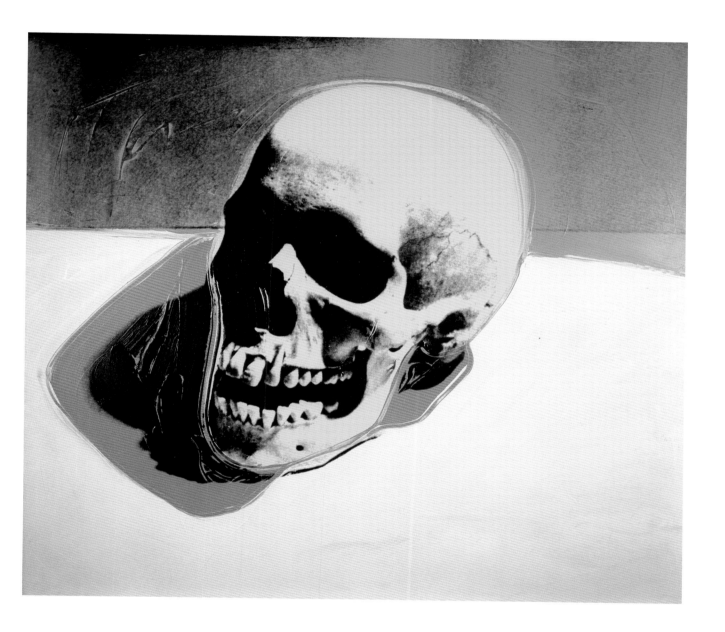

25. *Male Torso (Buttocks)*, 1977

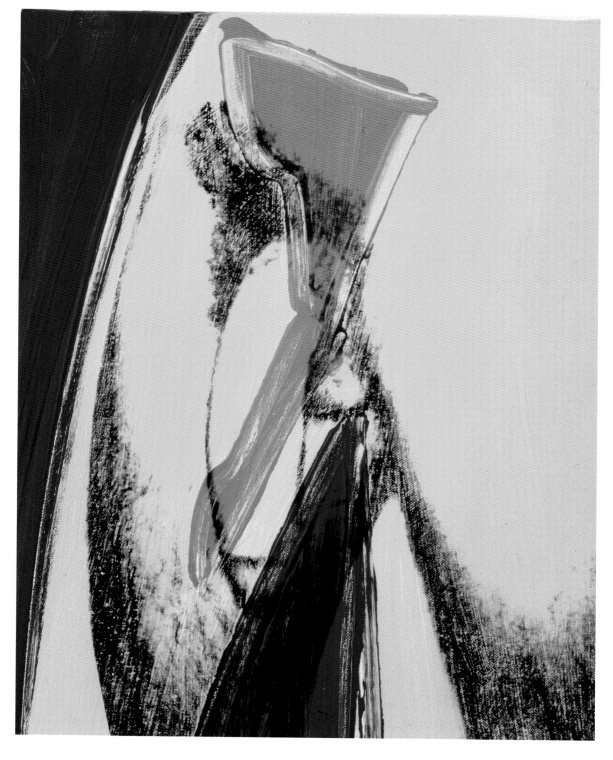

29. *Self-Portrait*, 1978 30. *Shadow Painting*, 1978

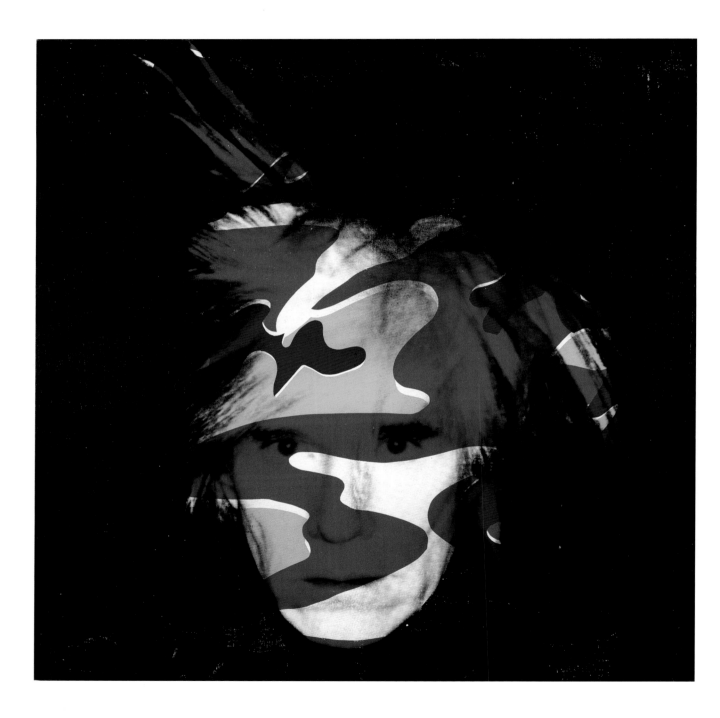

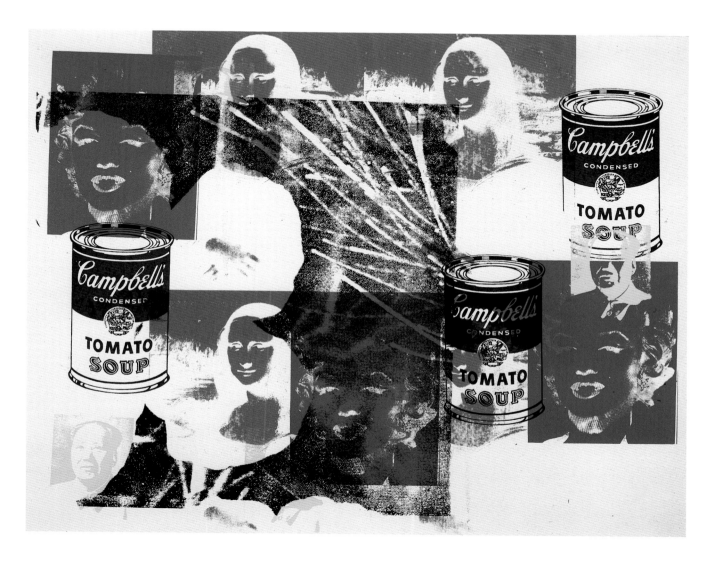

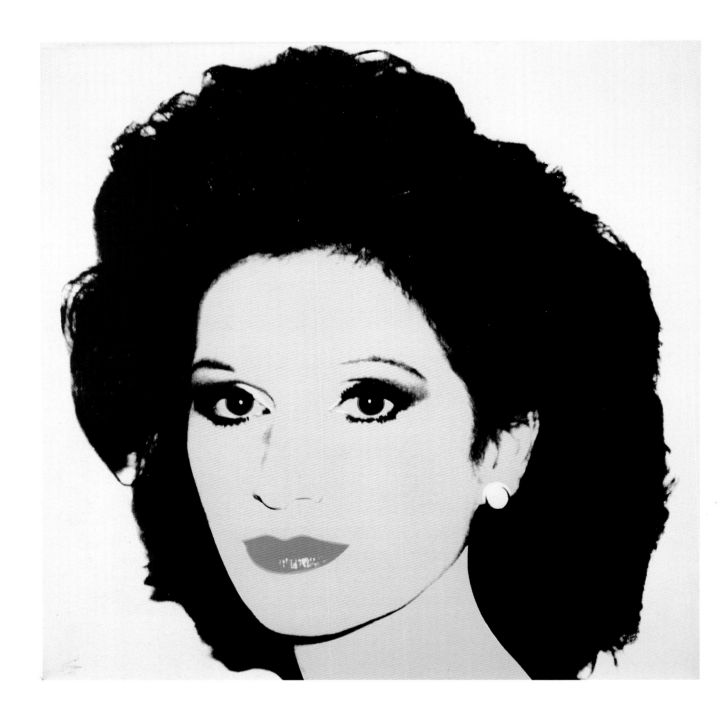

34. *The Portrait of an American*
Lady, 1979–1980

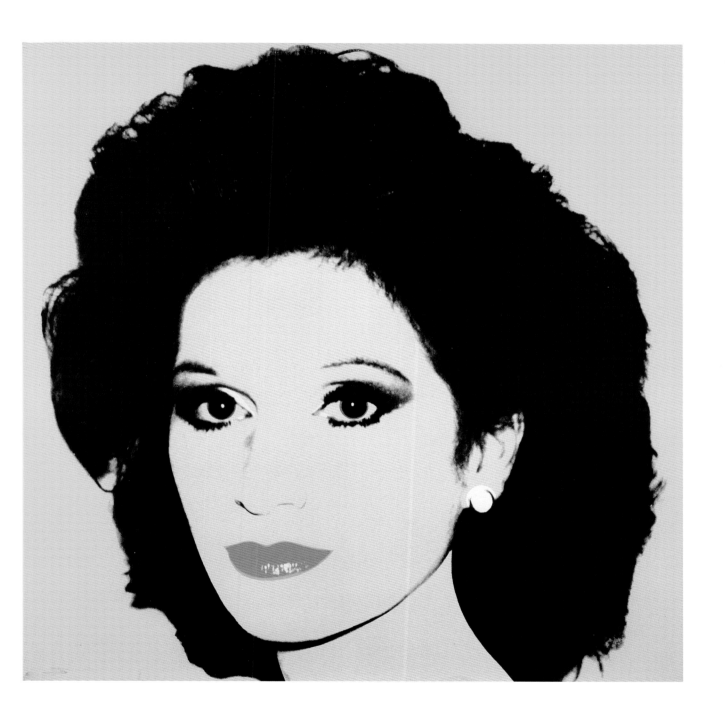

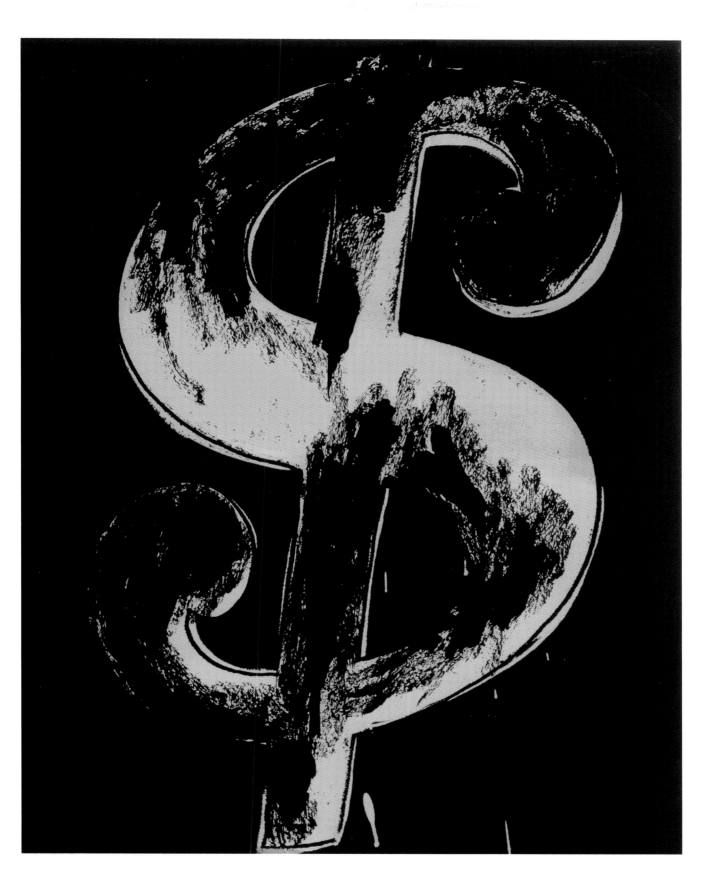

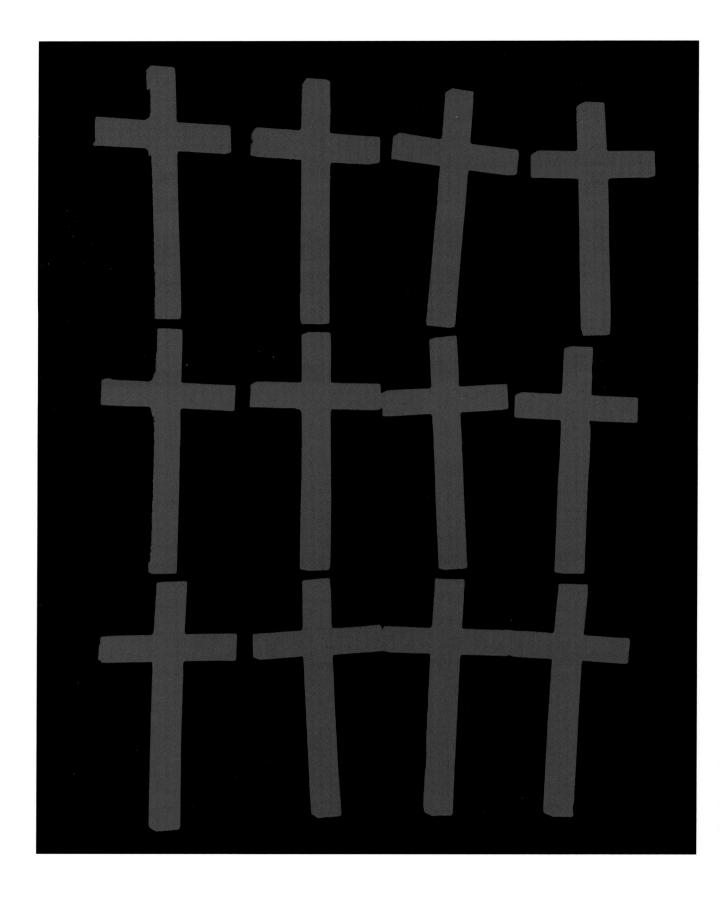

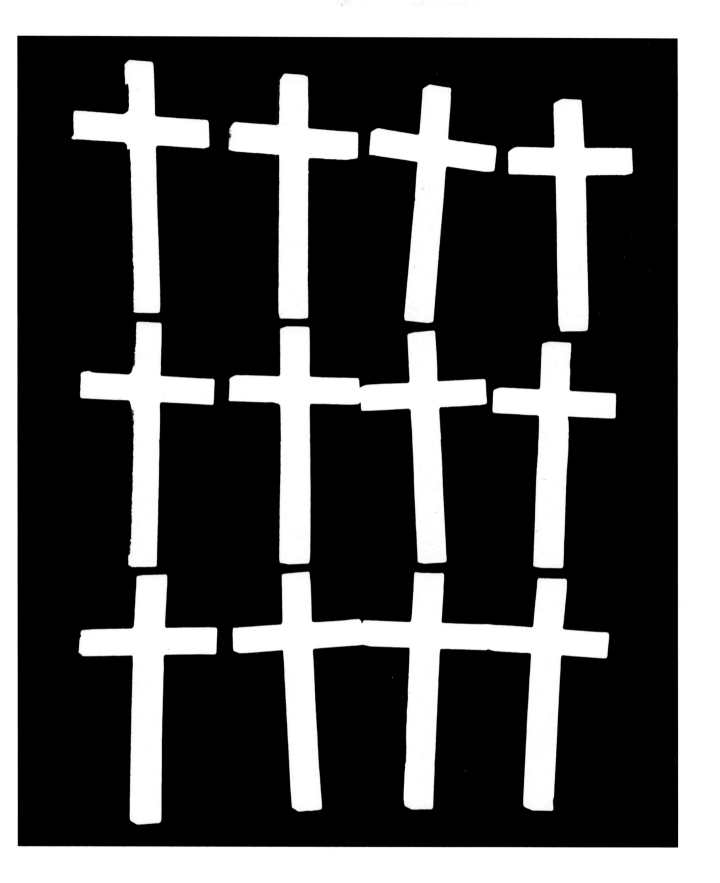

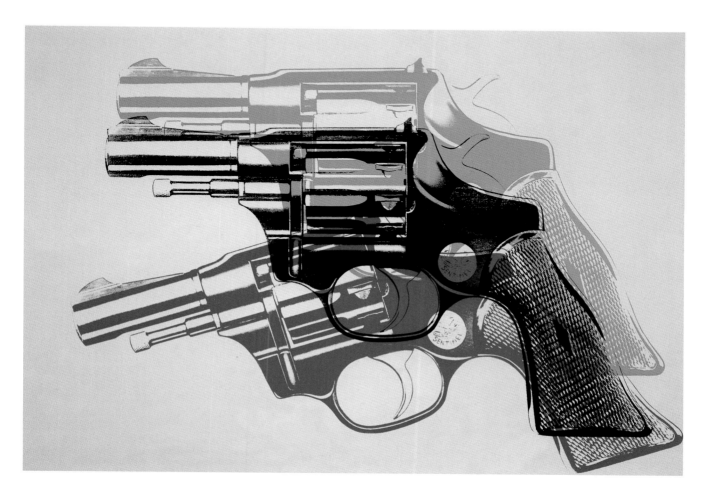

41. *Crown Princess Sonja of Norway*, 1982

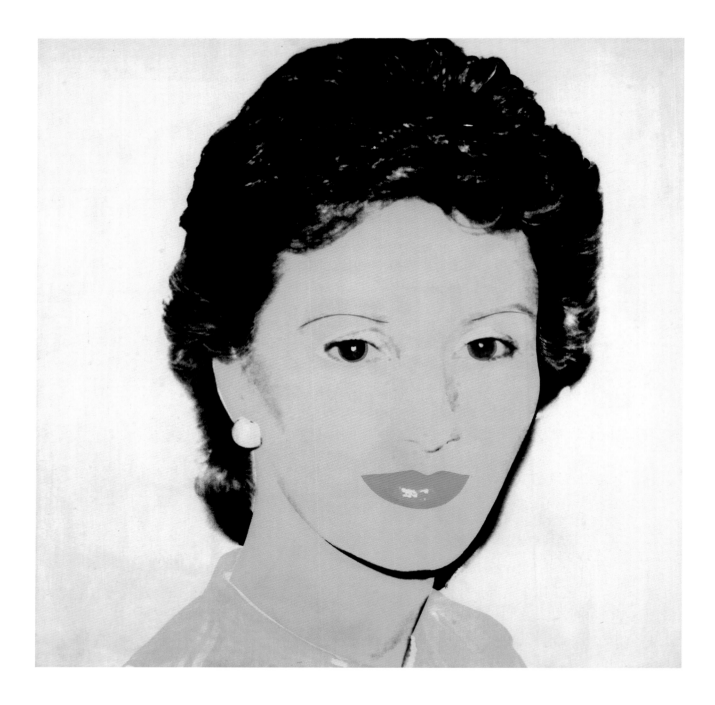

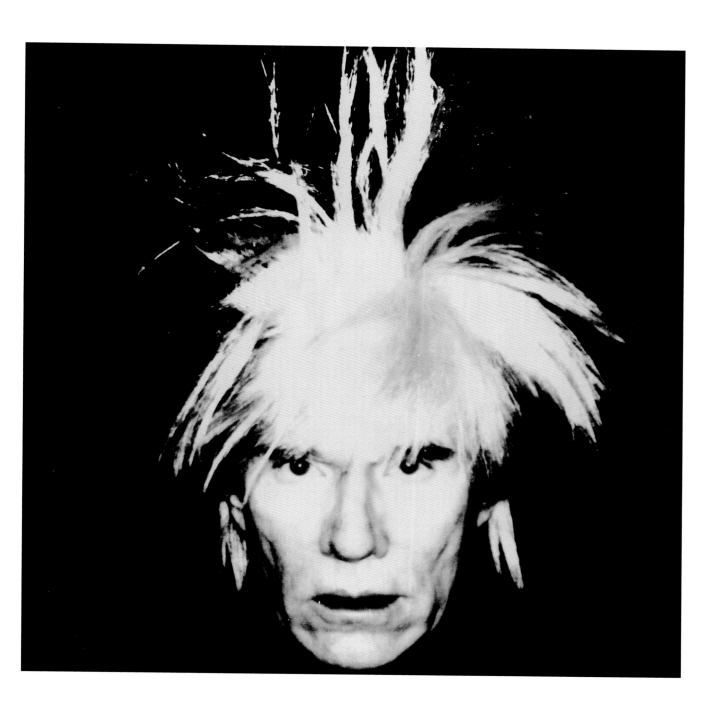

43. *Self-Portrait with Skeleton
Arm and Madonna*, 1984

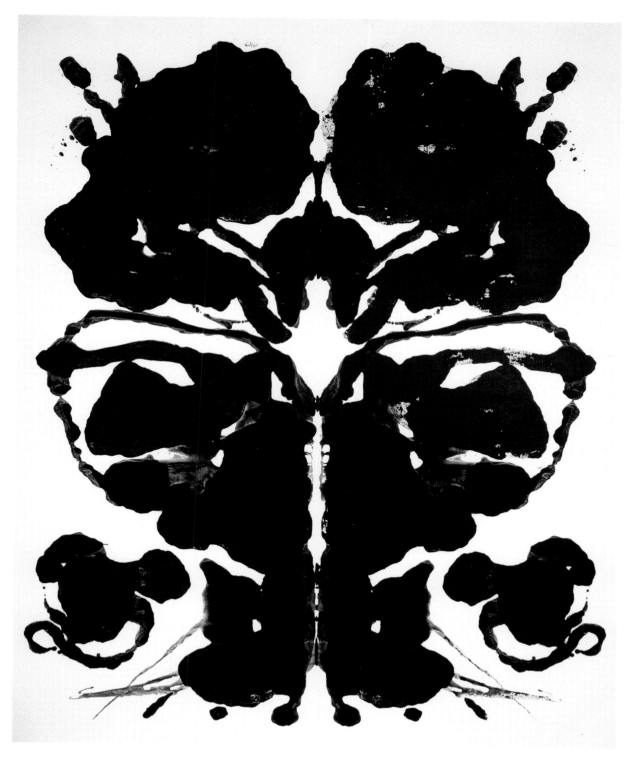

45. Andy Warhol T.V.
Productions
*Andy Warhol's T.V.
on Saturday Night Live*, 1981
© 2008 The Andy Warhol
Museum, Pittsburgh, PA,
a museum of Carnegie
Institute. All rights reserved
Still courtesy of The
Andy Warhol Museum

46. Andy Warhol
The Chelsea Girls, 1966
© 2008 The Andy Warhol
Museum, Pittsburgh, PA,
a museum of Carnegie
Institute. All rights reserved
Still courtesy of The
Andy Warhol Museum

47. Andy Warhol
*Andy Warhol's Fifteen Minutes
[episode 3]*, 1987
© 2008 The Andy Warhol
Museum, Pittsburgh, PA,
a museum of Carnegie
Institute. All rights reserved
Still courtesy of The
Andy Warhol Museum

48. Andy Warhol
Blow Job, 1964
© 2008 The Andy Warhol
Museum, Pittsburgh, PA,
a museum of Carnegie
Institute. All rights reserved
Still courtesy of The
Andy Warhol Museum

49. Andy Warhol
Couch, 1965
© 2008 The Andy Warhol
Museum, Pittsburgh, PA,
a museum of Carnegie
Institute. All rights reserved
Still courtesy of The
Andy Warhol Museum

50. Andy Warhol
Empire, 1964
© 2008 The Andy Warhol
Museum, Pittsburgh, PA,
a museum of Carnegie
Institute. All rights reserved
Still courtesy of The
Andy Warhol Museum

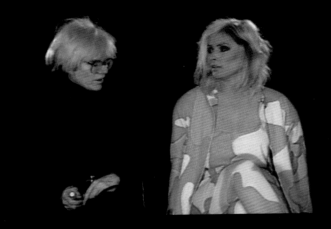

51. Andy Warhol
Haircut (No. 1), 1963
© 2008 The Andy Warhol
Museum, Pittsburgh, PA,
a museum of Carnegie
Institute. All rights reserved
Still courtesy of The
Andy Warhol Museum

52. Andy Warhol
Harlot, 1964
© 2008 The Andy Warhol
Museum, Pittsburgh, PA,
a museum of Carnegie
Institute. All rights reserved
Still courtesy of The
Andy Warhol Museum

53. Andy Warhol
Kiss, 1963
© 2008 The Andy Warhol
Museum, Pittsburgh, PA,
a museum of Carnegie
Institute. All rights reserved
Still courtesy of The
Andy Warhol Museum

54. Andy Warhol
Lonesome Cowboys,
1967–1968
© 2008 The Andy Warhol
Museum, Pittsburgh, PA,
a museum of Carnegie
Institute. All rights reserved
Still courtesy of The
Andy Warhol Museum

55. Andy Warhol
Poor Little Rich Girl, 1965
© 2008 The Andy Warhol
Museum, Pittsburgh, PA,
a museum of Carnegie
Institute. All rights reserved
Still courtesy of The
Andy Warhol Museum

56. Andy Warhol
Screen Test #2, 1965
© 2008 The Andy Warhol
Museum, Pittsburgh, PA,
a museum of Carnegie
Institute. All rights reserved
Still courtesy of The
Andy Warhol Museum

57. Andy Warhol
Sleep, 1963
© 2008 The Andy Warhol
Museum, Pittsburgh, PA,
a museum of Carnegie
Institute. All rights reserved
Still courtesy of The
Andy Warhol Museum

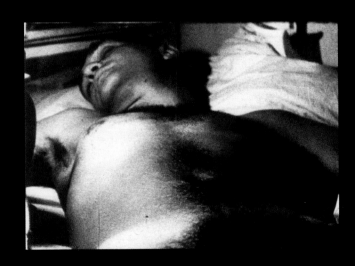

List of Works

1
210 Coca Cola Bottles, 1962
Silkscreen ink, acrylic
and pencil on linen
208 x 267 cm
Daros Collection, Zurich

2
*Campbell's Soup Can
(Turkey Noodle)*, 1962
Silkscreen on canvas
50.96 x 40.64 cm
Sonnabend Collection, New York

3
*Campbell's Soup Can
(Tomato)*, 1962
Casein, metallic paint
and pencil on linen
50.96 x 40.64 cm
Sonnabend Collection, New York

4
Dollar Bill, 1962
Silkscreen on canvas
50.8 x 40.64 cm
Sonnabend Collection, New York

5
Mona Lisa, 1963
Acrylic and silkscreen on canvas
111.8 x 73.7 cm
Metropolitan Museum of Art,
New York, Gift of Henry
Geldzahler, 1965

6
Blue Liz as Cleopatra, 1963
Acrylic silkscreen ink and pencil
on linen
208 x 161.5 cm
Daros Collection, Zurich

7
Merce Cunningham, 1963
Silkscreen ink on linen
68.5 x 48 cm
Private Collection

8
Statue of Liberty, 1963
Silkscreen ink and pencil on linen
198 x 205 cm
Daros Collection, Zurich

9
Race Riot, 1963
Silkscreen ink on linen
307 x 210 cm
Daros Collection, Zurich

10
Flowers, 1964
16 silkscreens on canvas
90.8 x 90.8 cm
16 canvases in one frame,
20.32 x 20.32 cm each
Sonnabend Collection, New York

11
Jackie (Gold), 1964
Silkscreen on canvas
51 x 41 cm
Sonnabend Collection, New York

12
Self-Portrait, 1964
Acrylic and silkscreen
ink on linen
50.8 x 40.6 cm
Courtesy The Stephanie
and Peter Brant Foundation,
Greenwich, Connecticut

13
Sixteen Jackies, 1964
Silkscreen ink on synthetic
polymer paint on canvas
16 panels, 50.8 x 40.64 cm each
Courtesy The Stephanie
and Peter Brant Foundation,
Greenwich, Connecticut

14
Red Explosion (Atomic Bomb),
1965
Silkscreen ink and acrylic
on linen
264 x 204 cm
Daros Collection, Zurich

15
Big Electric Chair, 1967
Silkscreen on canvas
137.2 x 188 cm
Astrup Fearnley Collection, Oslo

16
Self-Portrait, 1967
183.2 x 183.2 cm
Tate, London

17
Sidney Janis, 1967
Synthetic polymer paint
and silkscreen ink on canvas
61 x 102 cm
Private Collection

18
Silver Coke Bottles, 1967
Silver paint on 24 glass Coke
bottles in wooden crate
20.96 x 46.36 x 29.53 cm
Private Collection

19
Dominique de Menil, 1969
Silkscreen on canvas
121.9 x 121.9 cm
Astrup Fearnley Collection, Oslo

20
Mao, 1972
Silkscreen, pencil and acrylic
on primed canvas
208 x 142 cm
Froehlich Collection, Stuttgart

21
Vote McGovern, 1972
Screen print on acetate and
synthetic polymer and collage
on manila paper
107.32 x 107.32 cm
Courtesy The Stephanie
and Peter Brant Foundation,
Greenwich, Connecticut

22
Ileana Sonnabend, 1973
Acrylic and silkscreen on canvas
102 x 203 cm
Sonnabend Collection, New York

23
Hammer and Sickle, 1976
Acrylic and silkscreen on canvas
182.9 x 218.4 cm
Astrup Fearnley Collection, Oslo

24
Skull, 1976
Silkscreen and acrylic
on primed canvas
183.5 x 203.8 cm
Froehlich Collection, Stuttgart

25
Male Torso (Buttocks), 1977
Synthetic polymer paint
and silkscreen ink on canvas
Triptych, 81.3 x 66 cm each panel
Sonnabend Collection, New York

26
Male Torso (Genitals), 1977
Synthetic polymer paint
and silkscreen ink on canvas
36 x 28 cm
Sonnabend Collection, New York

27
Male Torso (Genitals), 1977
Synthetic polymer paint
and silkscreen ink on canvas
36 x 28 cm
Sonnabend Collection, New York

28
Oxidation Painting, 1978
Mixed media on copper,
metallic paint on canvas
198 x 528 cm
Collection Bruno Bischofberger,
Zurich

29
Self-Portrait, 1978
Synthetic polymer paint
and silkscreen ink/canvas
101.6 x 101.6 cm
Private Collection
Courtesy Jablonka Galerie,
Cologne/Berlin

30
Shadow Painting, 1978
Silkscreen and paint on canvas
192.8 x 132.3 cm
Louisiana Museum for
Moderne Kunst, Humlebæk

31
Shadows, 1978
Acrylic and synthetic polymer
paint and silkscreen ink
on canvas
197 x 127 cm
Private Collection

32
Multicolored Retrospective, 1979
Acrylic and silkscreen on canvas
128 x 162 cm
Astrup Fearnley Collection, Oslo

33
*The Portrait of an American
Lady*, 1979–1980
Synthetic polymer paint
and silkscreen ink on canvas
101.6 x 101.6 cm
Sonnabend Collection, New York

34
*The Portrait of an American
Lady*, 1979–1980
Synthetic polymer paint
and silkscreen ink on canvas
101.6 x 101.6 cm
Sonnabend Collection, New York

35
Diamond Dust Shoes, 1980
Acrylic and silkscreen
and diamond dust on canvas
228.6 x 177.8 cm
Astrup Fearnley Collection, Oslo

36
Dollar Sign, 1981
Silkscreen ink, diamond dust and
synthetic polymer paint/canvas
228.6 x 177.8 cm
Private Collection
Courtesy Jablonka Galerie,
Cologne/Berlin

37
Crosses, c. 1981–1982
Synthetic polymer paint
and silkscreen ink/canvas
228 x 178cm
Private Collection
Courtesy Jablonka Galerie,
Cologne/Berlin

38
Crosses, c. 1981–1982
Synthetic polymer paint
and silkscreen ink/canvas
228 x 178cm
Private Collection
Courtesy Jablonka Galerie,
Cologne/Berlin

39
Duty Free, 1982
Synthetic polymer paint
and silkscreen ink/canvas
203 x 203 cm
Private Collection
Courtesy Jablonka Galerie,
Cologne/Berlin

40
Guns, 1982
Synthetic polymer and
silkscreen inks on canvas
142.2 x 203.2 cm
Astrup Fearnley Collection, Oslo

41
*Crown Princess Sonja
of Norway*, 1982
Acrylic and silkscreen
ink on canvas
101.6 x 101.6 cm
Astrup Fearnley Collection, Oslo

42
Self-Portrait (Fright Wig), 1984
Synthetic polymer paint and
silkscreen inks on canvas
203 x 203 cm
Astrup Fearnley Collection, Oslo

43
*Self-Portrait with Skeleton
Arm and Madonna*, 1984
Silkscreen on canvas
129 x 180 cm
Astrup Fearnley Collection, Oslo

44
Untitled (Rorschach Series), 1984
Synthetic polymer paint
and silkscreen inks on canvas
304 x 244 cm
Astrup Fearnley Collection, Oslo

45
Andy Warhol T.V. Productions
*Andy Warhol's T.V. on Saturday
Night Live*, 1981
1" videotape, color, sound,
3 segments, 1 minute each
© 2008 The Andy Warhol
Museum, Pittsburgh, PA, a
museum of Carnegie Institute.
All rights reserved
Still courtesy of The
Andy Warhol Museum

46
Andy Warhol
The Chelsea Girls, 1966
16mm film, black and white
and color, sound, 204 minutes
in double screen
© 2008 The Andy Warhol
Museum, Pittsburgh, PA, a
museum of Carnegie Institute.
All rights reserved
Still courtesy of The
Andy Warhol Museum

47
Andy Warhol
Andy Warhol's Fifteen Minutes
[episode 3], 1987
1" videotape, color, sound,
30 minutes
© 2008 The Andy Warhol
Museum, Pittsburgh, PA, a
museum of Carnegie Institute.
All rights reserved
Still courtesy of The
Andy Warhol Museum

48
Andy Warhol
Blow Job, 1964
16mm film, black and white,
silent, 41 minutes at 16 frames
per second
© 2008 The Andy Warhol
Museum, Pittsburgh, PA, a
museum of Carnegie Institute.
All rights reserved
Still courtesy of The
Andy Warhol Museum

49
Andy Warhol
Couch, 1965
16mm film, black and white,
silent, 58 minutes at 16 frames
per second
© 2008 The Andy Warhol
Museum, Pittsburgh, PA, a
museum of Carnegie Institute.
All rights reserved
Still courtesy of The
Andy Warhol Museum

50
Andy Warhol
Empire, 1964
16mm film, black and white,
silent, 8 hours 5 minutes at
16 frames per second
© 2008 The Andy Warhol
Museum, Pittsburgh, PA, a
museum of Carnegie Institute.
All rights reserved
Still courtesy of The
Andy Warhol Museum

51
Andy Warhol
Haircut (No. 1), 1963
16mm film, black and white,
silent, 27 minutes at 16 frames
per second
© 2008 The Andy Warhol
Museum, Pittsburgh, PA, a
museum of Carnegie Institute.
All rights reserved
Still courtesy of The
Andy Warhol Museum

52
Andy Warhol
Harlot, 1964
16mm film, black and white,
sound, 66 minutes
© 2008 The Andy Warhol
Museum, Pittsburgh, PA, a
museum of Carnegie Institute.
All rights reserved
Still courtesy of The
Andy Warhol Museum

53
Andy Warhol
Kiss, 1963
16mm film, black and white,
silent, 54 minutes at 16 frames
per second
© 2008 The Andy Warhol
Museum, Pittsburgh, PA, a
museum of Carnegie Institute.
All rights reserved
Still courtesy of The
Andy Warhol Museum

54
Andy Warhol
Lonesome Cowboys, 1967–1968
16mm film, color, sound,
109 minutes
© 2008 The Andy Warhol
Museum, Pittsburgh, PA, a
museum of Carnegie Institute.
All rights reserved
Still courtesy of The
Andy Warhol Museum

55
Andy Warhol
Poor Little Rich Girl, 1965
16mm film, black and white,
sound, 66 minutes
© 2008 The Andy Warhol
Museum, Pittsburgh, PA, a
museum of Carnegie Institute.
All rights reserved
Still courtesy of The
Andy Warhol Museum

56
Andy Warhol
Screen Test #2, 1965
16mm film, black and white,
sound, 66 minutes
© 2008 The Andy Warhol
Museum, Pittsburgh, PA, a
museum of Carnegie Institute.
All rights reserved
Still courtesy of The
Andy Warhol Museum

57
Andy Warhol
Sleep, 1963
16mm film, black and white,
silent, 5 hours 21 minutes
at 16 frames per second
© 2008 The Andy Warhol
Museum, Pittsburgh, PA, a
museum of Carnegie Institute.
All rights reserved
Still courtesy of The
Andy Warhol Museum

Biography

Fish Wallpaper, 1983
Screen print on wallpaper
Image, 106.7 x 71.1 cm each
Collection, The Andy Warhol
Museum, Pittsburgh

Andrew Warhola was born in Pittsburgh, Pennsylvania, on August 6, 1928. His parents, Ondrej [Andrew] Warhola (1888–1942) and Julia Zavacky Warhola (1892–1972), emigrated to the United States (Ondrej in 1912, Julia in 1921) from a village in the Prešov region of north-eastern Slovakia. He had two older brothers: Paul (b. 1922) and John (b. 1925). In 1936 he was diagnosed with St. Vitus's Dance, a nervous disorder, and had to spend weeks in bed, where his favorite occupation became coloring books and paper dolls. From 1942 to 1945 he attended Schenley High School and during most of junior and senior years he attended free Saturday-afternoon art classes at the Carnegie Museum of Art. He studied at the Carnegie Institute of Technology in Pittsburgh between 1945 and 1949, receiving a Bachelor of Fine Arts in Pictorial Design. In June 1949 he left Pittsburgh together with Philip Pearlstein to go to New York and establish himself as an artist, and during the first months in New York he changed his name to Andy Warhol. Throughout the 1950s Warhol achieved considerable commercial success as an illustrator. He started making silkscreen paintings in the early 1960s and was soon a recognized leader of the pop art movement.

His first experimental film was made in 1963, and throughout the 1960s, 1970s, and 1980s his paintings, films, and sculptures transformed the art world. Warhol is also known as an author, record producer, TV host, and model, and his studio, "the Factory," was an important meeting place for artists, filmmakers, actors, models, and musicians. Warhol exhibited extensively both in Europe and America throughout his life, and his works have been displayed in numerous major exhibitions around the world after his unexpected death on February 22, 1987.

Silver Clouds, 1966
Helium-filled metalized
plastic film (Scotchpak)
91.4 x 129.5 cm
Collection, The Andy Warhol
Museum, Pittsburgh

Cow Wallpaper (Pink on Yellow),
1966
Screen print on wallpaper
Image, 116.8 x 71.1 cm each
Collection, The Andy Warhol
Museum, Pittsburgh

Washington Monument
Wallpaper, 1974
Screen print on wallpaper
Image, 104.1 x 71.1 cm each
Collection, The Andy Warhol
Museum, Pittsburgh

Washington Monument

© Copyright Andy Warhol Enterprises Inc. 1974

Long Day's Journey into the Past

Gunnar B. Kvaran Speaks with Gerard Malanga

Gunnar B. Kvaran: First I would like to ask you where you come from and about your family background, social environment in your youth, and education.

Gerard Malanga: I was born and raised in the Bronx under modest circumstances. I was an only child. First-generation Italian-American. My mother was what you would call a homemaker; she took care of the household, did the shopping, cooked the meals. We lived in a one-bedroom apartment facing onto an alleyway. The neighborhood's social dynamic was Jewish, German, and Irish. An interesting mix.

My dad was a salesman, not your door-to-door type. He had his own private customers and sold on-time and would make the weekly rounds collecting down payments and taking new orders.

Sometimes he would take me along; it was his way of watching over me when my mom wanted me out of the house. There was a mutual trust he had with his customers. He specialized mostly in dry goods—sheets, pillow cases, slipcovers, etc. Some jewelry. It was a modest income but covered the bare essentials. The Bronx was a terrific place to grow up in. There was no crime to speak of. No drugs. No gangs.

Nothing like that. The neighborhood was cohesive. Nearly every day there was a man selling fruits and vegetables from a horse-drawn cart! We had local stores, bakeries, delicatessens, groceries where you could run up a bill and pay at the end of the week. Everyone trusted everyone. I made friends easily and we played street games like stick-ball and curb-ball, pitching cards and Johnny-on-the-Pony 1 2 3.

But sometimes I'd keep to myself. I was imaginative from an early age. We had this empty lot in the neighborhood where a building once stood and I would play king of the hill among the ruins. My parents would take turns taking me to the nearby parks. We had three close by—Poe Park, St. James Park, and the Bronx Botanical Gardens. Also, the Bronx Zoo, which I loved and where I think my love for animals grew. I attended the local public school, grades 1 through 6. P.S. 46 it was called but Edgar Allan Poe was its namesake. A century earlier he lived in a cottage literally three blocks up the hill from our apartment house. The cottage is now surrounded by a city park, Poe Park. So this was the first time I heard the word poet used, but I knew nothing about the man. There's an old snapshot of me taken by my dad in front of Poe's cottage. I always thought that maybe this photograph had cast my fate at age four.

GBK: Did you have some kind of artistic environment when you were brought up?

GM: Artist?!! The idea of an artist to my parents was nonexistent. If you had a talent for drawing—and I did—you became an art teacher. That's as far as they understood it. That was as far as it goes. During the time I was growing up there was literally not a book in our apartment to speak of. Well, a couple of children's books here and there. One book was Carlo Collodi's *Pinocchio*, as I recall. I still have that original copy, but that was it. Between the ages of ten and twelve were perhaps the most important and richest period in the development of my creative sensibility—the building blocks as it were—although I had no way at the time of knowing where it would lead me. I was always curious by nature and so spent a good deal of time after school hours at the local library, the Fordham Road branch, reading back issues of *LIFE* magazine and discovering books that filled my imagination. One book in particular, *Lives of the Liners* by Frank Braynard, was about the history of oceanliner travel and anticipated my interest in collecting steamship post cards; an interest which I still maintain. Ironically, I photographed Frank Braynard just about three years ago, so it was an important picture for me to make, simply it allowed me to reconnect with that part of my childhood that dazzled me as a kid. My other interest was in the movies. I'd spend weekends seeing what in those days were called double-bills. The A movie and the B movie. I saw the first CinemaScope and the first VistaVision movies ever screened when they first came out. I saw *The Blob* when it was first released and *Invasion of the Body Snatchers*, *Johnny Guitar*, and *Rebel Without a Cause* and many more. In wanting to know more about steamship post cards, I'd read somewhere that the New York Historical Society had a large collection on display, and so convinced my dad to take me to the museum one Sunday afternoon, and while we were there I wandered into one of the adjoining rooms and was confronted with what I could only characterize as my first artistic experience, a series of mammoth paintings called *The Course of Empire* by Thomas Cole. I was good at remembering names and so started reading as much as I could about him at the local library. I was—and still am—fascinated by transformation and change and that's what these paintings were all about. What in effect was happening is that I was acculturating myself through change itself but I couldn't know that; I didn't have a name for it. I could only feel it. Everything I did was based on an innate curiosity to want to know more about what I was seeing and feeling—as if a whole world was out there on the other side of this invisible mirror waiting to be explored.

GBK: Did you know some artists or did you go to museums or attend concerts or the theater?

GM: I was too young and certainly not aware of what artists were. My environment was not cultured, in any sense of the word, nor did I attend concerts or the theater. Whatever culture I had came from the streets, from comic books, from spending time at the local public library. I didn't know such a thing as a museum existed until I was in the sixth grade when one day the teacher announced we were going on what was called back then a "class trip" and we ended up visiting the Museum of Natural History. I might've been ten at the time. I think that was my first exposure to a museum or what a museum was. I wasn't so much interested in the museum as much as the trip itself proved exciting. Just that I was going somewhere outside my neighborhood for the first time without my parents. It was like exploring. When I was a kid I had this uncanny ability to be able to draw from memory. I'm not talking here about sunsets and trees and birds, but detailed renderings in pencil of things I'd seen in the streets like lampposts and subways and elevated trains. I was never any

good with figures, but I was a really good drawer. I had no initial source for this interest. It was pure imagination. As I said, we didn't have any serious books in the apartment. I kind of figured out one drawing wasn't enough to include all that I'd seen and so devised this plan of continuing the drawing from one sheet of paper to the next until I had a string of drawings lined up running nearly the length of the apartment from kitchen to bedroom. It was like a picture storybook I created for myself, except the stories were mostly invisible. They were in my head. I'd draw details of lampposts and elevated trains and cross-sections (again I didn't know the term back then) of the subway below ground. Everything was meticulous, faithful to the way my imagination remembered it. I think the source of all this was actually riding the El train and subway with my parents. By the time I was twelve I memorized every station on the "D" line which was closest to our apartment. But the 3rd Avenue El was the most fascinating of all. It ran all the way from the Bronx into lower Manhattan above ground. Here I could look through the window onto the tracks and into peoples' apartment windows. For me it was a joy ride, pure and simple. Well, my parents decided to enroll me in an arts and crafts class at the local YWCA after school let out. It was their way of keeping me out of trouble and off the streets and perhaps, too, to nurture my talent. The class usually started at around 3:30 most afternoons and ran for about 2 hours. There were maybe ten of us in the class. The YWCA was just two long blocks from my house, so it was easy to get to. It was in class that I discovered a black and white picture book of New York City depicting the city as I would soon discover from twenty years earlier. I could see the changes. The lampposts were slightly different and the cars and the clothes people were wearing, but not much else. This book—it was called *Metropolis*—peaked my imagination. Every time I'd come to class I'd go off in a corner somewhere and pour over it. When the class term was over I must've charmed the teacher into letting me have it and I still have it. It's become a talisman for everything that came after. It was one of two sources that I can honestly say started my interest in photography.

GBK: So how did you become interested in photography at such an early age?
GM: I'd been looking at pictures—all sorts of pictures—for as long as I could remember. The bound volumes of *LIFE* magazine I'd been thumbing through at my neighborhood library were an instant connection. There was this column in the *Sunday News* magazine section—it was called "Coloroto" as I recall—that I immediately went to when my dad brought the paper home. It was called *New York's Changing Scene*. It was a vertical 1/2 page column consisting of two photographs taken many years apart—as much as fifty years in some cases. The photos included captions and depicted a particular street or intersection in the city. What you had was the before-and-after shots. The photo from above was the before-photo. It was usually from the archives of the New York Historical Society. The photo at the bottom of the column was taken by a staff photographer from the newspaper and approximated or was as close as possible in camera angle from the one above. It was as recent as let's say 1953 or '54 which is when I was clipping these columns to make up scrapbooks. I might've done this for at least two years. I was fascinated by the transformation, the changes that had occurred between the two pictures and I must've realized the only way of preserving these changes was through photography. It was also a way of getting to see how my city once looked and how it looked in the present. These columns broadened my horizon as to the urban landscape and the geography that made up the city. In a way, it was a good learning tool. Also, at around this time, I discovered the picture book, *Metropolis*, which I've already mentioned. Together, these two sources would fully anticipate the pho-

tographer I would become. Well, just around Christmas '54, my parents gave me a Kodak Brownie Hawkeye camera. It was 2 1/4 format. You looked down into the viewfinder which was also square to compose the shot but it lacked any aperture or focus mechanisms. It was truly your first autofocus camera. So this was the camera that connected my eye to what I was actually seeing through this little black plastic box. Some of my earliest photos were of lampposts from a cat's eye view looking up. I look at the surviving shots now and they remind me of Moholy-Nagy. Wow! I was already way ahead of my time and I didn't even know it.

One day in early spring I'd read somewhere in a newspaper or it might've been announced on TV, that the 3rd Avenue El was discontinuing service and the city was going to tear it down. I was extremely saddened by the news, but I convinced my dad to accompany me so I could take pictures on the very last day, May 12 (1955), that the train was in service. After school let out at 3 o'clock, we headed down to the Fordham Road stop to catch the train downtown. We disembarked at 125th Street in East Harlem and I made my first picture of the station exterior at street-level. Then we ran up the stairs to catch the next train heading uptown not knowing it would officially be the very last train, closing down each station it left. Talk about timing! The train was packed with people heading home from work. It was the rush hour. We were in the third car, I believe, so I left my dad behind and scrambled to the front of the train where a few newspaper photographers had gathered with their big cameras and they saw me coming and made room for me to reach the front window where I had a good vantage and immediately started taking pictures. I had already shot the first picture, so I only had eleven left on the roll and I had to be extra careful as to what I wanted to shoot and I had a pretty good idea since I was thoroughly familiar with the route between 125th and 149th Streets—the most picturesque of all. The pictures turned out extremely well considering what an amateur camera could do. I had this idea, so six months later my dad and I returned on a Sunday morning to exactly the same area north of where the 125th Street station was and I shot a second roll of film of the El structure in a semi-dismantled state. Lucky for me, the ambience was all I needed to capture what I hoped was still remaining of the girders, trusses, and track. This second roll also proved successful and so I had innocently replicated the before-and-after shots I found so fascinating in the newspaper columns I was collecting. Sadly, I didn't continue with this pursuit. I took some shots of my parents in the apartment and also on a visit we made to the Catskills in winter but nothing much after that. Maybe I was distracted. Maybe I felt the camera was limiting. I clearly don't have an answer. What I do know in hindsight is that the seeds were planted for when I would pick up the camera again years later, and then I never stopped.

GBK: When did you begin to write poetry? What did you think initiated that practice?
GM: This is where it starts: a newspaper reporter named Thompson comes to interview the character Bernstein about what was purported to be Charles Foster Kane's last dying word, Rosebud; the windows behind him are drenched with rain. The lighting is low—and for about 15 seconds Bernstein slips into this state of reverie reflecting on a long bygone time, having seen a young girl on a ferry and wanting to talk to her but was too shy and then they part ways not saying a word and how he kept that moment with him for the rest of his life and here he's telling it for the first time to a stranger, equating that moment with the word Rosebud. The theme of having had something precious and then to lose it; sometimes we spend our entire lives trying to regain what we lost or what we never had. This was of course from *Citizen Kane*, which I happened to see one night as a rerun on television. It was 1954,

I believe. I was eleven. I knew nothing of the movie, its history, or Orson Welles; but I was mesmerized by what I saw even though it would take years to comprehend the complexity and simplicity of what this movie was about. I became an instant fan. *Citizen Kane* was part of a weekly program called "Million Dollar Movie" that was televised each night for an entire week and so for the whole week I was glued to the TV set. This scene that I've just described touched something deep within me. What was it? Was it my soul? It certainly seemed in retrospect to be an epiphany. But I had no way of knowing or articulating what I felt. Yet I truly believe that these few fleeting seconds of grainy black and white anticipated my becoming a poet five years later. How do I know this? Call it an awakening. I felt connected with myself for the first time. So now it's five years later. I hadn't given thought to *Citizen Kane* for some time. I'm a senior in high school. The teacher in my English class was Miss Daisy Aldan, a poet and translator of French, and she opened up the world of poetry for me and I knew from the start that's what I wanted to do, that's what I wanted to be. I felt blessed somehow and that my guardian angel had guided me to this decisive moment—it could've happened differently. I could've had a different teacher that last year. There were several and I didn't really know one from the other when I signed up.

A roll of the dice, so to speak. It's like the razor's edge.

You take a turn in your life one way or the other and you're fated by that choice. What I'm saying is I can't imagine having done anything else in my life except being a poet. That's the honest-to-God truth; that's the scary part, as if a part of me was left back there somewhere in the darkness. A part of me died. A part of me survived.

GBK: Which poets were you reading as a young poet? What kind of poetry was an inspiration for you in those days?

GM: It was a long time ago, so my memory may be a bit fuzzy. I know that Daisy introduced me to Angel Flores's groundbreaking *Anchor Anthology* of French symbolist poetry in which she had several translations, including the first appearance ever of Mallarmé's *Un coup de des*. I also read numerous critical texts covering the French surrealists, including Anna Balakian and Wallace Fowlie. I was sixteen, seventeen at the time. I wrote my term paper on the Comte de Lautreamont and Daisy gave me an A. I was also reading a lot of Auden at the time which continued for a couple of years at least after I'd graduated from high school in 1960. He seemed fairly accessible to me for someone whose poems were fairly complex. What made the big impression which turned my head around were these two anthologies edited by Oscar Williams, *New Poems 1940* and *The War Poets* which was published five years later. They belonged to Willard Maas, my mentor and English teacher in college, and I would pour over them every time I went out to Brooklyn to visit, and I have them now right by my bedside. They contained an abundance of both British and American poets, including Auden. One poet who appeared in both books really stood out. Ben Maddow was his name. He had this long poem called *The City* with these sweeping long lines. There was hardly anything to know about him from his biographical note. He remained a total mystery to me but someone I was ever curious about. It would be several years later: one night Allen Ginsberg, Barbara Rubin, and I were out on an all-night binge—the dawn patrol I called it—when Ben's name came up. Allen said to me over coffee in an all-night diner that *The City* had been a main influence in his writing parts of *Howl* which was just another of the things Allen and I had in common, and then as it turned out, Charles Henri Ford, another close friend at the time, had actually known Maddow and was in correspondence with him. It would be many years later that Ben and I became good

friends and I visited him where he lived in L.A. He honored our friendship with an essay he wrote, *Acts of Friendship*, which introduced my first book of photos, *Resistance to Memory*. With the exception of Auden and Maddow, I can't say there was any one specific poet who was an influence on my early work. Of course, John Ashbery figures in a bit later.

Certainly from '63 on. But that's another story. You have to understand, I was only seventeen, eighteen, nineteen at the time. I still had my parents' home to return to, but many times I was homeless, crashing here and there on a friend's couch. So it's amazing I kept my dream alive wanting to be a poet and the important thing was I was reading voraciously anything that caught my eye. But being a poet without a voice of my own was a tricky tightrope to walk. I still had so much to learn, but luckily for me the passion and curiosity gave me the strength to keep going.

GBK: I was wondering what you did after having graduated from high school in 1960?

GM: First off, I must say that although Daisy was extremely encouraging with my new-found talent, she didn't want to press too far. She wanted to see how serious I was, whether I would continue with the poetry, or like so many of her other students, drift off into the everyday world of reality and work. I guess you can say I didn't fit the mold. It was good I was left on my own. I applied to two colleges, University of Cincinnati and the University of Florida in Fort Lauderdale to continue my studies in art and design. My major in high school was advertising and graphic design and I was accepted to both, but opted for Cincinnati because a high school buddy, Bob Schumaker, was heading out that way and I felt more secure tagging along. In the meantime, it was the beginning of summer and I needed to get a job fast. Daisy spoke with a former student from years past, Leon Hecht, a textile designer with his own company that made men's ties, Sun Fabrics, and he hired me for June and July. I reported for work at the factory that silkscreened the fabric and worked as assistant to this textile chemist, Charles Singer, who showed me every step of the silkscreen process. One of his responsibilities was mixing the powdered dyes into liquid. The screens were already made so all we had to do was move the screen by hand down 30 yards of pre-striped fabric rolled out on this long wooden table. Charles and I would be facing each other over the table moving the screen from one section to the next until the entire roll was screened. Since the dyes were water-based the screen was pretty simple to clean. I'd place a screen in this big metal sink and hose it down with water until not a speck was left and then I'd let it dry. The patterns we screened were basically repros of old engravings like airplanes and cannons and sailing ships. Things like that. We'd use one color or it was your basic black and the pre-striped colors combined caught your eye. The ties were quite trendy and unique for the kinds of men's fashion out there at the time.

Needless to say, Leon was already a very successful and gifted designer. Your so-called self-made man. That was the very beginning of how I learned to handle a screen. Summer was now coming to an end and I would shortly hop a train with Bob out to Cincinnati. It would be a whole new world for this kid from the Bronx. You know, some people find out important things about themselves early in life; some don't. I guess I was lucky. Being a poet was what I wanted to be, but I also took on responsibilities that were seemingly un-related, but I simply enjoyed what I was doing. I had no way of knowing that the skills and knowledge I acquired early on would serve me well later.

GBK: So you went out to Cincinnati. How was your first year at university?

GM: As a city, Cincinnati was a very lonely place as I would soon find out and the univer-

sity compounded that feeling. The school was overwhelming; I mean it was big and straight-laced besides. As soon as Bob and I arrived he joined up and moved into a fraternity within the first week and I literally never saw him again. It's as if he'd been swallowed by a whale. I was virtually on my own and knew no one on campus. I didn't know where to turn, where to go. I felt like a waif. But I shortly started meeting students during suppertime at the Student Union. One student in particular, Susan Plummer, was extremely kind to me and basically took me under her wing and was like my social advisor. She was a sophomore and I think came from Cleveland. There was another student, Helen Tworkov, I got to know a little. As it turned out her father was Jack Tworkov, one of the leading abstract expressionist painters, but like a lot of the students I met at this time, I lost touch with them quickly. And being on a strict allowance didn't help much; it really limited how much I could do just to get around. My dad was sending me $25 a week and even in 1960 that wasn't a whole lot to live on. But I made the best of it. I had no other means of support and I'll tell you I can't even remember how I got through it all, but somehow I managed.

Letters were a very important morale booster for me. Daisy would be writing words of encouragement about my poetry and concerned for my social wellbeing, and for awhile to make extra change she let me sell copies of her anthology, *A New Folder*, on campus. That certainly didn't get very far! Then I had this idea to start a literary magazine and wrote a letter to Anaïs Nin whom I'd met in Daisy's creative writing class a year earlier, and she sent me a short story and a glowing letter of encouragement, but then I couldn't come up with the funding and for months felt terribly guilty and had to send back the story. So that project bit the dust fast. But Willard wrote me constantly, first berating me for going out to Cincinnati saying he could've gotten me a scholarship at Wagner College where he'd been teaching out on Staten Island. But his letters really sustained me—every week they'd keep coming and I wrote back. Partly inspired by his work as an avant-garde filmmaker, I joined the staff of the university film society and was able to curate a couple of programs. The first was a screening of *M* with Peter Lorre that went off well and the second program was a double-bill: *Los Olvidados*, a film I was curious about though I knew nothing of Luis Buñuel, its director, and Willard sent me a print of his movie, *Image in the Snow*, which was already acclaimed in avant-garde circles. The program caused such a sensation and some students accused me of showing pornography, so my involvement with the film society was quickly curtailed. I was only on campus for a few months and I already felt like an outcast. What to do next? I'd met this student, Mitch Bartlow, who as I recall had canary yellow hair and a very outgoing style. He was a couple of years older. He was majoring in interior design at the Department of Art and Design where I was taking classes also and we hit it off immediately. He showed me some of his sketches for interiors and I knew instantly he was head and shoulders above the rest in terms of talent. We were inseparable. I finally met someone who was a true friend and whose work I respected. He became a big influence on how I dressed. I shortened my trousers to just above the ankle. Sweaters that practically came down to my knees and I didn't wear socks, not even in winter. I became the campus beatnik. I stood out! Mitch invited me to his parents for Thanksgiving holiday. It was somewhere in the middle of nowhere in Ohio. We had to take a bus to get there. During this weekend he made portraits of me with his little 35mm camera and I still have the film. The pictures gave me a sense of what a poet should look like. I was certainly dreamy-eyed. Now I felt like I was a poet in the making. In the meantime, I was losing concentration and interest in my studies. I was having too much fun hanging out with Mitch and writing poetry and meeting people off-campus. One young poet I'd met was George Thompson who

was always reading his work aloud in one of the local cafes in Mount Eden, a bohemian-style neighborhood not far from the school. So it was encouraging to talk about each other's work and swap ideas. And then something happened during my second semester that was to have a major impact on my work at the time. Richard Eberhart, famous for his poem *The Groundhog*, a truly great poem, and whose work I was thoroughly familiar with from the *War Poets* anthology, was coming to campus for a couple of months as the university's annual poet-in-residence. I immediately seized the moment and arranged to interview him for the school newspaper and we struck up a rapport. For an eighteen-year-old, he was as close as I was ever going to get to the real thing. He'd known both Willard and Daisy's poetry and I must've given the impression I was well connected. I carried his book bag for him between classes and participated in a major way in his creative writing seminar and occasionally he'd take me out to dinner. We had great talks about poetry. When it was time for him to return to his home in New Hampshire we said we'd stay in touch and a lasting friendship ensued for many years after. By this time, however, my grades had taken a precipitous plunge and at the end of the spring semester I'd flunked out in every class except for Physics [*laughing*]. There was no way the school was going to let me back in. Surprisingly, my parents didn't take it all that badly. My dad at the onset thought one year of college was enough. I couldn't understand his attitude on all this. He didn't realize you had to go to school for four years to get a degree. It was summer 1961. I was back home, adrift of any prospects to know where to turn next. But flunking out of school was not going to stop me. I was writing poetry nonstop. That's all that mattered to me at the time. My head was in the clouds.

GBK: So you returned home. You had no idea what you were going to do with yourself. You were at a loss, I gather. Where do you go from here? What was happening with your poetry?

GM: It was like I hit rock bottom. It was certainly scary. The last thing I expected was to be back home with my folks, but I had no choice and had no immediate job prospects either. Everywhere I turned there was a blank. I even had a serious blow-out with Willard and so I didn't know when I'd see him again, if ever. I had these two friends from the neighborhood, Jerry Gelb and Jerry Torres. Together we formed a team—the three Jerrys. You might say, together we were the unemployed and incorrigible. Some days we'd hang out at a neighborhood park or head out to Orchard Beach. I definitely became what was called a beach bum in those days. We were a trio of daredevils. We were certainly leading a wayward existence. I rarely came home except for an occasional meal or change of clothes or a shower and then my mom would scream at me and I'd be back on the street. I kept all my writings and books at the apartment. So at least I knew they were safe. As summer was winding down I still had no prospects and whenever I was away from home for long periods of time I'd be crashing on someone's sofa in some out-of-the-way place, but I'd always let my mom know where I'd be or if I was on my way home. And then at some point I basically became unreachable. No one knew where to find me. Then one day I phoned home and my mom started screaming at me and calling me all sorts of names and saying Professor Maas—that's how she referred to Willard—was desperately trying to reach me, something about arranging for a scholarship so I could attend Wagner College. I found this utterly astounding since I didn't exactly part ways with Willard on a happy note, but when I phoned, he started reprimanding me for my lack of consideration and whatnot and said that classes at Wagner had started a week past and how he had gotten this fellowship for me and then couldn't

find me and I'd have to start classes a week late and how I'd better straighten out or he'd never ever talk to me again. So now here I am back in school where I didn't expect to be. I believe, every time something happens, it's a learning moment. OK. My life gets turned around without my even knowing it. It's like I'm given this second chance. So the arrangement is, Willard secures this fellowship from an anonymous donor to further my creative writing with the proviso that if I get top grades the college is then obligated to give me a full scholarship, but the caveat is I have to start over as a freshman because that first year in Cincinnati no longer counts. So I keep the promise and get through my classes with top grades and am placed on the Honor Roll and as summer '62 is coming around, Willard is directing the New York City Writers Conference on the Wagner campus and I get invited to be featured in a prominent way. This is an auspicious moment for my work as a poet, since I had only just published a few poems in the *Wagner Literary Magazine*, which, however, was considered the most distinguished college literary journal in America. Everything was just happening so fast for me to keep up.

GBK: So how did you fit in at the Writers Conference? How was your work advancing?

GM: Well, just prior to the Writers Conference my work appeared for the very first time in a prominent literary journal, *Chelsea Review*. Let me tell you that was a big deal. Lots of people see the magazine and this followed with a number of other publications, including *Locus Solus*, which Kenneth Koch, Harry Mathews, Jimmy Schuyler, and John Ashbery edited, and *The Minnesota Review*. All through this time I'd been writing at a feverish pitch. The Writers Conference was essentially structured as three separate workshops centered on poetry, playwriting, and fiction. This was the Conference's second summer; I'd been a student in the poetry workshop the year previous taught by Robert Lowell.

This year, however, some changes had been made and besides Kay Boyle for fiction and Edward Albee for playwriting, the poetry section was being taught by Kenneth Koch. During the weeklong festivities of film programs, readings, panel discussions, and parties, I was included on this panel moderated by Kenneth Koch which included Frank O'Hara, Bill Berkson, and LeRoi Jones who years later adopted the name Amiri Baraka. I can't remember what we discussed really—something like the plight of American poetry. Don't ask me what that means; I haven't a clue. There was an important write-up on the panel in *Time* magazine's internal newsletter which also quoted a poem of mine in its entirety, so that was a big deal also. It meant not only my name but my work went out over the wires. Kay Boyle arrived at the Conference with her daughter, Faith, and I fell head-over-heels for her. She was absolutely stunning. Six feet tall with a hooknose and long flowing blonde hair like something out of a Grimm's fairy tale. There was an immediate and instant attraction. One night we snuck off and took a taxi to South Beach down toward New York Bay and plunged naked in the moonless surf and later dried off on a big bathroom towel I snatched from the dorm and got totally involved in a moment of ecstasy. But as the week wore on Faith kind of cooled it with me and my heart was broken for the first time. I became totally distracted but there wasn't anything I could do. I was in a glum mood. It took almost a year to shake out the cobwebs.

I got through it. Sometime in September, while hanging out with Willard and Marie, his wife, one weekend afternoon out in Brooklyn Heights, Marie announced that Charles Henri Ford was coming over to visit. I'd never heard of the guy. Marie told me that Charles was America's first surrealist poet and that I should know about him. I could see Willard didn't take to Charles much; he had a frown on his face. There must've been some kind of

rivalry, but Marie adored him. When she introduced us, Charles and I hit it off immediately and he said to come and visit any time where he lived at the Dakota. Shortly after, Charles invited me to one of his high teas, as he called them. No alcohol allowed! And we saw a lot of each other after that. We'd go to Saturday night movies at some trashy second-run theater in Times Square or attend museum openings or just hang out talking about poetry and art; he'd introduced me to Tchelitchew's paintings and gave me inscribed copies of his magazine *View*, which he had published back in the early 1940s. He didn't much care about discussing his own work, except to say that Jean Cocteau once said to him, "Charles, astonish me!" and Charles did astonish. Everything he talked about was so colorful and atmospheric. He had an unorthodox way of approaching his work through games and cut-ups and funny rhymes or things he'd just clip out of magazines; but this was not the kind of work he was known for. He made his reputation on a series of poetry books at an early age with titles like *Sleep in a Nest of Flames*, *The Overturned Lake*, and his first book, *The Garden of Disorder*, with an introduction by William Carlos Williams. Where Willard back in the late 1930s was lauded as the "golden boy of poetry," Charles was much discussed in artistic circles as a "wunderkind." Both exceptionally gifted for their times but at opposite ends of the spectrum. But, hey, they became my role models for a poet. Where Willard projected a dedicated, serious approach, there was something unmistakably youthful and adventurous about Charles that made it really fun to be around him with all his stories and such and we pretty much kept in touch or went places together whenever I'd come down from the Bronx. In a way, Charles took me under his wing. We even ended up at Auden's fifty-seventh birthday party together way down at his flat in St. Mark's Place, hobnobbing with all the literary luminaries and just having a great time. We knew how to have fun.

I was nineteen going on twenty. School would shortly be letting out for the summer and I had to think about work. I didn't want to get caught in a jam like the last time. Charles was already aware of my artistic capabilities and my skills with the silkscreen, having dabbled with it himself at one time. He said he had this close friend, an artist named Andy Warhol, who was also working with silkscreens and was desperate for an assistant to work the screens with him and maybe I was the person to help out.

Charles said he would talk to him about it.

GBK: Now that you were a part of the literary scene, what did you know about or what was your relationship with the Art World at the time? Did you know about the emerging pop art, Rauschenberg, Jasper Johns, or Andy Warhol?

GM: The two primary sources for my education and my relationship with modern art, or the Art World, were from Marie Menken, Willard's wife and a stunning artist in her own right who was a rising star in the late '40s/early '50s, having had solo exhibits at Martha Jackson and Tibor de Nagy galleries, and also from Daisy Aldan's fusion of art and poetry in her anthology, *A New Folder*.

Together, there was an abundance and richness in the art that I directly had knowledge of and had seen frequently at galleries during the early '60s. For instance, I attended several openings at Tibor de Nagy, including major shows by Larry Rivers, Mike Goldberg, Norman Bluhm, Joan Mitchell. Marie, on the other hand, introduced me to the work of her good friend, Irene Rice-Pereira, whose multilayered, luminescent canvases I greatly admired. Of course, I was aware of the groundbreaking work of the first generation abstract expressionists, Jackson Pollock, and Franz Kline. I was a big fan of abstract expressionism from the start. That was the dominant movement in the art world for me at the time and

that's where my focus took root. I can say the same for Duchamp and Dalí and happily our friendships would develop later on. As for Rauschenberg and Johns and the pop artists, none had emerged far enough for me to be aware of their presence. The Art World was a big place to explore, and you had to be there to be intimately involved. I was still more or less on the periphery. I wouldn't exactly call myself a gallery-goer; I was just a young poet from the Bronx and obviously, there was only so much I could know about the art scene. Most of what I learned came from books or from what I sometimes saw up close.

GBK: And then did you meet Andy? What was it like?

GM: I knew you were going to ask me a question like that [*laughing*].
Especially early in the day! Oh dear. In point of fact, it all happened rather quickly and by chance, like a sudden alignment of the stars, you might say. Again my guardian angel was right there beside me. Well, about a week after Charles has this idea to find me a job and help Andy out, he arranges to have me meet Andy at this reception following a Sunday afternoon poetry reading at the New School. It was June 9, 1963. I didn't know what to expect. I hadn't any prospects for a summer job, so I was pretty much open to anything and hey, what the heck, I needed the money and I liked silkscreening. I hadn't a clue as to who Warhol was. So at the cocktail reception there's this strange-looking, silver-haired apparition standing way over in the corner hiding behind brown-tinted sunglasses and Charles leads the way and makes the introduction and all Andy could say in his meek voice was, "Oh, can you come tomorrow to my studio?"

GBK: That was it?!

GM: That was it, as if history can be made in the blink of an eye without blinking. I've always credited Charles as being the catalyst in this instance. He had the knack of bringing people together. You could say this was his new kind of art and giving high teas was his way of making things happens. He thoroughly enjoyed the moment.

Connecting people. The funny thing was, the next tea I attended I came with Andy. You had to see the amused look on Charles's face.

GBK: Can you tell me about the working process with Andy Warhol, from the initial idea to the finished work? And what was the first work you silkscreened together?

GM: Well, first off, I told Andy I couldn't come to his studio the next day because I had to clear out my desk at school and take care of some unfinished business regarding my scholarship and he understood. So I arrived at the studio Tuesday just around noon. Andy was standing outside the studio door with a couple of friends, Barbara Rose and Ed Wallowitch. We started talking and Andy introduced me and Ed started taking some photos and this was the classic, archival photo of us taken on June 11, 1963. I'm looking directly at Ed and his camera, unaware of Andy's admiring glance at his newfound assistant. Ed, as I found out later, was Andy's classmate at Carnegie Tech.

So Ed leaves and Andy and Barbara and I head out for coffee/dessert at this Greek luncheonette over on 86th Street/3rd Avenue. Barbara and I get into a chat and she tells me she's in her last year at the NYU Art Institute and Andy says Barbara is married to the painter Frank Stella, whose name and work I'd not been familiar with, let alone Andy's. I'm having a tough time processing all this information. Everything is going by so quickly. And then Barbara has to leave. Andy and I head back to the studio over on East 87th Street which is actually a decommissioned firehouse he's rented from the city. We climb a flight

of stairs to the second floor where he's already set up his work area in front of these very tall windows and he starts explaining how he works and everything is quite casual and I know immediately what needs to be done. It's like you fall off the bicycle and years later you get back on without losing a step. So now here we are setting up the canvas and outlining the image from the clear acetate of the image we're going to silkscreen: a headshot of the movie star, Elizabeth Taylor. First, Andy paints the canvas silver. Once the paint dries I cover the canvas with tracing paper and draw in the outlines of the face and features and rub the outlines with a pencil and then tape the tracing paper in place to prevent it from moving and then I drop the acetate over the tracing paper and with a hard pencil retrace the outlines through the acetate onto tracing paper which then transfers directly onto the canvas. The next step is to isolate those areas of the face like the lips and eye shadow with a thin roll of masking tape and to fill in those areas with acrylic water-base paint which dries quickly. Now Andy and I are ready to go and gently situate the silkscreen over the area where the ink gets pushed through the screen with a squeegee just like the one I used three years earlier and presto! we now have the finished painting which Andy calls *Silver Liz*. But wait! I then have to clean the screen with this nasty solvent called Varnolene. So the screen gets cleaned finally which only takes a few minutes and then we clean up.

Andy invites me back to his house for lunch and Julia, his mom, happily greets us and clasping her hands exclaims in her broken English, "You are Andy's younger brother!" Well, we hit it off famously. Andy excuses himself for a few minutes and I get comfortable in a chair in the living room. My eye starts taking in all the Americana antiques he's got laying about, like the wooden horses from a carousel and a wooden Indian statue advertising cigars and various circus posters. Stacks of *SHOW* magazine are piled up next to where I'm sitting and as I'm casually flipping through the pages I come across this article on pop art and instantly recognize Andy's name and included is a reproduction of a Campbell's soup painting. Andy comes down the stairs and a couple of minutes later Julia arrives with a tray of lunch consisting of Czechoslovakian-style hamburgers on buns stuffed with raw onions and 7 Up.

After lunch Andy has some business to tend to and he gives me money for a taxi back to the Bronx and I tell him I'll see him tomorrow same time same place and he's very happy and when I leave instead of taking a taxi back home I pocket the money and take the subway instead. There was no way I could anticipate where all this was heading. It was supposed to be a summer job but I found myself completely immersed in it.

GBK: Before we go further, did Andy say something about the subject matter Liz, and did he say something about the visual expression he was initiating?

GM: When we silkscreened the *Silver Liz* portrait—and I believe we made at least three that first day—there was very little conversation that I can recall about why he chose this subject, except at some point—maybe later—he expressed to me his interest in movie stars. He said something to the effect that they were or could be as powerful as politicians. We had a number of shared enthusiasms, and movies and movie stars were one of the several interests we'd had in common since we were kids. Andy was interested in movie stars and I was interested in movie studios.

I remember reading—I must've been twelve at the time—a history of the MGM movie studio called *The Lion's Share* by Bosley Crowther. You have to understand there were extremely few books that existed on such an esoteric subject. I mean it was a genre I wasn't really aware of. So discovering this one book was a rare treat for me. It supplemented my

going to the movies and I came to understand more about what I was seeing on the big screen on weekends. The other interest we shared was our love of cats. While I never had a cat as a pet growing up, he had had at least twenty Siamese cats and said he named each one Sam because it was a name easy to remember. By the time I met Andy the number had dwindled to just a few because several died of disease. I may have seen one in his house but they were extremely shy and would only appear at night when Julia put out food for them. And then we were both terrific drawers when we were kids.

As far as any visual expression he might have tried to convey in his paintings, I don't think he gave it much thought. Andy was not intellectual in that way and in those days he was a man of few words.

He was really the silent type, or was genuinely shy. Whenever we'd make a painting, it was mostly *take it as it goes*. He would hit on an idea or something that caught his eye in a newspaper or magazine and we'd appropriate that and then we'd move on to something else. It was mostly this and that. But we pretty much accepted everything we made as complete.

GBK: So how did the work progress over the summer?

GM: We were working at a feverish pace. One day we were screening *Tuna Fish Disaster* paintings and the next was a *Mustard Race Riot*, which was huge. In fact, we did nearly all the *Death & Disaster* series. It was a most inspiring time for me also. I started writing poems about fashion models killed in car crashes and a year later I launched a series of my own which I called Thermofax paying homage to this period when I utilized Andy's Thermofax copier, creating around forty combined words and images sourced from my own photo stash. We also screened the famed Ethel Scull portrait and the Elvis Presley paintings which were earmarked for a show at the Ferus Gallery along with the Liz portraits. In fact, we had to redo the Elvis paintings as the first rolls stored in the second floor rear of the firehouse were severely damaged by an intense overnight rainstorm which leaked through the roof. Andy had me shred the rolls of canvas, but because so much was going on at the time I lost track of how much I'd destroyed, so there might've been two or three rolls that survived. Anyway, as summer was coming to an end, Andy shipped the second Elvis series out to the Ferus and instructed Irving Blum, the gallery director, to cut them up so he could easily install them on the walls. It was time for me to go back to school. After all, I never gave it a thought that what I was doing would continue more or less permanently, but Andy invited me to accompany him to Los Angeles for the show's opening and for awhile I had a hard time deciding should I continue my studies or head out to L.A. with Andy. I was having too much fun to pass up such a terrific opportunity and well, I concluded, it wasn't a big deal to take off for a semester or two. In the meantime, we had to figure how we were going to get to L.A. Andy told me he once was involved in a car accident during a driving lesson and I didn't drive at all. So there was no way we were going to get out to L.A. unless we flew. But a couple of Andy's friends, Taylor Mead and Wynn Chamberlain, offered to drive us cross-country in Wynn's station wagon and we thought that would be a terrific way of seeing America and we jumped at the idea.

GBK: Just to be sure, I understand that Andy was already doing silkscreening in 1962: the *Disasters*, *Brando*, *Warren Beatty*. So when you came he already knew how to do silkscreening.

GM: It's true; Andy was using silkscreens in '62. The first screens were made from pen and

ink or pencil drawings he made like Savarin's Coffee and the One Dollar bills. Even the small Campbell's soup can paintings where the cans are repeated over and over. In effect, they are sometimes referred to as serigraphs because there are no tonal values involved; they essentially look like line-cuts. Then he moved onto photographic silkscreens made from photographs like the headshots of Warren Beatty and Natalie Wood and the red Elvis head-shot and also the series of small Marilyn headshots. But they are small silkscreens repeated over and over to make them look like a larger screen was applied and this was before he was renting the firehouse. So all the paintings from '62 were made on the living room floor in the townhouse he shared with his mother and even then the space was limited to about 12 to 15 feet wide max and he could only unroll a canvas—if it was to be a large painting—a little bit at a time and wait for the ink to dry before he could unroll the canvas further. I don't believe there were any paintings of Marlon Brando that I recall from this period. The *Death & Disaster* series hadn't really gotten off the ground. He may have made one large *Electric Chair* shortly after he rented the firehouse in February '63 before I came on, and anyway all this was before he had the solo show at Stable Gallery in New York where all the paintings we just mentioned were shown. So, yes, while he was working with silkscreens during this time, it was learning-as-you-go. I don't like saying it, but Andy became more proficient with the silkscreen once I came onboard and was able to show him just what you can do to move the process ahead. That's where falling off the bicycle and getting back on comes in.

GBK: On this trip to L.A. in 1963 you met Marcel Duchamp in Pasadena. Can you tell us about that meeting and what kind of position Marcel Duchamp had in Andy's vision/mind concerning the contemporary art?

GM: With regard to modern art, Duchamp had said that "when an unknown artist brings me something new, I all but burst with gratitude" and he was always generous in that way, echoing Pound's concerns about "Making It New." I think he felt a certain affinity to pop art, too, when it appeared on the scene. So here's Duchamp having his first museum ret-rospective ever at the Pasadena Art Museum coinciding with Andy's exhibit at the Ferus Gallery and most of L.A. looked like an outdoor pop art exhibit at the time with all these gigantic billboards of super-real hand-painted art that excited Andy to no end. Of course, Andy and I knew who Duchamp was, and Andy actually owned one of his *Green Boxes*, but we never dreamed we'd be meeting Duchamp. We arrived at the museum a bit early—it was still daylight outside—and Duchamp, as I recall, was sitting outdoors on a patio and we were like a couple of kids totally enthused by our hero. He certainly put up with us, though I was doing most of the talking! Actually, I ended up spending more time with Duchamp that evening than Andy. We attended a dinner party in his honor after the open-ing and as the party was winding down I went over and sat with him and we got to talk-ing about my poetry and he gave me this idea of how I could write a poem without writing it. That was pretty daring! He was into readymades; lucky finds, he called them. He said I could easily find a poem waiting to be discovered within or surrounded by a text having nothing to do with the poem. He was right. A year later when I was back in school part-time, having signed up for this course on Introductory Psychology, I was reading a chap-ter on the sense of smell in the assigned textbook and I started seeing a poem existing within the paragraphs and I began isolating a whole block of sentences and breaking them up into lines and now I had what looked like a poem and I even gave it a title, *Tempera-ture*, and I phrased it here and there and to me it sounded like something I'd seen in *The*

New Yorker. About a year later I submitted it to *The New Yorker*'s poetry editor, Howard Moss, and he accepted it for publication. I probably still hold the record as the youngest poet ever to appear in *The New Yorker*. Well, two years later, sometime in late '66, Duchamp calls the Factory and invites Andy and me to his studio down on 11th Street, I think it was; he was returning to France. Andy hadn't arrived yet so I left him a note to meet me at Duchamp's studio. The place had artworks leaning up against the walls or spread out on a table. What I was actually seeing—though I couldn't have known at the time, and Duchamp wasn't talking—were pieces of his grand work, *Etant Donnés*. I reminded him about the poem concept we talked about years earlier which he remembered and that the poem that resulted ended up in *The New Yorker* and we had a big laugh and he said I should pick out something for myself as a gift for following through on his idea. A pile of photographs caught my eye and I asked if I could have one of them, what looked like a self-portrait and he signed it for me. Andy must've arrived too late at the Factory to find the note, because he never called or showed up.

GBK: In a recent biography on Duchamp, Judith Housez [edition Grasset, 2007] talks about the mutual influence Duchamp-Warhol. She even suggests that Duchamp was in a way involved in the idea of "quantity and repetition" in Warhol's art. And that Andy gave Duchamp the idea of doing the multiplication of his early works in the '60s. Did they have more contact than you refer to?

GM: No doubt, this is a debate that will go on for a long time and academics will gladly toss around these theories of who influenced who. First of all, Duchamp was his own man with his own brand of intelligence bar none and secondly, Andy never had any direct contact with him before early October 1963 when we were all in L.A., and as I already pointed out, very little was exchanged except for the informal greetings as Andy's face turned a bright red at the mere thought that he was shaking hands with the master. Andy hardly read books, or if he did he skimmed them, contrary to what those Warhol apologists would have you believe, and I don't believe Andy would have curled up with a book about Duchamp's writings. How could he? At the time he was incorporating repetition into his paintings back in '62, there was no such Duchamp collection in print prior to '73 and Pierre Cabanne's now classic tome, *Dialogues with Marcel Duchamp*, didn't appear in English until 1971. Andy had said to me that early on he was working in a vacuum as were the other pop artists—that is, until the print media held a mirror up to itself and declared a new art movement. I would love to have been a fly on Clement Greenberg's living room wall.

In fact, if any one artist had any kind of affinity with Duchamp, it was Orson Welles. Surprise! Here in Cabanne's taped dialogues, Duchamp is describing the origin of Dulcinea for the work that would eventually evolve as being "a woman I met on the Avenue de Neuilly, whom I saw from time to time going to lunch, but to whom I never spoke. It wasn't even a matter of being able to speak to her. She walked her dog, and she lived in the neighborhood, that's all. I didn't even know here name." So he made up the name. Sound familiar? Compare that with the Bernstein sequence in Orson Welles's *Citizen Kane* where Bernstein is recounting the origin of Kane's last dying word, Rosebud, and the similarity is uncanny.

When Duchamp talks about repetition, it namely, in his own words, has to do with "taste." The remark is oblique to Cabanne's question: "What is taste for you?" Duchamp replies: "A habit." Already we're in for something quite remarkable to occur. He continues: "The repetition of something already accepted. If you start something over several times, it becomes taste, good or bad, it's the same thing, it's still taste."

In another instance, in responding to pop artists, Duchamp says, "When you do something twenty times, it falls very fast, it's too monotonous, it's too repetitive." Duchamp was completely antithetical to style, and what is repetition but an extension of style. That is, something being stylistic. He was anti-style through and through. So it's not like Duchamp was completely sympathetic to what was happening around him in his last years and you certainly can't accuse the guy of being a curmudgeon! He clearly states his position: "I don't attach very much importance to what I think is better; it's simply an opinion. I don't intend to offer a definitive judgment about all these things." What a kind man he is! So there you go.

GBK: What was Andy's contact with other artists at the time? In 1963? Who were his artist friends?

GM: For a shy guy Andy was pretty popular. His closest friend, I believe, at the time was Henry Geldzahler. He was the Met's wunderkind curator and created the museum's Department of Twentieth-century Art. We saw a lot of him. Then there was Bob Indiana and Marisol whom Andy first met when he joined up with the Stable Gallery. It was only natural that he made friends with some of the same artists who were exhibiting there. Ray Johnson came by the townhouse one afternoon; that's when I met him. He seemed a bit stand-offish. Was he jealous of Andy's new assistant? He certainly gave that impression. Then there were Wynn Chamberlain, a very gifted magic realist painter, and John Giorno, a young poet. One night, Andy and I and Wynn and John and Nicky Haslem, who was the art director of *British Vogue* at that time, headed out in Wynn's car for a night at Coney Island. There was a near-disaster when we all climbed into the Cyclone rollercoaster. As we were plunging down the first steep embankment I happened to turn around and see Andy's toupee lifting nearly to the back of his head and Andy trying to hold it down with one hand while hanging on with the other which was dangerous since all the signs posted said you had to use both hands to hold on. I thought the toupee was going to blow clear off but miraculously it didn't. No one joked about it afterwards; it would've been too embarrassing for him.

GBK: One has the impression now looking back that Andy was very much preoccupied by "the new," of being original in his art, creating new dimensions within art. Did you get the impression working together with him that he wanted to break new grounds within art? Did he express himself about that?

GM: Funny thing was I always had the impression when working the screens with Andy that we were breaking new ground. As I said, Andy was the shy type, but his enthusiasm was sincere, inquisitive when we'd lift a screen to see what we'd done with the canvas. It was, "Oh, gee, this is terrific!" or "Look how beautiful. Let's do more!" He was always looking for ways to make things better, but that was the hard part. The notion of breaking new ground within art was evident, especially because the pop art movement Andy was identified with was breaking new ground anyway. There was a fever pitch of excitement that the print media was generating because of what we were doing. Andy was beginning to be sought after for stories but a lot of reporters were let down by his monosyllabic responses. Maybe they thought he was a dumbbell, but just his appearance alone was instant press. He really looked like an alien which belied a certain creative streak in his nature beneath. I mean we approached our work seriously no matter what was swirling around us. No one could accuse us of being lazy. 1963 was a banner year for Andy. We must've churned out

at least sixty canvases, maybe more. So you see, Andy never expressed himself verbally about what he was going for. He just had an idea or someone would give him one and we went with it. People forget that there was a lot of prep work that went into these paintings. A lot of mundane activity. I'd have to fetch a screen from the manufacturer way downtown and carry it into the subway, or I'd go shopping for paint supplies and silkscreen supplies. Squeegees, cans of oil-based inks. A lot of heavy lugging. Also lots of photo research, which I had fun doing. Then there were the set-ups outlining where a screen would be placed on a canvas. Things like that. The actual creative phase took only a few seconds—15 seconds at most! And Presto! a canvas completed. And then the grunge time cleaning the screen. It had to be done. People sometimes get this wrong impression when they look at these paintings. Maybe we weren't thinking about breaking new grounds within art or preoccupied in "the new" as you put it; that was already a given. But I knew deep down that what we were doing would be considered important years later. That was my archival consciousness clicking.

GBK: In the beginning, I understand, it was just the two of you working on the silkscreening but then the studio developed into what became "the Factory." Can you tell us about this development?

GM: Well, it just happened. Shortly after our return to New York from L.A., mid-October, Andy received a notice in the mail from the NYC Department of Buildings saying that the lease on the firehouse was up the end of the year and that they wouldn't be renewing it. Something about liquidating city-owned properties, putting them up for sale to the highest bidder and the firehouse was one of them. That gave us about ten weeks to find a new work space. There was no way Andy was going to retreat back to his townhouse. His living room had filled up considerably and he'd gotten used to having a studio away from home and well it just wasn't going to work out. Andy didn't seem nervous about this new situation. He seemed pretty calm about it all considering it would be quite a big move. It was just something that had to be done and he said to me, "Start looking." And so we checked newspaper listings and made phone calls and appointments and went walking and walking. It took considerable time but none of it panned out. We may have made one painting during all the time this was going on, a portrait of Bobby Short, the pianist, which Marie Menken filmed for a film-portrait she was doing on Andy. There was one loft space I particularly liked way over in the Chelsea area near 10th Avenue, lived in by this poet, Howard Griffin, a friend of W.H. Auden, but Andy rejected it as being too far. We went to see this space over on East 47th Street near 2nd Avenue, an odd area to be having a loft, right in midtown Manhattan near the United Nations. It was, we were told, originally used as a hat factory. It was dark and cavernous and had concrete floors and seemed uninviting for the kind of work we wanted to do and also part of the plan was maybe I'd live there. You know, look after things. I was still living at home with my mom. A year earlier my dad just picked up and left. I guess he'd grown tired of all the bickering over the years. He didn't say where he was going and anyway I'd been spending more and more time away from home, so this situation presented the perfect opportunity to move on myself. Andy signed the lease and now it was nearing Christmas. One weekend afternoon we went to a party at this apartment on the Lower East Side; it was all painted silver. Three or four guys lived there, including Billy Linich. Andy was entranced with the way the apartment looked.

His favorite color was silver which wasn't really a color at all. He immediately hit on the idea that this was how he wanted the new space to look and invited Billy up to paint it

all over. It took almost a month to do, all of January, except for the floor which we just cleaned up and left as it was, cracks and all and a lot of what Andy accumulated and had stored in his townhouse and at the firehouse arrived one day by truck. Then, one day Andy decided that Billy should move into the space since he was already sleeping there while doing the painting and basically manage things. So my idea of moving in got turned around. Andy felt one person living in the loft was enough and also it afforded Billy a bit of his own privacy. So I found myself back in the Bronx again and commuting. Who said you can't go home again? [*laughing*] The first project we got involved with shortly after moving in was a series of boxes made of plywood and once silkscreened would replicate the kind of boxes you'd see piled up in a supermarket. Brillo boxes and Kellogg's Corn Flakes, Heinz Tomato Ketchup. Somewhere in all this, I think it was Andy who christened the new space the Factory, because that's what it felt like and what it was originally and the name stuck. I think he wanted to contrast it with what was commonly called the artist's studio. Well, he just wanted it to be different and I guess he wanted the new name to reflect the new kind of art we'd be making. "The Factory" simply caught on.

GBK: In 1963 Andy Warhol makes his first films and you were quite involved in this adventure for the next years. Tell us about the beginning. How did it come about that Andy began to do films and what or how was the working method?

GM: I think Andy had been thinking about making movies for some time, but he didn't know exactly how to go about it. He even professed to me once that he wanted to make a movie of Brigitte Bardot sleeping but knew it was impossible. Andy and I both had close friends who were filmmakers at the time. Andy would rely heavily on Emile de Antonio for his encouragement and ideas. Emile, who was an inspiring soul and a terrific human being and a truly great filmmaker, was a pioneer of the social documentary in America, but he got a lot of grief because of it. At the time I met him, he was already famous, or shall I say, infamous for his movie, *Point of Order*, which basically chronicled the trial of Senator Joe McCarthy who years earlier had spearheaded this witchhunt of so-called communists he accused of infiltrating the US government, but then the red-baiting had spread to all corners of American life, especially targeting the Hollywood film industry and television as well. A lot of creative lives were ruined or disrupted, including my friend, Ben Maddow. That's how the term "blacklisted" got started. The title of the movie, *Point of Order*, was a legal phrase repeated over and over by the judge in the trial. You could hear his voice off-camera shouting, "Point of order! Point of order!" Emile relied entirely on existing grainy black and white newsreel footage of McCarthy's trial to piece together the downfall of this stalker. It was like he extended Duchamp's concept of the "readymade" a step further. My connection with films and filmmakers started when I was in my last year in high school in 1960. Daisy Aldan, my homeroom teacher, had posted an announcement for an evening of avant-garde films at the Living Theater and I traveled all the way from the Bronx to see them. I thought I was going to see "dirty movies," not knowing that this would be the beginning of my education in the avant-garde. And Daisy, the next day, was almost surprised I'd gone.

The program, as I recall, consisted of movies by Stan Brakhage, Kenneth Anger, Stan Vanderbeek, Maya Deren, Willard Maas, and Marie Menken, and a few others maybe. Within a year I would meet Willard and Marie who adopted me as their protégé and I helped out by making title boards for a couple of Marie's movies. I was extremely good at hand-lettering. So when I met Andy one of the things we discovered we had in common was the movies, though neither of us had even considered the thought that one

day we would be making our own. But shortly, all that would change. Finally, when it was I don't know exactly, but sometime during the summer, Andy said he wanted to buy a movie camera and would I come to help him pick one out. There was this terrific camera supply store I knew about from working with Marie and Willard called Peerless Camera, located in midtown Manhattan right near Grand Central Station. It was this floor-thru store with entrances at both ends on 43rd and 44th Streets. It was chock-full of everything imaginable you could find from still cameras, film stock, slide projectors, movie cameras, darkroom supplies, you name it. It was a really fun place to shop and go visit. I told Charles Henri Ford about Andy's idea to buy a camera and knowing Charles was interested in movies as well said he'd like to come along. So the three of us one bright sunny day took the subway to Peerless and helped Andy pick out a movie camera. It had to be something he could understand and easily handle. The salesman showed us several models, including the latest 16mm Bolex. It was called an H-16 Reflex. The price was around $500 with the extra accessories and lenses. It allowed you to shoot through the lens to see what you were getting. They called it through-the-lens Reflex. It came with a motor drive which you plugged into the camera's body allowing you to shoot a 100-foot roll of film nonstop for 3 minutes. "You push the button. We do the rest." That's an old Kodak promotion copy, but this was no Kodak. The camera was made in Switzerland. But that's generally the idea Andy wanted. He didn't want to think about how he was going to operate the camera. He just wanted to press the button and let the camera think for itself. I think that's the way Andy wanted it done all through his life. He just wanted to have everything done for him by everyone else. Within a week or two, he was off making his first movie, though I didn't come along because he pretty much knew what he wanted and it was too personal besides.

Every night after John Giorno went to bed, Andy at a precise time would let himself in with John's key and film him sleeping. He must've done this for three weeks or so and he shot hundreds of rolls and when we spliced them together, it fell short by about 2 hours, so we had the lab print up duplicate rolls to stretch the movie out to about 8 hours: Andy's first movie, which he called *Sleep*.

GBK: His first film *Sleep* was already a revolutionary film within film history. Do you see any relationship between his paintings, silkscreens, and films?

GM: As the cliché goes, if it didn't exist, it would have to be invented. The concept for the movie, *Sleep*—you didn't have to see it to know the plot—already anticipated its outcome, so it's natural that a film of this kind would make its way into the literature of film. As Allen Ginsberg once said regarding your first time around, "First thought, best thought." Andy lucked out. *Sleep* became a revolutionary film. It forced its way into the artistic consciousness. Well, first off, the one denominator that links Andy's paintings, silkscreens, and movies is photography. After all, as Charles Henri Ford once remarked to me, "Andy's silkscreens are paintings of photographs." Clever. What is a silkscreen but a reverse transparency of a photograph reproduced on acetate. The same can be said of his movies, but with a twist: Andy's early movies are a series of photographs on celluloid.

I emphasize the word early here because Andy's later movies don't operate or translate in the same manner. Andy's early films are all about images in stasis—you forget what you're looking at even though the picture is moving or slightly moving—whereas his later films—those shot with sound—are character studies because now you have people talking to each other and that changes the mood and the purity and the dynamic of what's being projected

and are in direct contrast to the earlier movies. You no longer forget what you're looking at because you're constantly being reminded what's going on up there on the screen.

[Gunnar, you won't believe what happened! Earlier this evening I took a bus to a Thai Restaurant for take-out in neighboring Greenpoint and took question no. 24 with me and wrote out a terrific answer while the food was being prepared and when I got off the bus at my stop I left the bag containing my handwritten answer on the bus. It simply slipped through my fingers! So now I've had to rewrite my answer partly from memory and partly from scratch starting over, though hopefully I've made it better. It's like the story of T.E. Lawrence losing his only manuscript of *The Seven Pillars of Wisdom* in a taxi and having to rewrite it word-for-word all over again. Imagine!]

GBK: Now at this moment in time you are engaged with the "most important avant-garde" visual artists of the international art scene. How did this relate to your writings?

GM: No. It didn't happen that way. Clearly, I had no idea who, besides Duchamp, were the most important avant-garde visual artists of the international art scene. Yes, of course, there were the dadaists who were fun to study, especially for all the mischief they instigated, but that's about as far as it went. Back in the early '60s, there was Cafe Le Metro, which sold antique furniture and served cappuccino and pastries, located over on 2nd Avenue near 9th Street in the East Village. It was where you met poets your own age or a bit older and where everyone read their poetry live. Monday nights were open to everyone who took turns reading their work and Wednesday nights showcased just one poet. And so there was a commonality of spirit, a sharing of ideas. It was definitely a testing ground for our work. A very exciting atmosphere. Ted Berrigan and Ron Padgett and Harry Fainlight were the poets I hung out with mostly, especially Harry. He was an English poet marooned in New York, but he had pedigree. His sister and brother-in-law, Ruth Fainlight and Alan Silitoe, were writers already making a name for themselves in London. There were times when I didn't have a place to stay I'd crash nights at Harry's pad in Chinatown. I guess you can say the one important visual artist who influenced my work early on was Marcel Duchamp whose ideas about the "readymade" I also embraced and absorbed into my fashion poems. I was rearranging fashion captions beneath photo layouts appearing monthly in *Harper's Bazaar*. No one was doing this, so I believe I was the first. I don't think it's been attempted since. Salvador Dalí was another artist of international renown who made an impact on my work just by the sheer force of his spirit. He clearly related to me as a poet; I know because he once gave me a very candid interview on his friendship with Garcia-Lorca which he had granted no one else. What struck me was his simpatico nature and his incredible sense of humor; his amazing grace and intelligence. I looked forward to visits with him at the St. Regis Hotel whenever he and Gala were in New York for extended stays during most winters. I definitely found him inspiring just to be with and of course to see his work firsthand as well.

GBK: Did your collaboration with Warhol affect your writings in any way? Or make you think differently about your poetry?

GM: At first, no, that is until we started working on the *Death & Disasters*. Andy kind of enlarged my social awareness of worlds I'd only been reading about in the newspapers. Suddenly I found myself going to parties and meeting people I'd never dreamed of. It was all happening so quickly. I felt like Cinderella going to the ball only to have to return to the

Bronx late nights by subway. But I did feel I was being treated seriously for the first time for who I was as well as for what I did. People at parties would ask what I did and I said I'm a poet. Just like that. I didn't get that kind of respect from the poetry world, per se. There was always some kind of backroom jealousy towards me and it only intensified once I was working with Andy. Anyway, I found the social scene quite inspiring and when I began juxtaposing that with the *Death & Disaster* paintings we were making I suddenly saw a way of bridging that kind of subject matter into my own work. I started creating these dreamy and mysterious landscapes wherein something suddenly tragic occurs, like a car crash in which a fashion model gets killed. Fashion models representing beauty killed without reason. It was like you can die in style. I guess I was equating style with violence. I didn't see that in any of the fashion photos, but I thought it would be fantastic to see fashion spreads where this could occur visually. You know, just once in awhile. I was consuming a lot of John Ashbery's poetry around this period. He was my big hero of the moment, you might say. His second volume of poetry, *The Tennis Court Oath*, had recently appeared and made a big impression on the way I saw my own work evolving. I felt I literally unlocked the dreamscapes inherent in John's poems and adapted them to my own angle and vision. Just carrying it a step further in a different way. A substantial body of my work from this period '64–'65–'66, which also coincided with the Factory period, was collected several years later in a book called *chic death* but by that time my lifestyle had changed and my work would follow a different path. Also, sometime in '64, Andy purchased a Thermofax copier and brought it to the Factory but rarely used it himself. Billy showed me how to manipulate the dials to achieve the desired effect I was looking for; I started juxtaposing some of these poems with grisly news photos I'd collected from my teenage years all contained on the same sheet. This series, about forty in all, were meant as a kind of homage to the work I was doing with Andy. So it wasn't anything he may have said or didn't say that affected my work or made any sense. It was more a combination of things, including the *Death & Disasters* that had a huge impact on the way my work was evolving. I really felt I was on to something.

GBK: Did you introduce Warhol to your literary friends and colleagues? Was he interested in literature, the world of literature? Did he read books, magazines, newspapers?

GM: It's always a wonder if Andy ever found time reading books, though occasionally I'd catch him glancing through a newspaper. He was no stranger to books, though. He had plenty of them. Friends would be sending him books in the mail; art books, museum catalogues, things like that. I remember borrowing a book from him, Edgar Morin's *The Movies*. It had a fascinating chapter on James Dean with a poignant passage about how heartbroken he was when an old girlfriend of his, Pier Angeli, ended up marrying Vic Damone and how he waited outside the church and when they appeared, he gunned his motorcycle and rode straightway nonstop from L.A. to the cradle of his childhood, Fairmont, Indiana. Well, that was Zen! One day a couple of months later, Andy reminds me to give the book back and I returned it natch, and since that time long ago I now have five copies of my own. That's how important that book is to me. I discovered years later the book's inside front and back covers contained a reproduction of a full-length French billboard shot of Marlon Brando from *The Wild Ones* in which the affiche is repeated several times over and I suddenly realized I'd stumbled upon an obscure and important piece of Warhol scholarship related to the source of one of his paintings—the silver Elvis series. The similarity is uncanny. When I told Professor Morin over the phone my discovery back in 2001, he was

absolutely beside himself. I don't know how interested Andy was in literature. He always enjoyed the idea of someone reading books to him or just summarizing the plots. If it was poetry, he'd pretend to be interested but forget it! He didn't have sufficient interest or patience for reading poetry.

He did, however, enjoy the company of poets and I introduced several poets to him, including Ted Berrigan and Ron Padgett, and I did take him to Cafe Le Metro a few times. I introduced him to Ronnie Tavel from which a long collaborative relationship shortly ensued. Once, when Frank O'Hara, who was at that time a MoMA curator, was scheduled to read in the Wednesday night series, Andy set up his Bolex to film him, but Andy claimed later to have lost or misplaced the film and it's likely it was never developed. My theory is it was his way of getting back at O'Hara for dismissing his art entirely. Joe Brainard whom I also brought to the Factory would send Andy a postcard a day for nearly a year until he realized Andy was not likely ever to write back. I know Andy was particularly fond of Ted and wanted to help him out any way he could because Ted was living on a shoestring. He once gave Ted a Brillo box just like that when Ted came to visit once at the Factory, knowing that he probably would sell it because he needed the cash. When Andy and I went to Paris in '65 and I arranged for us to have lunch with John Ashbery, then art critic for the *Herald Tribune*, when the bill was brought to the table Andy snatched it just as John was reaching for it. It was Andy's way of showing respect; John had written a glowing essay on the *Death & Disaster* paintings when they were exhibited the year prior at Ileana Sonnabend's gallery, which impressed Andy to no end. When John came to New York the following summer we hosted a beautiful people party at the Factory in his honor. John didn't know what to make of it, reticent as he was when put under the spotlight.

GBK: In 1963, on your trip to L.A., Andy makes his first narrative movie with a number of "actors" like Taylor Mead, Naomi Levine, Brooke Hayward, Irving Blum, John Chamberlain, Wynn Chamberlain, Patti Oldenburg, Dennis Hopper, Claes Oldenburg, Wallace Berman, Andy Warhol himself, and you, Gerard Malanga. *Tarzan & Jane regained, sort of,* a 1 hour and 20 minute 16mm film made in black and white and color. Can you tell us about the film's genesis? What was it about? The transition from more static films like *Sleep* towards this kind of narrative-based film? The change in Andy's working methods and your role in the film?

GM: First off, this is not an Andy Warhol movie at all, and he had only made the one movie, *Sleep*, so no transition even existed up to this point. Why it's credited to Andy is another one of those instances where the Warhol apologists are giving credit where credit is definitely not due, but that's best left for another discussion.

This was always a Taylor Mead movie right from the start, conceived by Taylor and starring Taylor and all the parts cast by Taylor. Andy's only involvement was Andy's camera and Andy behind the camera and, as is commonly known, not knowing what to do or where to point the lens. Taylor even directed many of the camera angles and decided on the locations and that was time-consuming in itself. We were driving all over L.A. Taylor played Tarzan to Naomi's Jane in scantily-clad costumes which Taylor fastened with safety pins. The movie's genesis was a mock satire on Hollywood movies and what better place to film it was in the very place where it all began. Taylor was basically your virtuoso in the tradition of Charles Chaplin whom he was continually compared to in reviews, and he earned those accolades, believe me. He did it all himself and he knew what he was doing. My role in all this: I helped Andy set up the camera and I handled the slate between shots.

I was the slate person, as they say in the movies. There's hardly anything I can recall that would make a bit of sense. I remember one early afternoon Dennis Hopper showed up at the Beverly Hills Hotel and there was this quick scene with Taylor and Dennis chasing each other up a palm tree and beating their chests. That was pretty glamorous, having a real movie star in your midst. Cecil Beaton was living in one of the hotel bungalows so we had the privilege of filming on the hotel grounds that day under the pretext of being Cecil's guests. Cecil set up house at the hotel because he was contracted to do the costumes and sets for the movie *My Fair Lady*, so he was in Hollywood for nearly a year. He literally transformed his living quarters to look like something out of his drawing room study in London, with piles of art books here and there and furniture draped every which way in brightly twilled fabrics. He was most accommodating and charming and a friendship blossomed between us.

GBK: In 1963 Andy meets with Jonas Mekas for the first time. Can you tell us about their relationship and how important Jonas was for Warhol's filmmaking?

GM: Without Jonas's enthusiastic support it's quite likely Andy would've had a very difficult time getting his movies shown publicly. At the time, Jonas had a basically traveling cinémathèque. You might say it was on the order of a carnival show or band of gypsies. Filmmakers without a home of their own to show their work. But Jonas did find a home— several, in fact. He would find a theater to rent out during off-seasons, which was a good time for a theater owner to make extra cash, or he would find movie theaters willing to allow him one or two nights a week at very late hours to present film programs. Thus the term "underground" came about. Jonas had a wide range of filmmakers to showcase their work, including Stan Brakhage, Kenneth Anger, Marie Menken, and Jack Smith. So he would package these programs and place them in whatever space he happened to find at the time. As I recall, Jonas was absolutely taken with Andy's first movie, *Sleep*, parts of which Andy screened for him at Wynn Chamberlain's loft on the Bowery. Sometime during the summer, perhaps late July, Jonas offered Andy right on the spot a chance to show the film in its entirety and, of course, Andy was quite excited by the prospect. The whole film—not just bits and pieces. It's not every day a filmmaker makes his first movie and his whole reputation rests on this one movie making instant cinema history. When *Sleep* was shown, the audience was jeering and booing, walking in and then walking out, and the press went wild with negative reviews mostly. Andy was biting his fingernails and red in the face. Jonas was ecstatic with excitement. Interestingly, at around the same time that *Sleep* had its one-night/one-screening premiere, a live performance of Erik Satie's *Vexations* had its world premiere in New York for a total of 18 hours and 40 minutes nonstop. The score consisted of an 80-second 180-note passage repeated 840 times by a host of composer/musicians, including the young John Cale, Freddy Herko, James Tenney, Philip Corner, and John Cage who was responsible for producing this piano marathon. So, as it turned out, Erik Satie even outdid Andy's 8-hour *Sleep*. Something was in the air. The avant-garde seemed to be conquering the New York cultural scene overnight and Jonas Mekas was one of the movement's stellar personalities. He was what you would call a mover-and-shaker. He made things happen and, yes, he was very important to Andy's filmmaking endeavors because now it was understood anything Andy churned out would immediately find a home with Jonas and I'm talking here within weeks! But more than that, Jonas created the opportunities for a number of underground filmmakers, as I've already mentioned, and Andy was now the movement's newest member.

GBK: More than anybody else you worked with Warhol on most of his important films. In general and in a few words, would you characterize and contextualize the films Warhol was making during the period you collaborated with him?

GM: Andy's movies, in a way, mimicked the history of Hollywood movies, though it wasn't done purposely: silent, sound, and color.

Andy starts in summer '63 with his first movie, *Sleep*, which is shot without sound. Could you imagine making a movie about sleep with sound to it! Subsequently he makes a series of movies all through 1964, including *Empire*, all shot without sound. *Empire* becomes the first movie shot with the Auricon camera which we rented from a film supply outfitter. Where the Bolex is limited to 3-minute film rolls, the Auricon allows you to shoot a 33-minute reel nonstop. The irony is that Andy shoots *Empire* without sound with a camera capable of recording sound. I guess looking at a building can be a silent experience too. [*laughing*] In fall '64, Andy purchases his very own Auricon and in late November shoots *Harlot*, his first sound movie.

Not until sometime in mid-'65 does Andy shoot his first color sound movie called *Suicide* and all through '65, well into '66, and through '67 Andy alternates between color and black and white movies. In fact, when he shoots his 24-hour epic, **** *(Four Stars)*, he's no longer shooting black and white anymore. Also, by the end of '66 he's abandoned the Bolex. So what we have is basically a flow chart mimicking the history of Hollywood movies: silent movies/sound movies/color movies. Andy was just learning as he went.

GBK: Before we go further I would like to ask you about the "social awareness" of Warhol. Warhol makes paintings like *Disasters* (electric chairs, riots and racism, everyday violence), *Wanted Men* (which was censured!), and the portrait of Nixon where the subject matter is highly social, even political. Can you talk about Andy's social awareness? And furthermore, do you think Warhol had a "political consciousness"?

GM: It's quite obvious the *Death & Disaster* series reflected what predominated the news in the late '50s and especially in the early '60s which is when these paintings were begun. Andy latched on to subject matters he felt no one else had touched, so it made him feel like he was the first. I know for certain that this work didn't reflect Andy's social awareness and he certainly had no political consciousness to speak of. Yes, you can be aware and you can be conscious, but Andy never acted on any of this, never acted in any political way, except to depict what was in the news in his work. For him, it was only a painting per se. Where's the revolution in that? It was not meant to be art that would inspire change in the status quo or to overturn any injustices that were occurring. Andy was not active in that sense. He was a passive observer. He didn't want to get involved. He wasn't about to go out and protest in the streets.

GBK: Can you tell us about the organization of the work at the Factory, who was doing what? Who was doing the paintings? Who was doing the administration work? How did you split up the time between the film production and the silkscreen production?

GM: There was no "Warhol System." There was no particular organization to speak of. It was basically whatever we felt like doing that day. Of course, silkscreening the paintings involved set-ups and prep work. Andy and I worked in an area near the back of the Factory. It wasn't secluded, mind you. Anyone visiting could see what we were doing, but strangely no one walked over to look. Good. Outwardly, it might've looked boring. I was Andy's chief assistant.

I say that with a bit of humor, because there were no other assistants under me. My main function was to help him screen the paintings. Once, during the summer of '64, Philip Fagan, Andy's boyfriend at the time, helped out with silkscreening the *Flowers* but after a while he got pretty bored with the work and soon quit and there was never anyone else. There was no administrative work, to speak of. If you're talking about paperwork, Andy would turn over all the receipts to his tax accountant. Otherwise, a business plan was nonexistent. In fact, we wouldn't have known what that was if you told us! When we were not concentrating on the paintings, we would shoot a movie. After the exhibit of *Flower* paintings in December '64 at Leo Castelli, Andy refocused his interests more into film-making. It was at this time Andy started shooting movies with sound. No more static or conceptual silent movies. Now we needed stories to record. I introduced Ronnie Tavel, a fellow poet, to Andy because I had a hunch they could work well together. Ronnie seemed responsible and earnest and given the right conditions he could produce almost anything, and he did. So for the next two years we were churning out movies on the average of one every two or three weeks it seemed. In between the movie production we were still able to screen paintings. That's pretty much how it went.

GBK: In 1964 there seem to be more and more people involved with activities in the Factory, and from the outside retrospectively it seems to have been quite chaotic and wild, drugs, sex. Was it as wild as it looked?

GM: There's this great myth about the Factory that it was party lights, drugs, and rock & roll nonstop; it wasn't. I keep trying to correct this until I'm blue in the face but the myth keeps persisting. Like I said, Andy and I hosted this one great party for John Ashbery in '65 and the year before that, Ethel Scull gives a party after his triumphant *Brillo Box* opening at Stable. She'd bought about a half-dozen boxes of various sizes and brands but when the media attention shifted from her to Andy, she sent them all back the next day. No kidding. Otherwise, it was pretty quiet. We went back to our daily routines. Yeah, of course, Billy would have friends dropping in, now and then, and he'd be playing opera records on the stereo, or if someone came by to see us, we'd set up the Bolex and they'd sit for their "screen test" that lasted a mere 3 minutes. In July '65 I was conducting an interview with a young filmmaker, Paul Morrissey, for the Superstar issue of *Film Culture* Jonas Mekas invited me to guest-edit. I was so impressed with what Paul was saying about the history of Hollywood movies that I invited him to the Factory.

Andy was seriously thinking of getting a new sound person because the sound on the movies was so shitty every time we'd get them back from the lab. It wasn't our sound person's fault; it was just the way Andy was shooting them. Anyway, Paul showed up one day and got to talking and suggested Andy would be better off shooting what was called "double system" involving a tape recorder. So Paul was the sound person for *My Hustler* and for every movie thereafter. He also became Andy's liaison with the press or with any extra business that came Andy's way. In the end, Paul was a godsend. Andy really relied on him for these kinds of details. Danny Williams was another fixture but at first I couldn't quite figure out what he was doing. I knew he was Andy's new boyfriend; he'd show up at the Factory fairly frequently and then one day he just moved in. Andy had kicked him out of the townhouse. So he set up a little corner in the rear of the Factory with all his lights, tools, and wires. When the Velvet Underground entered our lives, Danny designed and operated the lighting for the live shows. So, in effect, two new faces joined our band of gypsies.

GBK: Andy exhibits the *Disasters* at Sonnabend in Paris in 1964 and *Flowers* in 1965. You went with him to Paris. The Nouvelle Vague, the new wave in French movies, with film directors like Truffaut, Godard, and Rohmer, just to name a few, had already introduced a new vision within French movies. Did you and Andy know about these film directors, and if so, did they have any kind of impact on Andy's production and did he relate to them?

GM: We didn't go to Paris for the *Death & Disasters* exhibit. Too bad. That was the one for which Ashbery wrote the Sonnabend catalogue essay. We did finally arrive in Paris a year later for the *Flowers* exhibit. Ileana was most kind; she and Michael arranged for me to give a poetry reading in the gallery. Anita Pallenberg, Denis Deegan. and Stash de Rola (Balthus's son) arrived at my hotel room with a "fatty" the size of a baguette rolled in French newspaper and we lit it up and the entire room was now filled with aromatics. I couldn't see 12 inches in front of my face! I arrived at the gallery late and my mouth was so dry my lips were sticking together as I was reading my poems but I got through it all OK. The young Joseph Kosuth and Ashbery's boyfriend, the poet Pierre Mortary, were in the audience. Michael and Ileana were extremely pleased the event went off well. When it comes to French movies, I think I knew more about the Nouvelle Vague than Andy. In fact, I don't think Andy ever saw one of those movies. Here was our opportunity. It just so happened Godard's *Alphaville* had just been released and was showing at one of the art cinemas on the Champs-Élysées, so I dragged Andy along. The movie had no subtitles and neither of us spoke any French, so we were already handicapped culturally in the very country that gave birth to the New Wave. All we could do was follow the movie visually but even that proved a bit difficult. When we emerged in the daylight Andy was whining about how Godard was stealing his ideas and I basically had to shut him up saying that there was no way that could have happened because Andy had only been shooting his sound movies for the past four or five months and none of them had been seen in Paris, let alone Europe. The whole notion of Godard stealing from Andy was simply ludicrous. Furthermore, even if Andy had seen one or two of these movies back in New York, they were so far removed from his sensibility he probably wouldn't have understood them anyway.

GBK: During your visits to Paris did you and Andy get to know the French art scene? The European version of pop art? Did you make friends with any of the French or European contemporary artists?

GM: Good question. Aside from hanging out with Denis, Stash, and Anita who was one of the top models in Paris at the time, I became reacquainted with Pierre Restany who was the guiding spirit and spokesman for the movement known as *Les Nouveaux Réalistes* which some critics had designated the French version of pop art, though I don't. I got to meet Mimmo Rotella through Pierre who was a major force in that circle and we became lifelong friends. Mimmo had given Andy and me inscribed copies of a recent gallery catalogue of his work, but I don't get the sense Andy thought much about what the New Realists were doing, and I still have both copies. Maybe Andy felt a sense of rivalry there. We may have met other artists during our stay but I can't recall any just now. Denis was my tour guide and we pretty much went all over Paris together. He took me to see the house and studio of Gustave Moreau and the curator there opened up the archives and we got a firsthand look at his sketches. We also spent an afternoon at the Musée de l'Homme. Most nights we ended up at Castel's, what they called a discotheque in those days. A lot of glamorous people hung out there, including Omar Sharif and Françoise Dorléac. It was my first trip abroad and I was having the time of my life.

GBK: The changing in Warhol's "artistic concept" seems to be partly related to techniques, silkscreening added to painting, camera became filmmaking, and then in 1965 it's the tape recorder. In your opinion, what did the use of the tape recorder bring into Warhol's creativity or Warhol's world? What was the role of the tape recorder?

GM: I think as Andy advanced with his work he came more and more to rely on a less "hands-on" approach. At least he made an attempt. He was early on often quoted in the press as wanting to be "a machine."

It was a metaphor for eliminating authorship. It was also his way of shedding attachments, both physical and emotional. Maybe he wanted to project himself as the selfless artist—that is, everything should become more mechanical to his way of making art. Technique was only a by-product of process or at least an extension of it. He gradually moved away from the physicality of painting; the silkscreen would in a way erase all vestiges of the human touch (with the exception of some of the very late work). Pushing a button on the movie camera and letting it do the filming mechanically rather than physically hand-holding it was merely another way of distancing himself from making physical decisions involving the hand and the eye, even. It was like the tripod became the human backbone. The introduction of the cassette recorder in '65 only extended these ideas further. You could write a novel let's say without physically writing it down on paper. You could record your characters talking; you could choose people, like Ondine for instance, who were good talkers and let their stories become the narrative that someone would later transcribe. No more creative novels and plays, even. The machine does all the work. Of course, Andy didn't figure that there was no escaping the physical work. Decision makes art and usually those decisions were physical.

But the illusion was cast . . .

GBK: You say that "maybe he wanted to project himself as the selfless artist" but he seems to have been a religious person. Some of Warhol's last paintings have religious references and in his funeral the priest talked about Warhol having been a practicing Catholic. During the years you spent together with Warhol did you notice that he was a religious person?

GM: Much, too much, has been made of Andy's religiosity and all of it after he died, as if to set him apart. He may have had a lot to atone for, but that's between him and his Maker. He certainly hurt a lot of people along the way, not intentionally, mind you; but he never wanted to solely take responsibility because that would make him fallible and that would show a weakness. I think in his mind everyone was responsible for themselves. Cause and effect was not something he could grasp. It's like you lead someone down the primrose path and suddenly there's a cliff! Oops! He had that kind of effect on people because they believed in him. That's the way it is with anyone striving for power. They have followers. We would on occasion stop off at this church, St. Thomas Moore's Church it was called, up the street a couple of blocks from his townhouse—that's if we were passing through the neighborhood and he'd suggest let's go in and we'd sit for awhile in one of the pews in utter silence and maybe he was saying a prayer. We did this a few times. But that's about it. I wasn't around later to know that Andy, as the priest remarked, was a "practicing Catholic." Yes, Andy's last painting was curiously adapted from Leonardo da Vinci's depiction of the *Last Supper*, and if you go through all of Andy's oeuvre, a lot of what he made was based on photos that became iconic or already were or the movie stars; Elvis and Marilyn Monroe were already referred to in real life as iconic. Same thing. But Andy, perhaps, was the most iconic of all when you look back. Icons are attracted to other icons, you see. But I don't buy this con-

nection with the religious icons of Andy's youth as influencing the art he would make later on. That's a bit of a stretch to my mind and as Virgil Thomson, a friend, once said, the "games of influence are as profitable a study as who caught a cold from whom when they were standing in the same draft." [*laughing*] There's enough of that going around already.

GBK: In January 1965 Andy meets with Edie Sedgwick who became an important "partner" during that year. And you, according to photos and documentation, are quite present as well. What kind of role did she have in the "Warhol World" during that period?

GM: What you have here is a dynamic where two individuals are taking each other seriously upon an instant encounter by chance. You have Edie Sedgwick, ending up as a "poor little rich girl," having already gone through two trust funds by the time Andy meets her; but still her charm and vivaciousness and the aura of old family wealth and history are what attracts Andy who, as we know, comes from a very modest Pittsburgh background. Andy is using his already worn-out Hollywood cliché, "You wanna be in a movie?" and Edie who wants nothing more than to break into movies, sees what she thinks is her meal-ticket and instant fame and fortune, although it's not as cynical as all that. It was more sincere for the naiveté that played out. They really liked each other. Andy also knew that his friendship with her would certainly enhance his relationship with the press and Edie rightly saw it in the same light, though she at this point had no fame at all. Just a string of tabs at some posh restaurants and a beat-up Mercedes to chauffeur her friends around. She'd only arrived in New York from Cambridge a few months earlier and here we're meeting her for the first time at one of Lester Persky's penthouse parties and it was all so magical. It was as if they launched each other into each other's aura. Andy had finally found his muse.

GBK: You created together with Warhol *Interview* magazine. What was the concept and aim of this magazine?

GM: Andy was thinking of doing a magazine back in '69, but he didn't know what kind and wasn't sure how to go about it. He had no previous experience in this area. Three years earlier Andy and I were going to bring out a one-shot literary publication and I ended up doing all the work and he did"t do a stitch of anything! It was called *Intransit: The Monster Issue*. So now I'm figuring uh-oh it's gonna happen all over again. A friend of mine, John Wilcock, who was a columnist and staff editor for the *Village Voice*, had also this idea of launching a monthly tabloid. He had worked briefly for the *East Village Other* after leaving the *Voice* and now underwrote an even smaller newspaper called *Other Scenes*. He'd come to visit me at the Union Square Factory one day; I was guest-editing an issue for him on the subject of eroticism in poetry and the arts. He got into a conversation with Andy about what he was doing and shortly after they had another meeting where John outlined his plan. He already had the structure in place because he had an art director working for him on *Other Scenes*, so it would be pretty easy to add on a second publication. At around this time, Andy had requested press passes for us from the New York Film Festival and was denied. So it was decided John and Andy would start a film magazine—a newspaper really—and we'd reapply for the passes and they named me a founding editor. Andy's notion was it would give me something to do. We added Paul Morrissey as a fourth editor on the masthead. We came up with the name, *Inter/View*; that's how it looked as a logo with the slash dividing the two words. It was meant to echo Charles Henri Ford's magazine, *View*, which he'd published back in the '40s. The punch line is we did receive our press passes finally and the first issue appeared I believe in late September/early October just after the film

festival ended. The first issue was a big hit. We left a bundle of copies to be given out free at Max's Kansas City. John decided it would be feasible to publish *Inter/View* monthly. Eventually, *Other Scenes* folded and John put all his efforts into publishing *Inter/View*.

GBK: Did you get to know the person Warhol, the Self hidden behind the many masks?

GM: Your question is, like they say, of tall order. You present many facets of what you would like to know about Andy but not any one of them precisely is the Andy I came to know when working closely and partying with him. I can only respond to what I think I know: that is, his "appearance." Andy was not vain, but considering the childhood trauma he went through as a kid, he should've been. Instead, he did something quite clever and ingenious: he created a camouflage for himself, not a disguise, mind you. Camouflage and disguise are two entirely different things. Camouflage, I believe, is something that allows you to blend in, whereas disguise is what you do to hide yourself behind a mask, to change your appearance entirely so no one can recognize you. In that sense, you become someone else.

When Andy was quite young when he came down with an acute attack of the nervous system called chorea. This disease, according to my nifty *American Heritage Dictionary*—best to look these things up—is "marked by uncontrollable and irregular movements of the muscles of the arms, legs, and face." It also goes by the name of St. Vitus's Dance. St. Vitus, a third-century Christian child martyr, is venerated by sufferers of the disease and that's what Andy told me he had. Supposedly, it took about a year of bed rest for him to recover. So you have to imagine the amount of suffering a child would have gone through and it was during this time that Andy's talent for drawing developed and the Hollywood dream world of movie stars he imagined of beautiful faces just lifted off the magazine pages as a kind of mental balm. Something that soothes, heals, and comforts. He needed that. Andy lost most or all the pigmentation of his skin which accounts for his ghostly appearance and his eyes were sensitive to sunlight so he wore sunglasses a lot of the time. And then there was the hair. His hair started thinning out because of the trauma he'd been through. So by the time of his last year at Carnegie Tech he started wearing toupees. Imagine, he had suffered a lot and now he had to make his way into the world where appearances in the advertising business count for a lot. He had obstacles to overcome and one of the ways he approached this dilemma was to create a camouflage for himself. Not a disguise, because he didn't want to hide himself. He couldn't. He needed to be out there. Wigs and toupees in those days basically came in natural hair colors. Andy did something very daring; instead of a colored wig he had one sprayed silver. There was nothing natural about silver. Gray hair, yes, but not silver. So what you first see is not a toupee but a head of silver hair. Your visual sense is deflected. Then there was his behavior. Andy, for me, was the boy. He had this way of behaving like a boy as if he had never left that bed of his childhood and this, perhaps, accounts for his innate shyness. Shyness for him was a good shield to mask any emotions he wanted hidden. With all this, he got along well with everyone and everyone liked him. He basically got to a level where his self-confidence kicked in because he'd already mastered his skill as a commercial illustrator. In other words, he had to feel comfortable in his skin to move forward with the talent he had that to my mind was a god-given gift. This was the Andy I was privileged to know and to work with.

GBK: Why did you stop working with Warhol? Why did you leave Andy?

GM: After Andy was shot, it seemed his focus and work habits shifted. It was now 1970. Two years had passed. He was now concentrating all his efforts on the print editions. I be-

lieve we made only one silkscreen painting together during that time, and that was in fall '68; a series of portraits that Dominique de Menil had commissioned to give as gifts to her children. Activities had definitely slowed down a bit. I was maintaining the college film rental service. The atmosphere was getting a bit testy. Fred Hughes was definitely trying to undermine my position at the Union Square Factory—not overtly mind you, but in ever-increasingly, subtle ways. Finally, Paul decided it was not in the Factory's best interest to continue the film rentals. It didn't look good for business. There was nothing much else for me to do. I made the astute decision to strike out on my own. Andy gave me some paintings as a kind of severance pay—something I hadn't anticipated and that got me through all of next year. I became a photographer full-time and happily the poetry continued also. I was now on my own for the first time in seven years.

GBK: In looking back, what would you say was the one gift Andy had given you?

GM: It's easy and it's not so easy to look back. Yet by some trick of the mind I am thrust back into my past, to what Somerset Maugham called the razor's edge: of a life lived and of a life with all the possibilities before it still waiting. Two fates intertwined but only one destined by choice, and so on a fateful day at summer's end I took the high road when I went out to L.A. with Andy instead of returning to school. What would my life have been like had I chosen differently? It's a bit scary and that's what Maugham meant by the razor's edge. It's that close! It was up to me to choose between two unknowns and to choose wisely. In looking back, I realize that working with Andy gave me a glimpse of another world on the other side of a wall. Andy had given me a leg up to look on the other side and that was the gift he had given me. I'm still trying to make sense of it all.